LIKENESSES

LIKENESSES

JUDITH ARONSON

WITH THE SITTERS WRITING ABOUT ONE ANOTHER

FOREWORD BY

CHARLES SAUMAREZ SMITH
ROYAL ACADEMY OF ARTS

LINTOTT PRESS
MANCHESTER & GLASGOW

First published in Great Britain 2010
Lintott Press
Flat 23, Regency House
36-38 Whitworth Street
Manchester Ml3NR

in association with

Carcanet Press Limited
Alliance House
Cross Street
Manchester M2 7AQ

www.carcanet.co.uk

A CIP catalogue record for this book is available from
the British Library

ISBN 978 1 85754 994 2

The publisher acknowledges financial assistance from

Oxford English Dictionary

likeness 3. The representation of an object; a copy, counterpart, image, portrait.

1667 MILTON *Paradise Lost* VIII. 449-51

What next I bring shall please thee, be assur'd,
Thy likeness, thy fit help, thy other self,
Thy wish, exactly to thy heart's desire.

1815 JANE AUSTEN *Emma*

Did you ever have your likeness taken?

1885 EDWARD CLODD *Myths and Dreams*

They believe that their names and likenesses are integral parts of themselves.

* *Contributions are original to* Likenesses *except where dated.*

FOREWORD CHARLES SAUMAREZ SMITH

I FIRST CAME ACROSS THE WORK OF JUDITH ARONSON when I was the Christie's Research Fellow at Christ's College, Cambridge. I had been recruited to the College in 1979 by an intellectually formidable interview panel, chaired by the historian Jack Plumb, and including Christopher Ricks, the writer, critic and Professor of English, who asked me about the origins of Vanbrugh's "grand style" (it was only later that I discovered that his first book had been on *Milton's Grand Style*). Not long after I arrived, Plumb, as Master of the college, devised a scheme whereby Ricks's wife, Judith Aronson, at the time a photographer for the *Sunday Telegraph Magazine*, would take formal photographs of each of the Fellows for the historical record.

It was the first time in my life that I had ever sat for a formal photograph. I sat in front of a white background, which was placed in order to abstract the sitter from the surrounding epiphenomena of the room, in a professorial room of the college that had been converted into a temporary photographic studio. I remember the experience as being relatively painless in comparison to my later experience of sitting for photographers, including Richard Avedon, a friend of Judith Aronson when she was a graduate student and someone who used the same technique of white back drops to abstract the sitter from the setting. I was required to sit down on an academically austere chair. There was a little bit of polite conversation. Then, click. Don't take too long or one's expression is frozen.

From my experience of formal photography, most portrait photographers take far too much time and effort in concentrating on the pose and setting. They are interested not so much in the character of the sitter

as in the more general *mise-en-scène*. Judith concentrates on the expression of the sitter, although her training

as a graphic designer also means that she pays close attention to the geometry of the composition. I like the

photograph she took very much indeed, as it shows me still with a head of hair, rather long as was still the fashion

in the late 1970s, fresh-faced and earnest, as I no doubt was, wearing a jacket which I had bought cheaply from

Margaret Howell, and with my tie very slightly undone. I keep it on the walls at home as a reminder of lost hopes.

Since then, I have followed Judith's progress as a photographer. In the mid-1990s, she reappeared in my

life when Terence Pepper, the brilliant curator of photographs at the National Portrait Gallery, acquired some

of her work for its reference collection, including some of the big colour prints which she had done for the

Sunday Telegraph Magazine: Keith Simpson, a horribly austere portrait of a forensic scientist (NPG x26036);

Ralph Richardson (NPG x125467); and a tousle-haired Jonathan Miller (NPG x26035), one only of a particularly fine

group of photographs, another of which shows Miller slouched on a sofa in his living room with a transient cat

disappearing out of the foreground.

Now, nearly thirty years later, I have had an opportunity of seeing and studying the photographs she

has taken of others as well. Much of her work consists not just of formal, commissioned portraits, but also

photographs of friends, semi-formal, photographed in the sitting room or against a brick wall and often in groups

which make it possible to observe changes in mood and character, the fleeting transience of expression. She is

interested in the character and personality (often illuminated by their surroundings) of actors, academics,

novelists, poets, set designers, film makers, artists, and intellectuals. In quite a number of the photographs, she

depicts a world of studious high-mindedness, commemorating lunches in the Oxfordshire countryside where the

talk is of poetry and books.

I have been browsing the imaginary pages of the book, beginning alphabetically with Saul Bellow,

weather-beaten and wry, but with a Mont Blanc in his pocket and with someone who I first assumed was his

daughter on his arm, but now realise is his wife. William Empson looks pretty fierce (he was described by

one of his students in Tokyo as "forthright" and "uncompromising"). I didn't know what Richard Gregory looked

like, although when I was Director of the National Portrait Gallery, I was involved in commissioning a portrait of him by Tim Hunkin, an inventor, who photographed him using a modern version of a nineteenth-century camera, with cheap reading glasses as lens.

Once one gets to Seamus Heaney, one realises that he is someone who is used to being photographed and so somehow can't help playing around in Harvard Yard (or is it just that he is aware that he photographs well?), while the majority of Aronson's sitters are admirably and rather wonderfully unselfconscious, like the occasional voices one hears on the radio of people who are not used to being broadcast. Likewise, one has got so used to rooms which have been doctored and spruced up for portrayal in the *World of Interiors* that it is reassuring to see the unselfconscious interiors of people who don't particularly care how their houses look. This characteristic of unselfconsciousness extends to the quality of the photographs as well, which have a freshness of view which sets them apart from much professional studio photography.

Another characteristic is clear. These are often photographs of husbands and wives, as well as of father and son, parents and children, family and dogs. Relationships are an important part of the chemistry of friendship, of which these photographs are a documentary record.

Here is I.A. Richards, photographed somewhere in a park across the street from his apartment in Cambridge, Massachusetts (he taught at Harvard for many years before his death in 1979); Ralph Richardson, caught slightly unawares as he winds his grandfather clock; Anne Ridler, the poet, sitting in a cottage garden, with her husband, Vivian, who was printer to Oxford University Press. The young Salman Rushdie appears near the time that *Midnight's Children* was published, looking a bit wind-blown and melancholy in one photograph, and sitting at an electric typewriter with a small child on his knee in another. Aronson has recorded a world of intellectual high-mindedness, where ideas count, and in which the intellect is properly respected, before the days when Thatcherism (or Reaganism) destroyed the social esteem accorded to the academic élite and before the cult of celebrity made writers into newspaper idols.

Here, too, is Simon Schama before I knew him, when he was a young and still fresh-faced don at Christ's College, Cambridge, before the days when he became an international superstar. I didn't know Wagnerian Michael Tanner

when I was an undergraduate at Cambridge and wish I had: his room is a scene of wonderful, astonishing chaos. And then there's a charming photograph of Keith Thomas, the brilliant historian of seventeenth-century magic, who absolutely detested the various portraits that I was involved in commissioning, including the picture by Stephen Farthing in the National Portrait Gallery of the founding fathers of *Past and Present*.

Of course, in browsing through the photographs I have inevitably concentrated on those where I know, or think I know, the sitters. The full set includes the more formal compositions which were appropriate for publication; but for me the liveliness of the photographs lies in the more informal pictures, that are a record of the intellectual and literary élite of the second half of the century in London, Oxford, two Cambridges and elsewhere. The subjects, some of whom may not have liked being photographed, are caught slightly off-guard, but the more memorable precisely because they didn't have to pose too obviously. My favourite is the one of Ivor Richards, tightly framed, and the sad, lined face of his wife. One does not know what they are thinking.

—*Charles Saumarez Smith*
Chief Executive
Royal Academy of Arts

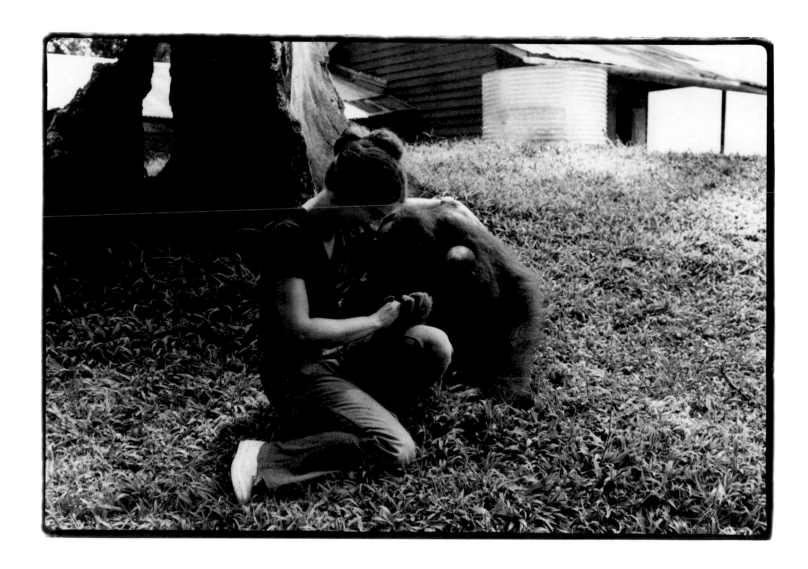

The photographer, Judith Aronson,
Borneo, 1972

INTRODUCTION

A PHOTOGRAPHER'S BODY OF WORK is likely to consist of professional assignments and of pictures taken in off hours. The latter may be deliberate set-ups, or experiments for personal expression, or the simple capturing of the day to day. There are the places one hangs out and the people one talks with. There is the decision to travel, and the pictures will reflect this. There is the company of good conversationalists, and so a gravitation to circumstances (a person, a situation) that invite a camera to eavesdrop. And if one opts for adventure over routine, this is another set of conditions. All of these have been my life for quite a number of years. When in the mid-1970s I moved to England to be with the man I would marry, an Englishman, a university teacher of literature, it didn't occur to me that I might be amongst people of pedigree, let alone anyone particularly ripe for photographing. I was and am a graphic designer, with some training in graduate school as a photographer, only late in life an academic and not of the literary sort; I now teach design at a university. Back then, in the 1970s, I had just returned from three years traveling and working off-and-on in the Far East, including one year with the photographer Hans Hoefer at APA Productions, the publisher of the *InSight Guides*. I credit this experience with most of my photographic knowledge, particularly that of taking pictures of people.

More than anything else it was probably my natural inclination, from a very early age, to pay particular attention to how people treated each other, beyond what they said—how they stood, what they did with their hands, what happened to their faces when talking or being spoken to. (When tiny I'd, apparently, tell my family and teachers how people were getting along.) I am not a great fan of traditional portraits—faces looking into the camera or at the photographer. Better to capture people in action even if they are just responding to or conversing with one another, their normal lives in a familiar setting of theirs. Others have called my photographs glorified snapshots. I would not disagree.

I value the photographs of Henri Cartier-Bresson, his *The Decisive Moment* is always close at hand, and those of Richard Avedon, where the white background makes the body as important as the face and leaves no question where the focus is. Margaret Bourke-White, Robert Doisneau, and Walker Evans (a teacher in graduate school), all made a difference to me when I started to take pictures and they continue to attract. While studying, Robert Frank was a favorite guest critic. Mary Ellen Mark is a contemporary whose photographs move me. In color portraiture Annie Leibovitz's pictures are fascinating, but I've never wished to art direct to this extent. Cindy Sherman's contrivances in a variety of self-portraits are remarkable for their simultaneous weirdness and beauty of composition. Probably the influence least direct but most widespread, especially in over-all form, is that of the graphic designers I admire: El Lissitsky, Alexander Rodchenko and other Russian constructivists as well as designers from the Bauhaus, notably Moholy-Nagy. Without deciding to do so, I position the human figure to contrast with architecture, windows, doors, staircases, and pictures hanging on walls.

Likenesses came about by chance when Michael Schmidt, the Carcanet publisher, happened upon a photograph of Anne Ridler that he needed for an anthology, *The Tenth Muse*, displayed among others of mine. With his inquiry he added a postscript: Might I be interested in doing a book of my double portraits? I was particularly pleased that he'd noticed relationships within the pictures—husband and wife, parents and children, collaborators at work such as a stage designer and his crew, or an actor and his director. It was clear from the start that the publisher and I wanted some form of commentary alongside the sitters. It made

sense, especially as many of them work with words. What had already been done many times was to accompany a photo with words by the sitter; likewise, to incorporate memories by the photographer of taking the pictures. But to have sitters writing about someone else in the book: this felt distinctive. (They could write if they wished about someone in the same photo.) A friend of mine warmed to the thought of a cocktail party of friends and acquaintances, where the reader drops in to listen to the conversation. Of course there was the question of who knew whom, and there was the sad fact that several sitters were no longer alive. But it was not essential that all the contributions be original, and moreover words from the old days (say, Diana Trilling on Norman Mailer, or Mailer on Salman Rushdie) are alive today and here given their publication dates. Still, I lacked a number of contributions new or old, so I had the pleasure of writing seventeen of the sixty contributions myself.

Teaching design, especially typography, being my full-time job, here was an opportunity in *Likenesses* to bring together my two careers. I undertook to be designer and production manager as well as photographer. To have the book form a whole, and to prevent either the pictures or the words from trumping the other, it was clear that the photographs be black and white. But then words do have their own texture and color (right down to differences, retained here, between British and American spelling), not black and white, but shades of gray.

Freelancing for a year in the US after returning from Asia, I got the chance to take the picture for *Ms.* magazine of Sarah Caldwell sitting amongst the original seats from the old opera house and in front of a musical score. Next came an assignment for the Commissioner of Human Services documenting the relocation to community housing of institutionalized Massachusetts residents. Such jobs were the experience needed to convince a few art directors that I was a professional photographer. But before I left for England in 1976 to proffer these experiences and to land a first tentative assignment for the *Sunday Telegraph Magazine*, Robert Lowell came to have coffee and discuss poetry with the man in my life. Aware that this wasn't exactly my milieu and not having much to say, I watched the two of them talk, and soon realized that here was a photo

opportunity. I was granted affectionate permission—although it was the first time I met Lowell—to take his picture on one condition: I would cut his hair. And so I did, taking pictures before and after.

In England, about a year later, Alex Low, the *Sunday Telegraph Magazine* picture editor, offered "a try", as he put it, on a story about unusual shops in London—as long as I didn't mention that I lived in Cambridgeshire. "The editor doesn't want to pay expenses for people who live outside London, and he wants people available on the spot".

The shops assignment stands out as the hardest I've ever done. I owned only one small photo-flash and hardly any equipment: a tripod, and two Nikon cameras, an F2 and a Nikormat, plus four lenses. Each shop to be photographed was different, dark, and complex. None had enough light for me to record people's faces, and many were full of reflective surfaces (mirrors, glass windows, shiny metal) that I had no experience photographing. I could see myself through the lens on what seemed a million surfaces bouncing there from who knew where. After a few test shots, I bought a 20-foot cable release (so that I could be out of the picture frame when pressing the shutter) and several tiny clip-on slave flashes that could be triggered by a light-sensitive eye attached to the top of the camera, equipment not common back then. I placed them around the shop behind objects. When one flash went off, the eye would signal all the others to go off simultaneously. This preserved the shop's ambience while giving enough light to capture the people. I don't use large strobes that might overpower normal light sources, though sometimes there are 200-watt incandescent bulbs as supplement.

Finally I purchased a 24 mm lens. It became my favorite, because if held parallel to the floor plane of the photograph, there is only minimal distortion, and I could take a full portrait of my subject while including much of the background. A third of the photo would show the subject (seeming to be close-up), and two-thirds the surroundings, something not possible with a standard lens. I much preferred these asymmetrical pictures to symmetrical ones with the subject placed in the middle.

Shop by shop (there were about twelve) I went in, by agreement of course, first observing for about a half an hour, and then taking pictures

without giving notice. I tried not to ask anyone to do anything, especially not to pose. I didn't want to disturb them, and I imagined the people would look natural if I could just snap a picture of them going about business as usual. Occasionally, I would move something out of the way or into the picture's frame. If I had to ask people to be still for a minute, I asked them not to look at the camera or alternatively had them talking to someone else, hoping that this would distract them into being natural. The *Sunday Telegraph Magazine* used all the photographs and employed me for several years. Assignments followed including on fly-fishing for sharks in the Atlantic and the last remaining steam engines, until I left when nine months pregnant. At that time the editor wanted pictures on an oil-rig in the North Sea and it was December. He said good-naturedly, but seriously, that they'd send a helicopter for me if I went into labor. I think the editor really thought I'd go.

During those three or four years at the *Telegraph* I was more and more assigned stories about the arts or art personalities, including Joan Plowright, David Hicks, Ralph Richardson, and Jonathan Miller while he was making the BBC series, "The Body in Question". On the second day photographing Robert Stephens in a BBC production of Sartre's *Kean*, part of a story about his "triumphant return to the National Theatre", I went with him to a TV center on the outskirts of London for an official celebration. Stephens was as usual charming and flamboyant. He had been drinking a little more than he should have, given that he was to perform as Gayev in *The Cherry Orchard* at the National Theatre that night, and I became increasingly worried that he would not make it. I phoned the theatre and was told, "Can you just put him in a taxi and send him off, we'll pay when he gets here". No, that was not possible, he had his own ideas, he certainly wasn't going to listen to me. Whether that night's performance was cancelled I'm not clear. Certainly, Stephens didn't show up.

Probably my favorite job for the *Telegraph* was shooting a Royal Shakespeare Company production, from the original read-through of the script in a barren London studio, to the last dress rehearsal in Stratford-upon-Avon. I was to cover everything or anyone important behind the scenes: the set designer, the props shop, the wig makers, the

costume designers, the voice coach, the green room . . . I would gladly have paid for this opportunity rather than being paid. The designer in me was living every setting as if I were one of the RSC. I would see a magnification, through the lens, of the hand crafts that had once brought me to graduate school in design: the woodworkers creating a foreshortened table in exaggerated perspective with the front legs a foot longer than the back ones, seamstresses stitching tie-dyed billowing costumes for the spirits.

Between professional assignments from 1975 to 1986 I photographed people who came to the house or were part of my life in Gloucestershire, in Cambridge, England, or Cambridge, Massachusetts where I returned from time to time. They were academics, poets, writers and their families. Many seemed to know each other from crossing the Atlantic to teach or give poetry readings, and they talked often about one another. Initially, with little knowledge of the people who came into my life in England, I might inquire. If the answer was cursory, as often it was, it didn't seem to matter. I liked them and enjoyed their company. They talked seriously or humorously about anything. After a number of such meetings I started asking to take their photographs. I managed to erase the entire take (six rolls of negatives) of William and Hetta Empson by confusing a familiar chemical from America (notable for having the letter "X" in its name), with a chemical just purchased in England, also with an "X". I was distraught. Still anxious two years later when I had further opportunity to photograph them, I made what could have been another disastrous mistake: opening the back of the camera before rewinding the film, and letting in light. Fortunately I slammed it closed quickly. Here then is one of my favorite pictures: Hetta backlit laughing, light-leak and all, while William looks on.

Cambridge life was in some ways just right for my kind of photography. Jack Plumb, at the time Master of Christ's College, needed only a white back drop to record his ever-present body language. The same went for the fifty portraits of the Fellows of the College, creating an appropriate uniformity and highlighting the character of each person in the ten minutes allowed. Ivor and Dorothy Richards,

photographed against a brick wall outside their apartment in Cambridge, Massachusetts when I was on a brief visit back to the United States. Rosanna Warren with her mother Eleanor Clark in her assisted-living residence a few days before she died, and Rosanna at home with her children in the kitchen. Greg Delanty is shown in my garden in America; Richard Gregory among his photogenic scientific, technical, and personal paraphernalia in his Bristol flat.

In 1986 my family and I moved to Boston, Massachusetts where I live today teaching, a career I took up first in Cambridge, England. Boston has allowed me to continue photographing writers and artists. For Boston University I was hired to take pictures of Saul Bellow, Leslie Epstein, Seamus Heaney, Robert Pinsky, and Derek Walcott, all attending a writers' symposium in 1990. Several participants said they would allow me to photograph them only if all the others were photographed.

So when Derek Walcott and Sigrid Nama, his partner, agreed to meet me two weeks after the event, I was delighted, having sensed that they might be the most challenging to track down. I set up appointments with all the others, and then on the day before the appointment with Walcott and Nama, I phoned to confirm. Alas they wouldn't be able to make it; if I wanted I could, however, come to St. Lucia in a couple of weeks, after their trip to Spain, and photograph them there. No one was going to pay my way, but I consented nonetheless, and booked tickets. The night before my departure a message on my answering machine simply said, "We won't be in St. Lucia on Friday as planned, deepest apologies". I spent a good bit of time trying to decide if this meant, don't come at all, or come but we can't see you until Saturday. Being tenacious, I started phoning universities in Spain hoping to find Walcott. Eventually someone answered in English, saying that at a lecture by Walcott the night before, the poet had been heard to say that regrettably he had to go to Puerto Rico to renew his visa and could not go on to Italy as planned. From this, I figured Walcott would return to St. Lucia once he was in the Caribbean. So I flew there and waited until Saturday to phone. I'm not sure who was the more surprised to find the other at the end of the line, but certainly Walcott had not been exactly expecting me.

Nevertheless, I was treated with the greatest hospitality and wined and dined as if I were a dignitary. It was a good trip. The only problem: Walcott never mentioned taking the photographs. An hour before sundown on my last day there, Sigrid said, "Derek, we must let Judith photograph you before it gets dark and she leaves the island". And so he did.

* * *

I hope this book makes the case for portraits, while acknowledging that Charles Tomlinson, with dry humor, issues a warning about them:

AGAINST PORTRAITS

How, beyond all foresight
or intention, light
plays with a face
whose features play with light:

frame on gilded frame,
ancestor on ancestor,
the gallery is filled
with more certainty than we can bear:

if there must be
an art of portraiture,
let it show us ourselves as we
break from the image of what we are:
the animation of speech, and then
the eyes eluding
that which, once spoken,
seems too specific, too concluding:

or, entering a sudden slant
of brightness, between dark and gold,
a face half-hesitant,
face at a threshold:

Yes, a "threshold:"—at which point, with the assistance of Charles Tomlinson's imaginative final punctuation I leave the reader to cross the threshold into the book proper.

—*Judith Aronson*

THE PHOTOGRAPHS

WILLIAM EMPSON *and* HETTA EMPSON

IN HIS MEMORIAL ESSAY ON WILLIAM ARROWSMITH and John Jay Chapman (*Arion*, Third Series 2.2 & 3, p.19) Christopher Ricks pays tribute to those who possess "a vocation for heroism". He would no doubt wish to place William Empson in this elect company; and he would be right. There is one reference to me in Empson's *Selected Letters* (Oxford 2006), in a letter of 1978, to Ricks: "I think it is lucky for him that the world is so dismal just now; he could not have made poetry out of anything else" (p.654).

The comment is entirely fair; but it could fairly be applied to just about every serious-minded writer of the Twentieth Century, including himself. I cite as evidence the title of his second collection of poetry, *The Gathering Storm* (1940).

The Structure of Complex Words (1951) is a magnificently intelligent book which exerted a powerful influence on the basics of my own critical method.

I was in his company on no more than a half dozen occasions, one of them in the famous Sheffield den, a tête-à-tête where it soon became evident that I could not operate at his pitch of discourse. He kept his impatience in check very civilly, but I knew that I had been found wanting.

His charity on that occasion, seen in the context of his habitual argumentativeness, seems in retrospect all the more remarkable. I am inclined to read it as an instance of his High Tory graciousness not wishing to embarrass the gamekeeper's son.

I liked the High Tory Empson very much. In his more frequent appearances as the chattering Radical Whig he could be tiresome.

He showed great magnanimity late in life by allowing his old Cambridge college, which had dealt brutishly with him in youth, to elect him into an Honorary Fellowship.

—*Geoffrey Hill*

*Cambridge, England,
1980*

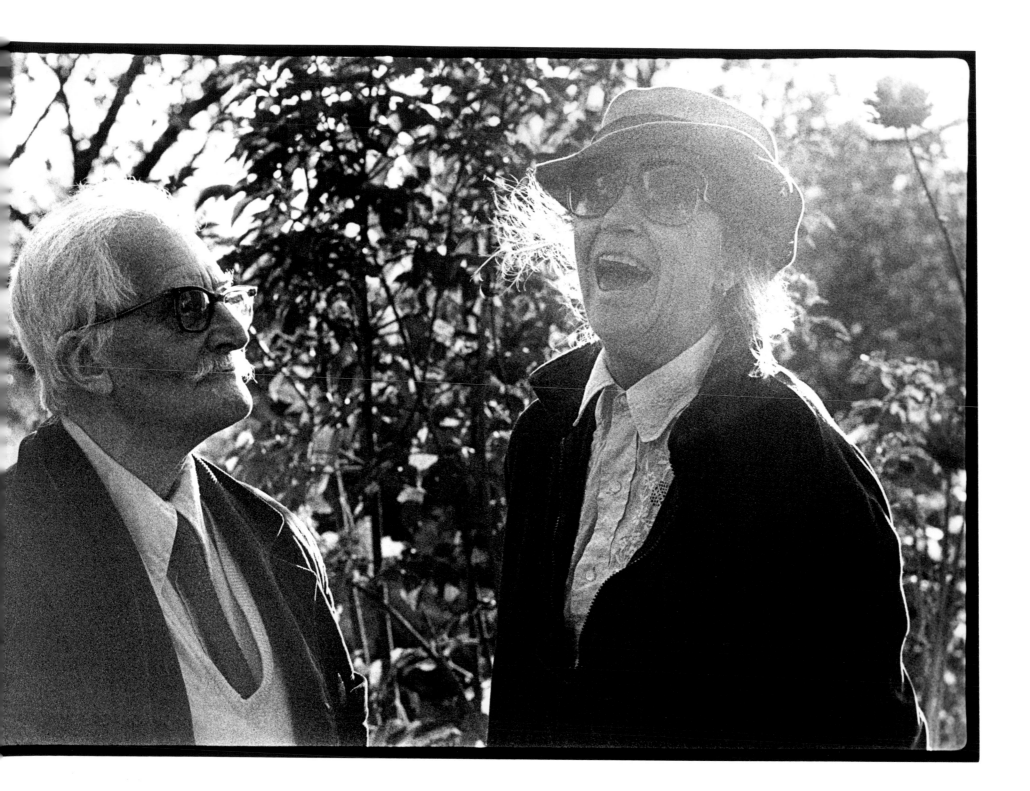

3

A LITTLE ENGLISH MAGAZINE has an interesting interview of Empson—rather sad. He says most nineteenth-century English poets began well, had a dismal middle-age, then wrote well again. That he himself stopped when he couldn't bear what [he] was writing. That he was interested in a kind of poetry promoted by Graves that was the working out of problems that in life one had no answer for, so that one tried to be clear as one could for the art and the working out, but really wrote for no audience, "not even Laura Riding". In middle age one is too busy living, working to send a son to college etc. to live with this kind of problem, even though underneath one seethes with scorpions. He hopes to write grand poetry when he is forced to retire at 65.

<div align="center">* * *</div>

My whole trip was minute little readings, stage, radio, TV, little lunches, rehearsals (six hours) for a minute and 15 seconds BBC TV recital of "Man and Wife", though of course I was with a mob of other people and didn't even rehearse more than four minutes. I saw quite a lot of Empson. They live in a hideous 18 room house on the edge of Hampstead Heath. Each room is as dirty and messy as Auden's New York apartment. Strange household: Hedda Empson, six feet tall still quite beautiful, five or six young men, all sort of failures at least financially, Hedda's lover, a horrible young man, dark, cloddish, thirty-ish, soon drunk, incoherent and offensive, William Frank Parker red-faced, drinking gallons, but somehow quite uncorrupted, always soaring off from the conversation with a chortle. And what else? A very sweet son of 18, another, Hedda's, not William's, Harriet's age. Chinese dinners, Mongol dinners. The household had a weird, sordid nobility that made other Englishmen seem like a veneer.

—*Robert Lowell*, 1963

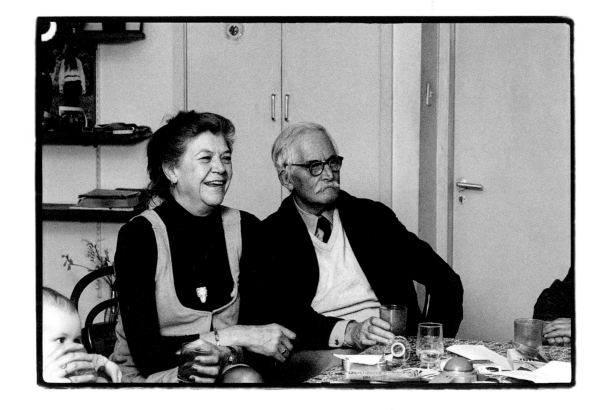

4

London, 1977

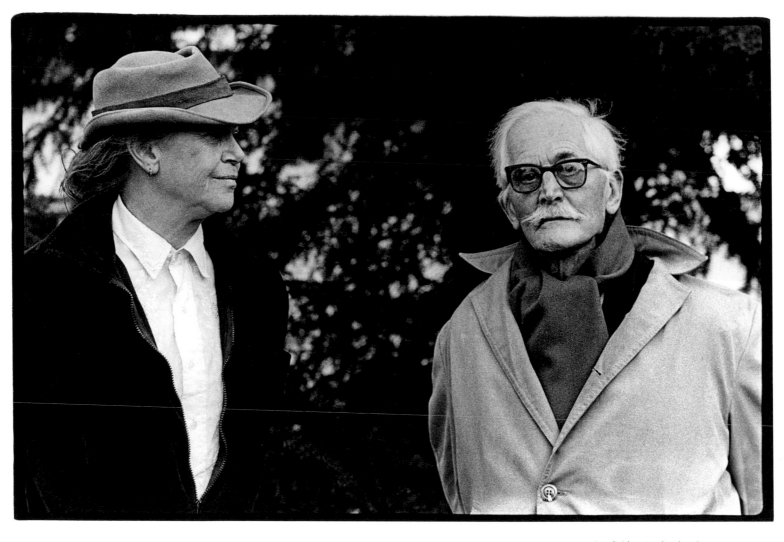

Cambridge, England, 1980

TO T.S. ELIOT Dear Eliot,

I've just heard today from the best man I've ever had at Cambridge, William Empson, that Magdalene after giving him a
Bye Fellowship largely under pressure from me have taken it away on the ground of some indiscretion with a feminine direction.
I don't know any details but am most indignant.

He talks of coming up to London and working at the things he is interested in. This covers a good deal of 16th and 17th
Century poetry and all sorts of things besides. I think he is a quite exceptionally good *poet. Cambridge Poetry 1929* will allow
you to judge of this. He is a very ready hand with a pen and can produce new and valuable ideas about books within a very
short time of first handling them. So he could be made great use of in reviewing. I'd always weigh his opinions as carefully as
anyone's. I've told him that I would write to you in case you could help him to any journalism. I think he has a *small* private
income. Don't mention to him that I have told you of his disaster....

Ever yours,

I. A. R.

—*I. A. Richards*, 1929

5

I. A. RICHARDS *and* DOROTHY RICHARDS

When I was a student at Cambridge, more people would at times come to his lectures than the hall would hold, and he would then lecture in the street outside; somebody said that this had not happened since the Middle Ages, and at any rate he was regarded as a man with a message. There were those who called him a spellbinder, implying that there must be something wrong with a lecture if it produced this effect; and I was glad of the opportunity to hear him lecture again in London shortly before writing this piece (1972)—as it has turned out, we have spent almost all our lives in different continents. I found him as spellbinding as ever, and many of the large audience seemed to be feeling the same, but as we were most of us in our sixties it didn't much matter whether we were spellbound or not. The spell had been useful, as an incitement to action in young people who were just going to choose a field of work; it held open a glimmering entry to a royal garden, or an escape route which would entirely transform common experience, or at least ordinary theoretical problems. In his moderate rueful way, Richards has gone on being fertile in proposing steps forward, but he has never lost the feeling that they are minor ones, because an immense opportunity lies unrecognised just beyond our grasp.

—*William Empson*, 1973

6

Cambridge, Massachusetts,
1977

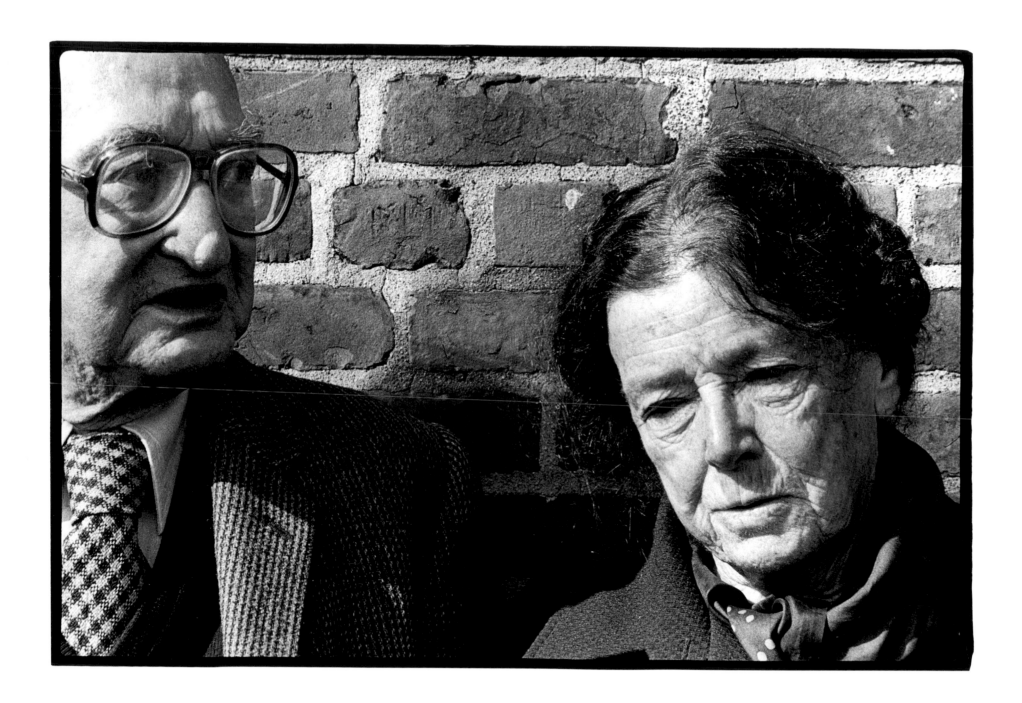

I.A. RICHARDS: "*GOODBYE EARTH*"

Sky-high on the cover of *Goodbye Earth*,
you flash and zigzag like a large hummingbird—
heavy socks and climber's knickerbockers,
sleeves rolled, shirt open at the throat;
an upended pick, your prisoner's ball and chain,
penitentially attached to your wrist.
Here while you take your breath, enthused, I see
the imperishable Byronics of the Swiss Alps
change to the landscape for your portrait, like you
casual, unconventional, innocent ... earned
by gratuitous rashness and serpentine hesitation.
It is not a picture but a problem—
you know you will move on; the absolute,
bald peaks, glare-ice, malignly beckons ... goodbye earth.

—*Robert Lowell, 1973*

8

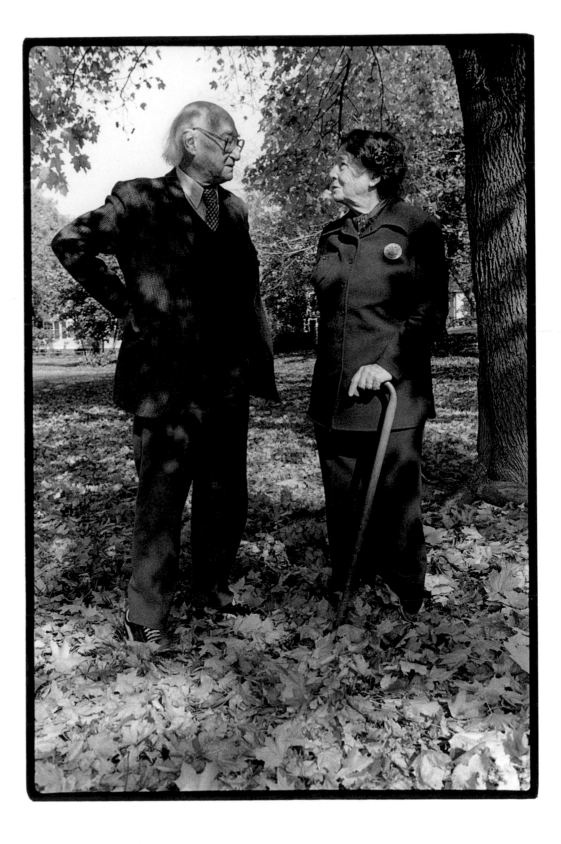

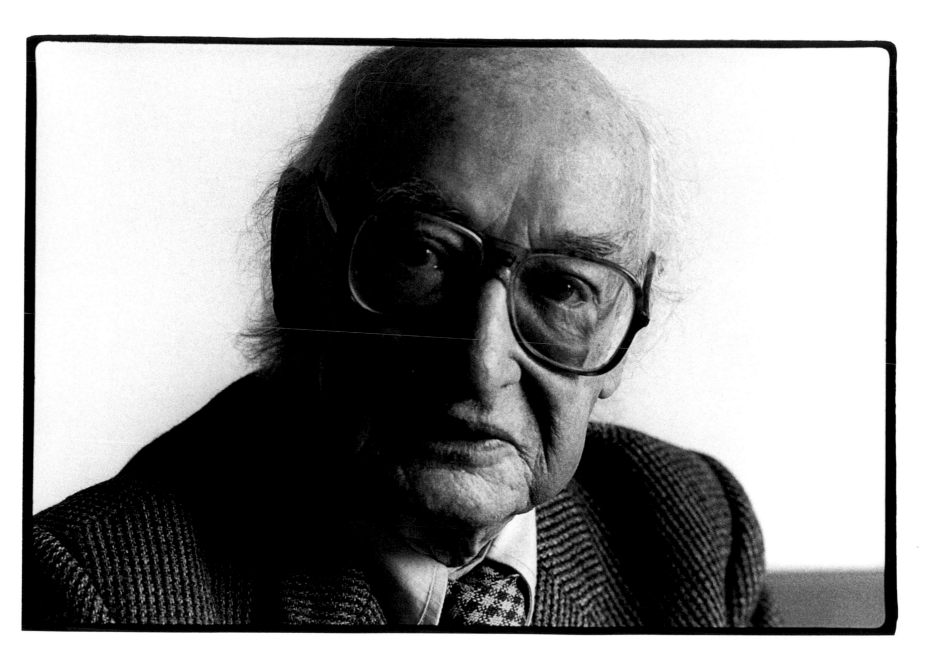

Cambridge, Massachusetts,
1977

ROBERT LOWELL

I MET CAL—SHORT FOR CALIGULA I was told, though no-one said why—in 1963, when I was in New York doing *Beyond the Fringe*. I got to know him, slightly as yet, when I fell in with Bob Silvers, Jason and Barbara Epstein and Lowell's wife Elizabeth Hardwick, i.e. with the newly founded *New York Review of Books* lot. I knew he was a poet and all that, but since I didn't know much about poetry I had no idea how important he was. In fact, I was scarcely acquainted with him, though I usually said Hi! at Epstein parties.

Anyway, for no apparent reason, he got in touch with me to see if, on the off-chance, I'd be interested to direct a trio of his recently written plays which had been commissioned by the Actors Studio and then turned down because it was not quite what they wanted. By that time I had read and liked a lot of his poetry and knew "For the Union Dead" off by heart. So I was flattered and intrigued by the offer. So I said yes and read *The Old Glory* with considerable excitement. It was some time before we found a theatre prepared to mount anything like that and I had to get back to London after almost two years in NYC. But shortly after I returned, the newly founded American Place Theatre said they'd put on the three plays in one evening. So I agreed to come back and start rehearsing.

The Lowells kindly agreed to put me up in Cal's studio, a flight of stairs or two above their apartment on West 67th. I became one of the family almost and we got along like a house on fire in the rehearsals. I liked the plays more and more, and unlike a lot of living authors I could name, he enjoyed and applauded the unexpected twist I put on the production. We got on extremely well and in the course of our many talks off-stage he assured me that he was in fact one-eighth Jewish himself. I can't remember openly expressing my need for such an assurance and at the time I didn't suspect that it was the first sign of one of his recurrent manias.

I don't think I knew anything of this disorder of his until it really got going as the rehearsals neared the opening. But as Elizabeth explained to me later, the excitement of forthcoming applause and approval often tipped him into these episodes and it really got going with a vengeance when, as I recall, he collared me a couple of days before the premiere with the disconcerting suggestion that he'd dashed off an epilogue in which Sir Walter Raleigh's widow was to come on stage bemoaning his unjust execution, carrying her late husband's head. "There should be blood streaming from his neck, but I guess, Jonathan, that you could fix that with a lot of red ribbons". I explained to him, as tactfully as I could, that I was only one-eighth certain that I could rehearse this addition in time for the opening. As it is was, Elizabeth forcefully suggested that there was no point gilding the lily of this excellent creation of his and that it was probably time for him to take it easy up at Columbia Presbyterian. Which, after a lot of hectic objections, he agreed to. It was only an hour or so after his admission that he called from hospital with the vehemently expressed invitation to visit him. He irritably waved aside my insistence that he was allowed no visitors with the claim that he was allowed any visitors he liked and that I should "Use the service elevator and insist that I was Stanley Kunitz".

—*Jonathan Miller*

10

Cambridge, Massachusetts,
1977

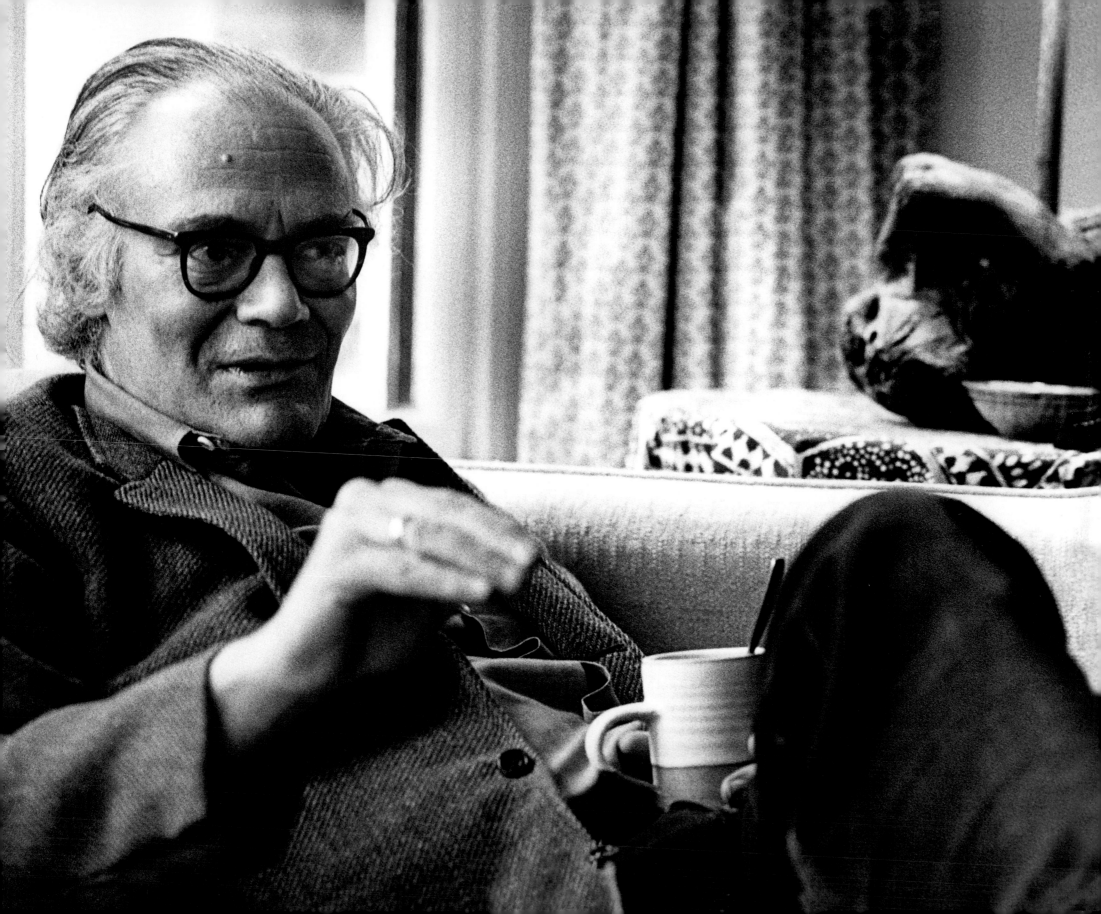

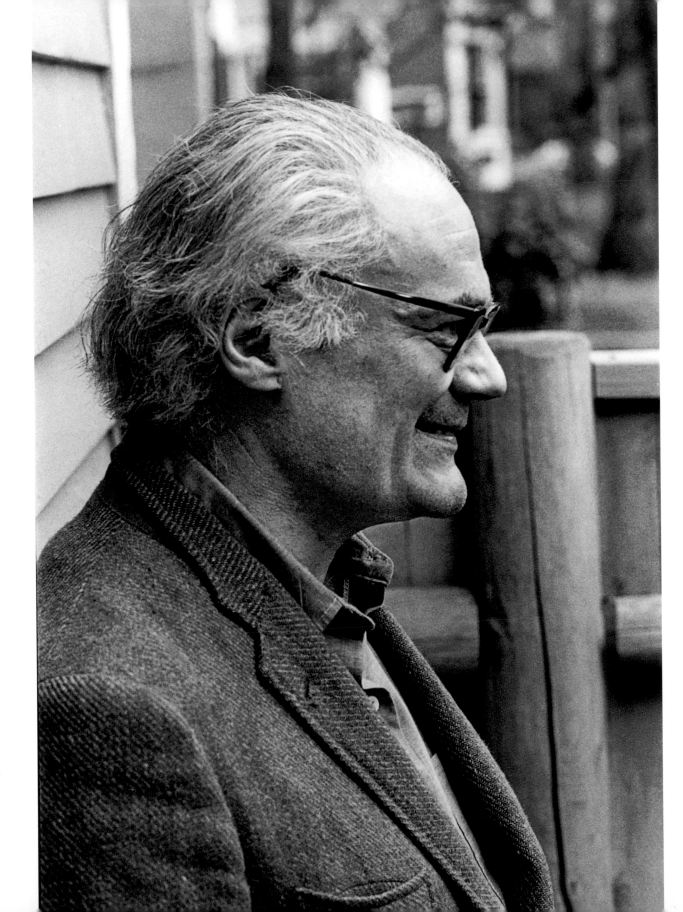

Cambridge, Massachusetts, 1977

12

Dear Cal,

So many thanks for *Notebook 1967–8* (an excellent title). Of course I have read it through and much of it more than twice. You'll not, I hope, be surprised or disappointed that I haven't as yet anything to say. This isn't, for me, the kind of poetry I can pretend to understand or reasonably respond to without—well I don't, as yet, well know what. Maybe more thorough study, longer exposure, deep reorientations, something like a religious conversion . . .? But, I fear, perhaps, it is, simply enough, that *I have grown too old, mentally, to understand justly a so much younger voice.* So many things about the form, the tone, the address, the reiterations, the *lacunae* in connexity, the privacy of the allusions, the use of references which only the *Ph.D.* duties of the 1990's will explain, the recourse to contemporary crudities, the personal note, the "it's enough if I say it" air, the assumption that "you must sympathize with *my* moans, *my* boredom, *my* belches, etc.", the dead-end stance . . . puzzle me. *You* can't be *wanting* to appeal to your least perceptive admirers, your imitators and fashionable followers: that great crowd of nincompoops. I know you are too serious and too much identified with your work to see how such an impression can be generated. But how am I to read these entries in some other more perceptive way at present beats me. I must be wrong and I've underlined the reason why I think so. But I can't help thinking also that you are wrong too: that you have become a captive of your moment—as I, no doubt, cannot help being a survival from mine.

<div align="center">Yours ever,</div>

<div align="right">—I. A. Richards, 1969</div>

IT WAS LOWELL'S HABIT, whenever we met, to recall to me the time before. A decade had elapsed between our drive along the banks of the Charles River and our second meeting in Bristol. "Do you realize", he said on that occasion, "you are the same age now as I was then?" As we sat in the Thames-side cafeteria, he thought back to a charity reading we had both taken part in the previous year at the Skinners' Hall, in the London of Wren and the right worshipful city companies. "Curious place", said Lowell; "you just couldn't get a drink". I was puzzled, recalling the wine there—its plentifulness had made me fear that the Royal Hospital and Home for Incurables, on whose behalf we were present, would benefit little from our services. Why, even the waiters were drunk—and had been audibly drinking behind the scenes—by the time they came to serve the charity dinner, so that boiled potatoes were rolling in all directions under the feet of the guests. "You just couldn't get a drink". It was only afterward I realized that what he had meant was spirits. He had said it with a curious, puzzled, tired little shake of the head. Quite the opposite of that sudden kindling of glance and face at his, "Gaudier is marvellous".

<div align="right">—Charles Tomlinson, 1981</div>

13

CAL WAS A BIG MAN IN BULK but an extremely gentle, poignant person, and very funny. I don't think any of the biographies have caught the sort of gentle, amused, benign beauty of him when he was calm. He kept a picture of Peter, my son, and Harriet for a long time in his wallet, and he'd take it out and show it to me. He was sweetly impulsive. Once I went to visit him and he said, "Let's call up Allen Ginsberg and ask him to come over". That's so cherishable that it's a very hard thing for me to think of him as not being around. In a way, I can't separate my affection for Lowell from his influence on me. I think of his character and gentleness, the immediacy that was part of knowing him. I loved his openness to receive influences. He was not a poet who said, "I'm an American poet, I'm going to be peculiar, and I'm going to have my own voice which is going to be different from anybody's voice". He was a poet who said, "I'm going to take in everything". He had a kind of multifaceted imagination; he was not embarrassed to admit that he was influenced even in his middle-age by William Carlos Williams, or by François Villon, or by Boris Pasternak, all at the same time. That was wonderful.

—*Derek Walcott*, 1985

A TREATISE OF CIVIL POWER, XVI

Add Lowell, R; the young Lowell: what he showed
was hot diggity Calvinist-Catholic
self-mortification plus flare of nostril
and angry forelock. Incapable of nuance
when nuanced by tired patrons; pitching
his loopy pup tent. Closet Confederate.
Dramatic ambiguities were his forte;
and final lines.

—*Geoffrey Hill*, 2005

Cambridge, Massachusetts, 1977

15

JONATHAN MILLER, RACHEL MILLER *and* WILLIAM MILLER

JONATHAN MILLER BELIEVES IN DISBELIEF. But he has certainly earned, with his many achievements, belief in himself. Being creative in so many ways—doctor, wit, author, scholar, director of plays on stage and television, of opera (he favours modern dress)—he hardly seems to be a single individual. Charles Darwin is his hero, but so also are Mozart and Bach, and the physician William Harvey discoverer of the circulation of the blood, and Freud.

Jonathan (now Sir Jonathan) became famous while a student at Cambridge, as a member of the Footlights review with Alan Bennett, Peter Cook and Dudley Moore. Combining humour with philosophy and neurology might be confusing, even annoying, yet somehow Jonathan Miller can expound and explore serious themes while keeping his friends and audiences at his lectures on the edge of laughter (very much laughter *with* him not *at* him). His ambitious exhibition on mirrors, *Reflections*, at the National Gallery in 1998 imaginatively bridged art and science.

He started conscious life in St Paul's School in Hampstead, London, in the same year as the neurologist Oliver Sacks who is a close friend. He then studied natural sciences and medicine at

St John's College, Cambridge. While I was a university lecturer I knew him and he visited my laboratory in the Department of Psychology several times. After university he worked for a few years as a hospital doctor in London. (His wife Rachel is a doctor in London too.) His television programmes on loss of memory and other neurological problems, as well as *The Body in Question* (1978), remain in the memory years later. With others in *The Permissive Society* (1969), he looked at social questions, and no doubt his later book with John Durrant, *Laughing Matters: A Serious Look at Humour* (1989), tied some of these knots in his mind.

Throughout his life and work he has made clear his scepticism of religion and what he would call irrational belief, not least as president of the Rationalist Association and of the National Secular Society. Discussions with friends and colleagues in his home came to constitute his television series *Atheism: A Rough History of Disbelief* (2004). A great advantage of such a wide range of interests and intellectual gifts is its avoiding the narrowness and bigotry so often associated with strong belief.

—*Richard Gregory*

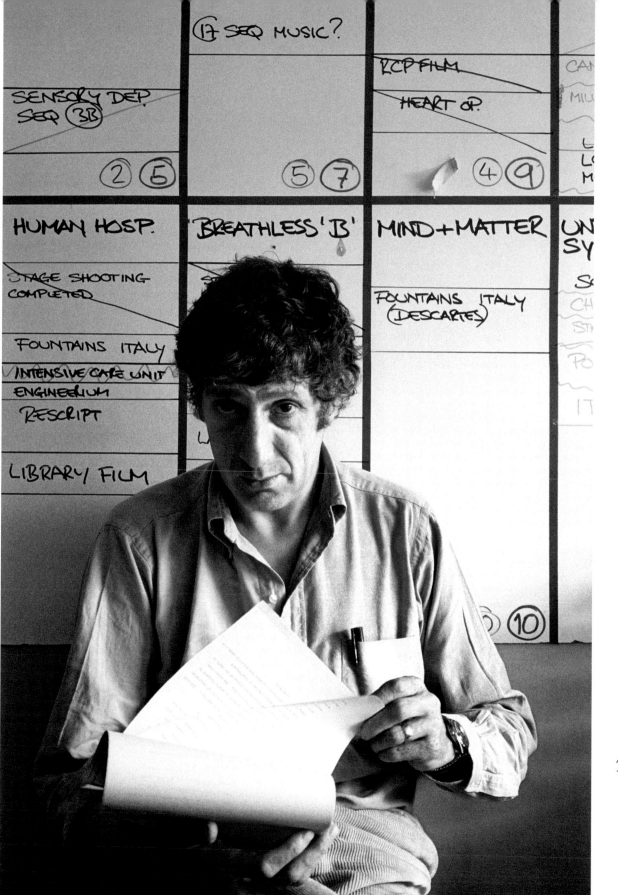

At the BBC studio during the filming of
The Body in Question, *1978*

IT WAS BREAKFAST TIME at Jonathan and Rachel Miller's house in Scotland. My children and theirs squabbled and joked with each other, shouting to be heard over their own din. There must have been—and not for the first time—some playful crack about Jews, because after a bit my ten year old daughter frowned, looked down at her plate, and asked, because she didn't know, "What is a Jew?" She spoke defensively, daring the other children to mock her ignorance. But Jonathan intervened: "That is such an interesting question", he said, and began to give her the most beautiful answer, starting with the statement that people have many different views on the matter. He told her that you might be a Jew by birth, or because you carefully adhere to certain rituals, or because, although born not a Jew, you convert to Judaism and call yourself a Jew. He touched on the history of the Jews, and where they come from, and where they live now, spread out all over the world, with some sitting right here, eating cornflakes.

I guess his answer lasted a minute at the most. It was given in perfect simple sentences, courteously, and without the slightest air of condescension. He might have been talking to undergraduates rather than a ten year old. When he finished, childish breakfast noise resumed, and I thought "He is a teacher, as well as all the other things he is famous for".

A moment after writing the above, I rang my daughter, now with children of her own, and described this incident. "Do you remember it?", I asked. "Nooo", she wailed. "How awful! Are you going to say that?" "Yes, I am", I said, "You were only ten". She laughed. "Couldn't you lie?", she said.

—*Nicholas Garland*

MICHAEL ROMAIN *When you played Trigorin in Jonathan's production of* The Seagull *at Chichester, did you find that he displayed a personal empathy with Chekhov?*

ROBERT STEPHENS Very much so—he is a doctor/director in the same way that Chekhov was a doctor/writer. There was none of the usual melodramatic fat on the production—it was so clean that it was like a skeleton. Jonathan can get to the heart of things in a very clinical way. There were no indulgences, no Chekhovian melancholy, or any of that kind of traditional nonsense. The emphasis was not solely on Nina, but on the whole ensemble. The open stage at Chichester meant that it had to be simple—there were no great heavy sets, no elaborate sound effects, nothing. Jonathan's skill was to treat it lightly as Chekhov wanted—Chekhov insisted it was comedy.

* * *

MR *Did Jonathan display the same reappraisal of the text in* Hamlet?

RS Yes, he did, and he gave me the most wonderful effect in the play-within-the-play scene by bringing out the play on words. Obviously the relationship between Hamlet and Claudius is very uneasy by this point. I simply went to Hamlet and demanded from him "Give me some light!", as though Claudius, in public, is "calling Hamlet out", in the sense of "Be honest with me!" That nearly blew Hamlet off the stage, and gave a real sense of the power in Claudius when someone pushes him too far.

—*Robert Stephens*, 1992

18

North London, 1978

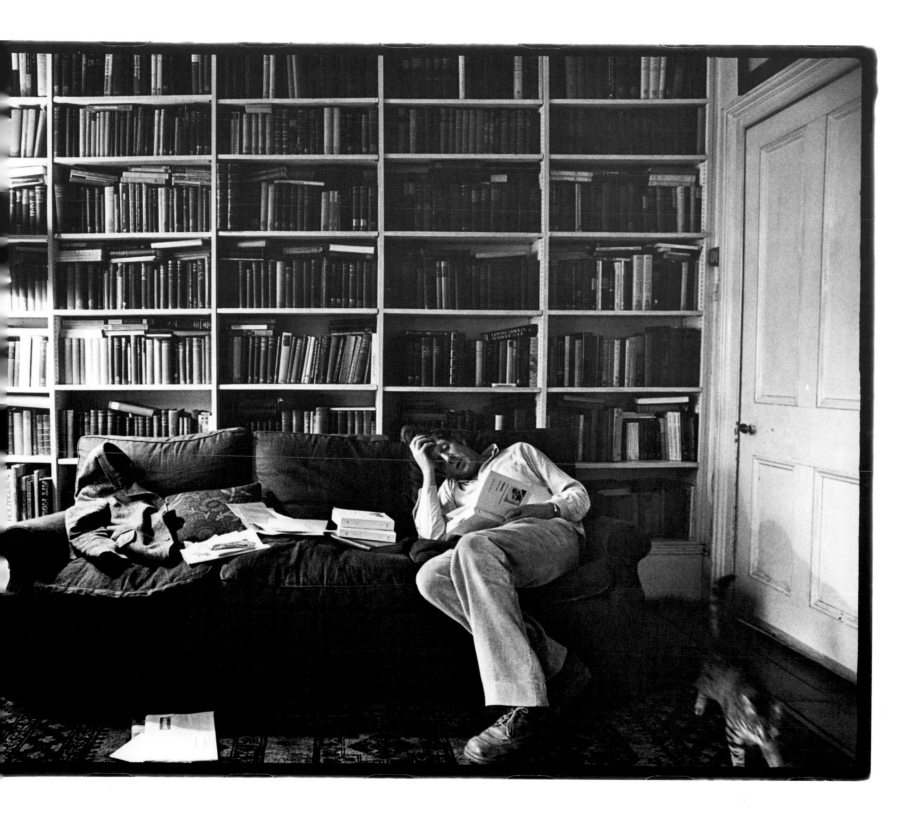

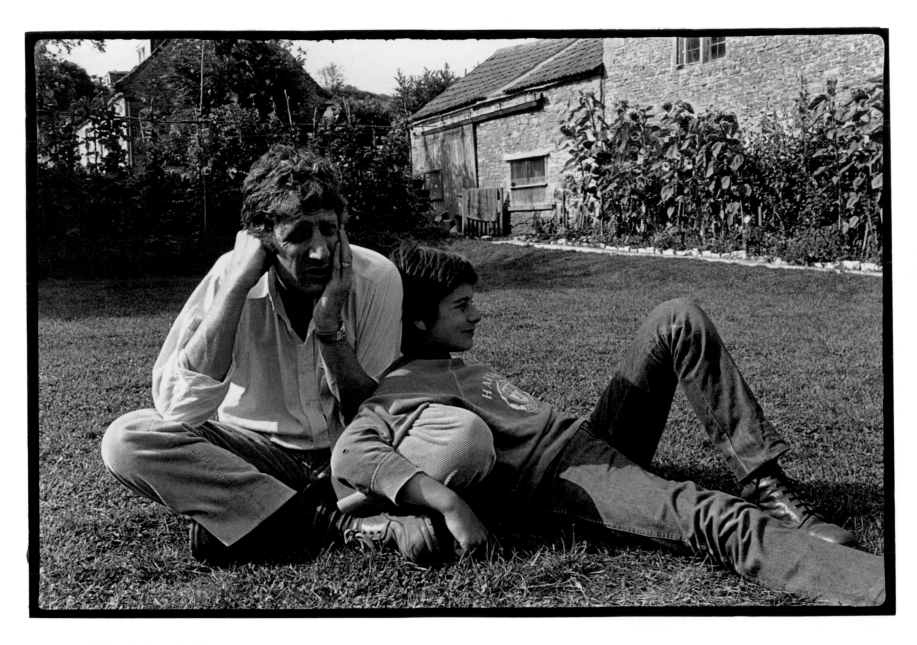

20

Chedworth, Gloucestershire,
1978

I HAVE BEEN LISTENING to readings of my play for a week, and feel it is something a ghost wrote and signed my name to. I have a brilliant bubbling young Englishman, Jonathan Miller, directing, and some rather optimistic but heavy drama people managing the production. I feel in a very alien element, and back Miller whenever there's division of opinion. The play has power, I think, and great length, almost four hours.

—*Robert Lowell*, 1964

AT TIMES MY FATHER COULD BE EMBARRASSING—particularly when he drove us to school wearing his dressing gown and swore at other drivers. He'd say things like, "I'll rip your f***ing thyroid out!" and would then always have to add, rather smartly: "And I bet you don't know where that is!" People would ask me what he was like at home, because he had a popular TV series on at the time called *The Body in Question*. It was about the human body and it caused controversy for screening the first ever televised postmortem. He was great at demonstrative science—and yes, he was exactly the same at home. It was perfectly natural for him to bring home animals he'd found at the side of the road and dissect them for us.

As I got older, though, that fun side of our relationship sort of disappeared. If I was doing homework, I began to dread asking him for help, because you'd ask him a simple question and he'd give you an entire lecture. He could also be a bully about reading. If you tried to impress him by telling him you'd read a new book, he'd point out the books you hadn't read. He was never very good at praise. In the end you'd think: "There's no point". Our sitting room was floor-to-ceiling with books, and I don't think I've read one of them. I slightly blame him for that.

* * *

It was only as I got older that I began to realise how tortured he was by his work in the arts. The critics would make him utterly miserable. If he read a bad review about one of his productions, he'd be so depressed he'd nose-dive into a state of gloom. It would last for days.

—*William Miller*, 2006

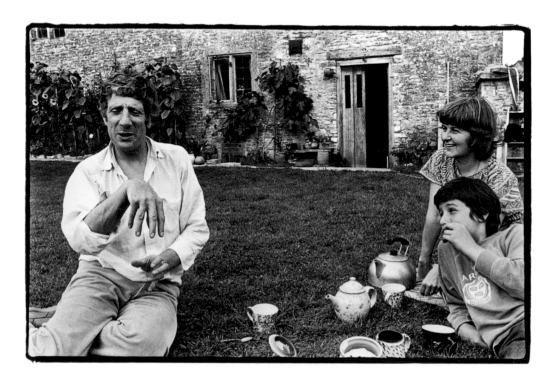

IF I SHOWED A LACK OF INTEREST IN William's entrepreneurial world, it wasn't because I was contemptuous: it was more that I don't understand how people make money. I'm baffled by it. William thinks of me as a soggy socialist, and rebukes me for not being more aware of my financial state of affairs. I guess I've always just been pleased that what I do earns me enough money to be comfortable in life.

—*Jonathan Miller*, 2006

RICHARD GREGORY

I ENCOUNTERED RICHARD GREGORY first when I was a freshman reading Moral Sciences, as Philosophy was still called in Cambridge in 1955. He gave three-hour seminars in psychology, which mainly consisted of "experiments", some of them on his very small and unprotesting son, concerning perception, sensory deprivation and other subjects on which Richard became a world authority. He was then, as always, boyishly and intensely enthusiastic, telling us what "jolly good fun" some result he had just registered was; indeed, fun seemed to be his fundamental category of worth, and the pursuit of it the source of his astonishing energy. His strong, powerful features and emphatic verbal delivery show the intensity which has, so far as I know, characterised the idiosyncratic body of passions in his life, and also made it less surprising that some things which concern most people, certainly most academics, have never mattered to Richard in the least. As someone who finds small talk essential for the maintenance of relationships, I found him, when he was a colleague of mine at Corpus Christi College in Cambridge, not really a person I felt easy with: unjudging, he still made me feel judged, and I imagine the penetration of his mind, and the blankness with which he confronts people who find interest—or fun—where he doesn't, don't alarm only me. He had—we haven't met for decades —a disruptive sense of humour which was extremely attractive, and even an element of whimsy. I note that in *Who's Who* he lists his hobbies as Punning and Pondering, which may indicate that he is one of the last of the great Characters of academe, whereas when I met him first he seemed, in the context of his colleagues, a regular guy, remarkable mainly for his industriousness.

—*Michael Tanner*

22

Bristol, England,
2003

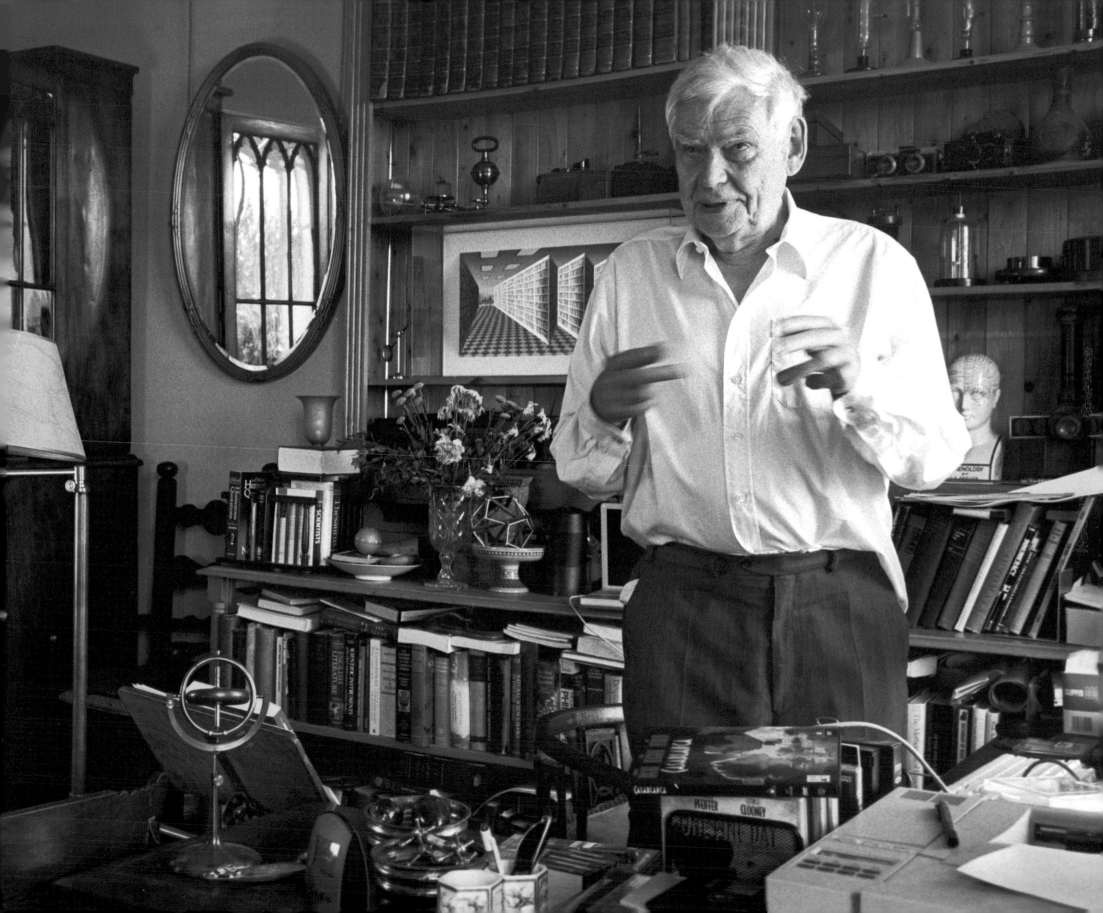

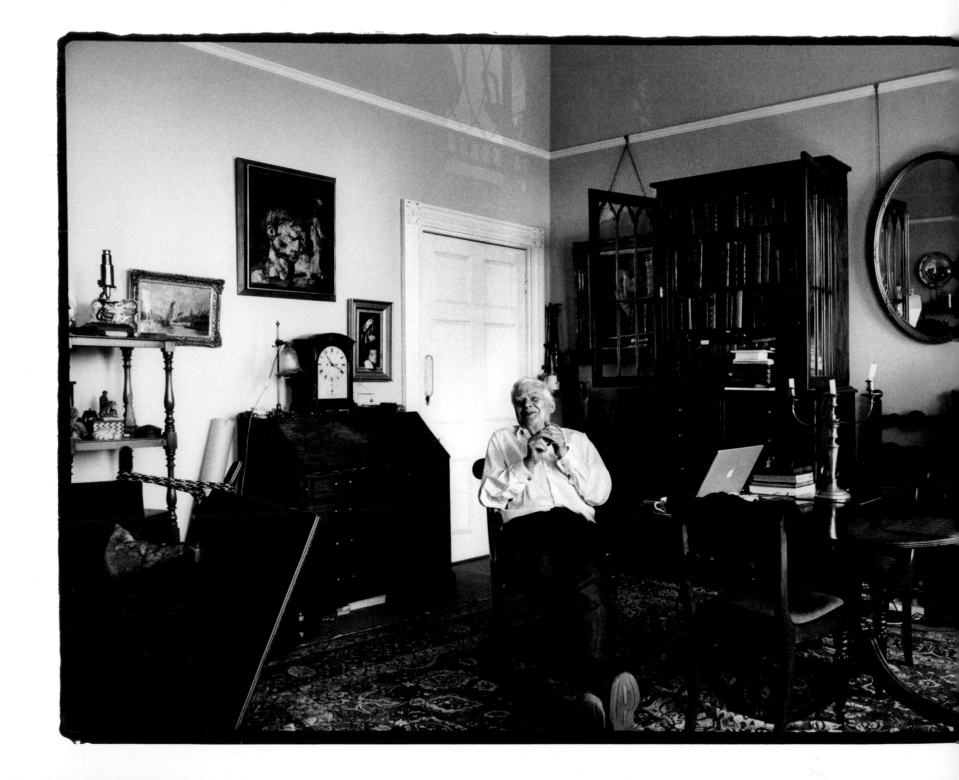

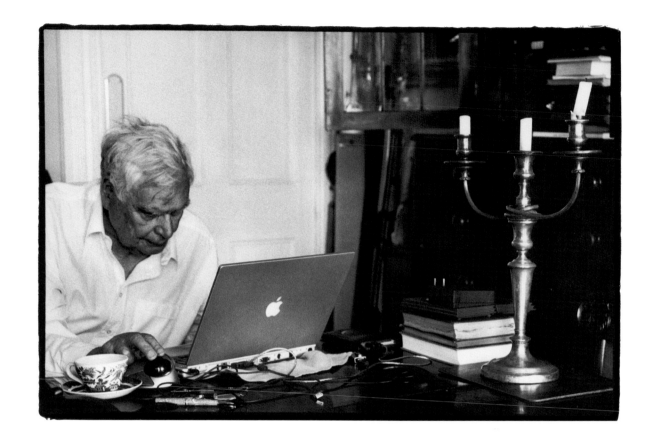

Bristol, England,
2003

25

MICHAEL TANNER

A friend of mine and of Michael Tanner looked at these photos and wrote:

> Not the Battle of the Books, but the battle with the books. Among the books by Michael Tanner, philosopher and Wagnerite, are several on Friedrich Nietzsche, philosopher and Wagnerite. And what did Nietzsche think about books?
>
> *I must count back half a year before catching myself with a book in my hand.*
>
> *I almost always seek refuge with the same books—actually a small number—books proved to me. Perhaps it is not my way to read much, or diverse things: a reading room makes me sick.*
>
> *Scholars who at bottom do little nowadays but thumb books—philologists, at a moderate estimate, about 200 a day—ultimately lose entirely their capacity to think for themselves. When they don't thumb, they don't think.*
>
> *The instinct of self-defence has become worn out in them: otherwise they would resist books.*
>
> *Against a book one lets oneself go, even if one is very reserved toward people.*

I think Michael Tanner must be aware of these Nietzschean thoughts and yet he went on amassing more books, presumably reading them, and for years creating taller and taller banks along the rivulets that ran through them in his college rooms. The day I photographed him, two visitors arrived. Michael was forced to stand while they were shown to two straight-back chairs strategically placed side by side in the riverbed. When seated, their heads were barely visible to me above the teetering boulders. The required ashtray could have set the whole room alight had one bumped its craggy pedestal of books.

Today Michael lives in a converted pub with an entire wing devoted to bays of books. They are accessible without stumbling over anything.

—Judith Aronson

Corpus Christi College, Cambridge, England, 1982

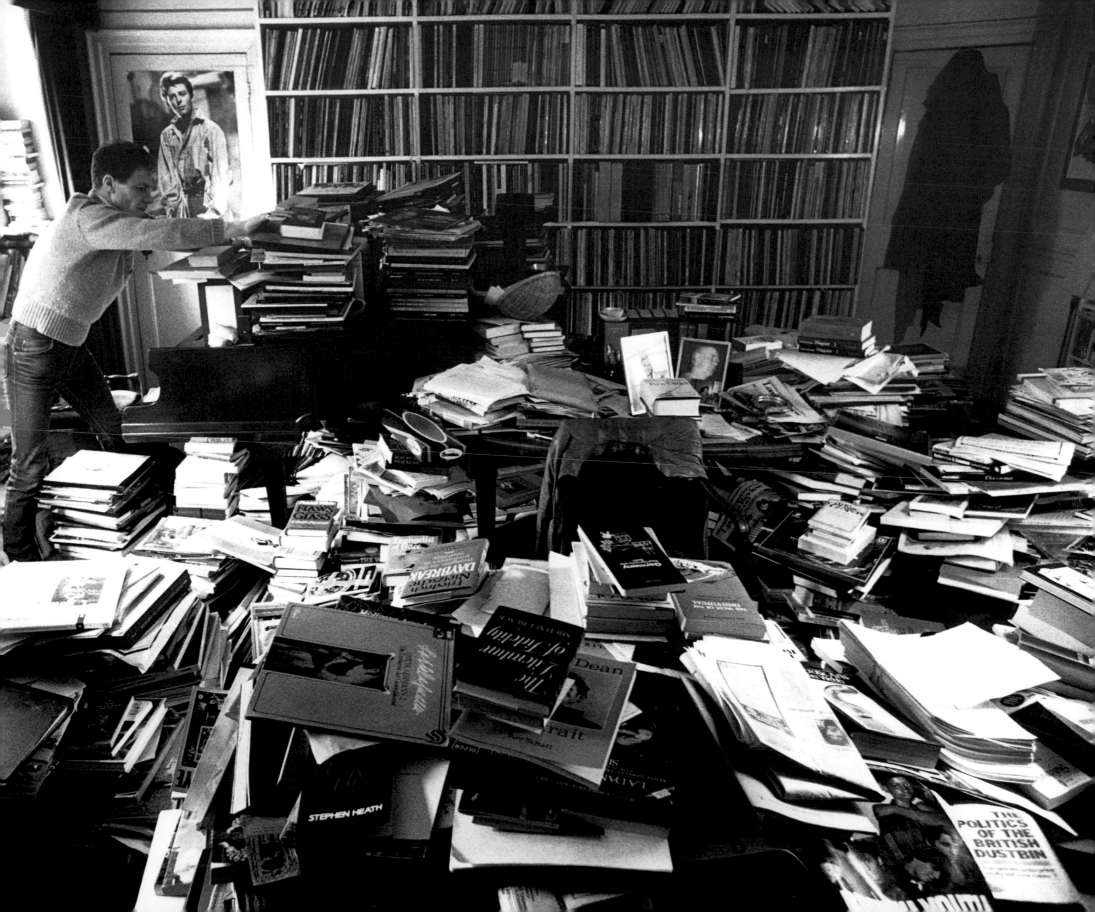

ROBERT STEPHENS

IN OVER HALF A CENTURY AS DESIGNER in the theatre, I had occasion to work with four of the luminaries photographed by Judith Aronson for inclusion in *Likenesses*. One rarely has the time or opportunity for a broader contact with actors beyond the demand of a given production. Robert Stephens was no exception to this. I worked on two plays with him, *As You Like It* under the Laurence Olivier regime at the Old Vic in 1967, and in 1978 Ibsen's *Brand* at the National Theatre.

I have retained a very vivid recollection of him as a man with a commanding presence, both on and off-stage. He was Jaques in *As You Like It*, an all-male production directed by Clifford Williams, with a memorable cast of Derek Jacobi, Anthony Hopkins (Audrey), Charlie Kay (Celia), Ronald Pickup (Rosalind) and the late Jeremy Brett. I can still remember his splendid delivery of "The Seven Ages of Man".

Although not the lead in *Brand* (that was Michael Bryant), Stephens gave as ever a powerful performance as the Mayor. Yet, looking back, though superb in both productions, I sensed he hated both intensely. He said as much in his autobiography* with regard to *Brand*, avoiding any reference to *As You Like It* altogether. I would question his judgement in that respect. For *As You Like It* has been acknowledged as a milestone in theatre history of the time, and *Brand* in Geoffrey Hill's translation directed by Christopher Morahan won awards and was much acclaimed by the press.

"And thereby hangs a tale"—Jaques, Act II, Scene VII.

—*Ralph Koltai*

* *LUCKILY FOR ME, Peter Hall invited me back to the National at the end of 1978, and I entered with considerable trepidation the concrete morass on the South Bank which was so much less friendly and manageable than the Old Vic. . . . That first season back at the National was good for me, but I don't think the productions were outstanding by any means. Peter's production of the Chekhov [The Cherry Orchard] was disappointing. And* Brand *was such a boring play, and it was dreadfully directed by Christopher Morahan but I came out of it all right, because the Mayor is the voice of the audience and he expresses their common-sense reaction to Brand's crazy ideas all the time. He gets all the laughs and, in the end, all the notices: perfect.*

Michael Bryant, who was droning on as Brand, couldn't understand that. I told him during rehearsals that he should cut the part; it's far too long and people soon become fed up with him. "The part is so boring", I told him. "You're even boring me!" He was off the stage for only fifteen minutes out of four hours, right at the end. King Lear he is not. And Brand *isn't even a play. It's a long, epic poem. After the interval, half the audience had gone home. On the other hand, I did get letters from people who had been to see it fourteen times! Heaven knows why. I couldn't have sat through it once.*

—*Robert Stephens, from* Knight Errant, *1995*

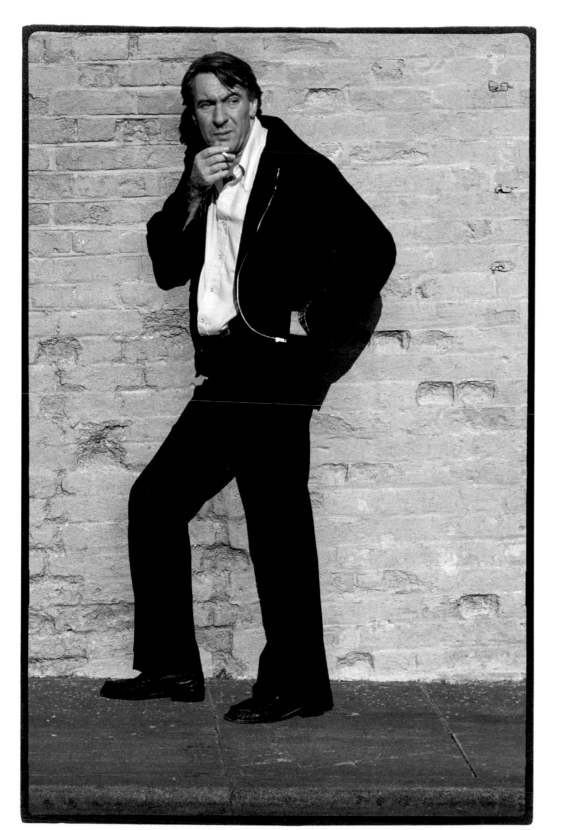

*Bury St Edmunds, England, for a BBC
production, 1978*

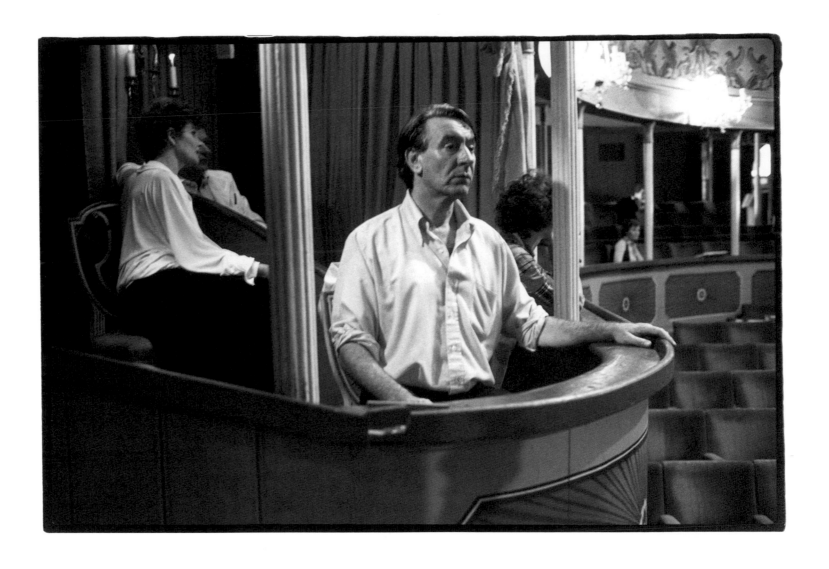

*Rehearsing balcony scene for the BBC
production of* Kean *by Jean Paul Sartre,
Bury St Edmunds, England, 1978*

*With the director, Cellan Jones, at a cast
party, London, 1978*

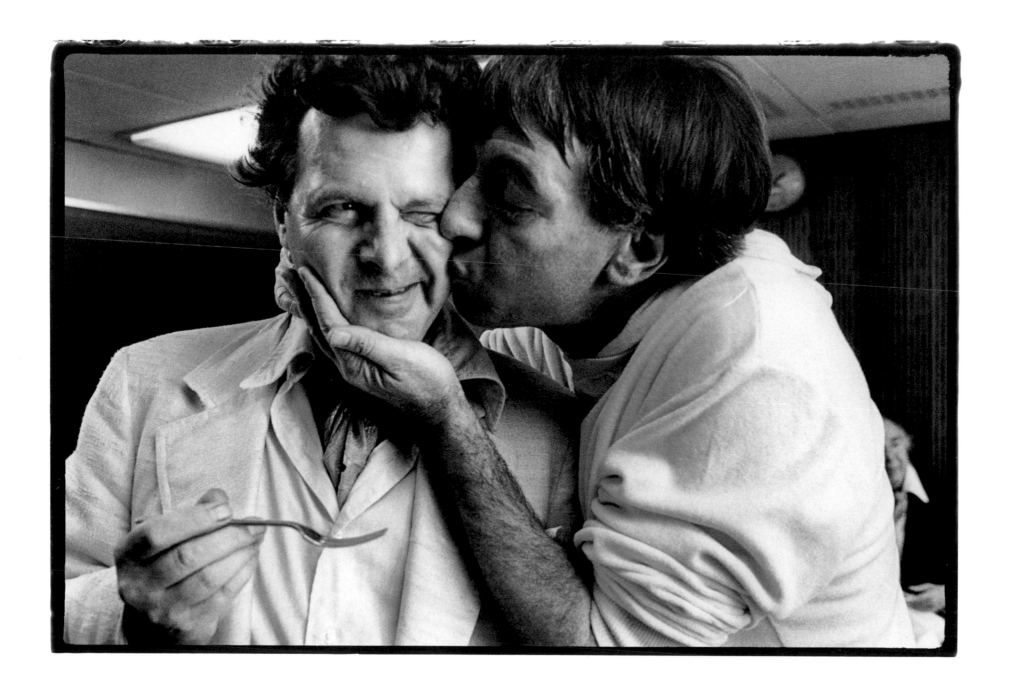

RALPH KOLTAI

IMAGINE MY DELIGHT while photographing the Royal Shakespeare Company for the *Sunday Telegraph Magazine* when I discovered that part of my assignment was to capture the life and work of the set-designer Ralph Koltai. Educated in design, my life time hobby has been constructing things from wood, fabric, clay or cushions (my favorite play-houses when young). I built all the furniture into my first English home, a thatch-roof cottage.

Ralph Koltai invited me to his studio and then his home, both sites of wonder. In the 1970s my contemporaries liked entertaining on the floor, some of us with an image of Marilyn Monroe in the room. But nothing was as exciting as watching Koltai upright on the set a few days before opening night of *The Tempest*. A consummate gentleman, Koltai directed the costume-designers, fitters, then the props craftsmen. It was obvious he enjoyed his job. No sniping, always cordial, many jokes. Everyone seemed pleased to be in his company. For the opening scene a great wave was created from plywood covered in patent leather that stretched out across the stage. For Ariel's entrance a trapeze was concocted to fly him in from the void above the curtain riggings. A scale model of every detail, created in Koltai's studio, was on hand for reference.

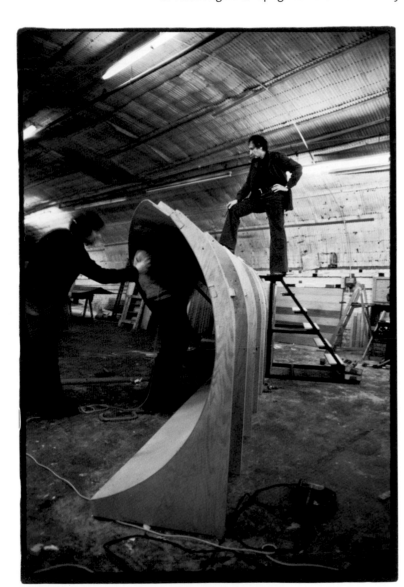

I couldn't believe my ears—as I waited for some test action —when I heard Ian Charleson (Ariel) refuse to try out the trapeze: the insurance wasn't in effect yet. A little kerfuffle, but then who should lift off from the stage into the rafters, behind a shimmering scrim, but the master himself. There was a delighted twittering amongst us while, with no snag, a safe landing was achieved.

Opening night was not so perfect. Miranda, advancing across the stage, caught the ridge of her eyebrow on the corner of the shiny black plywood wave, turning her face into a stream of blood. It was an extraordinary few minutes as she raced off-stage, blotted her face, and returned to complete the act with hardly a break in her cadence. Later that night, stitches replaced the bandage. In another one of Koltai's productions (Geoffrey Hill's version of *Brand*), with Robert Stephens at the National Theatre, the stage set, though completely different—"under the glacier's rim"—was equally challenging for the actors to navigate. How often do we see a stage floor transformed into anything truly resembling the great spaces of water and of land?

—*Judith Aronson*

*Royal Shakespeare Company
workshop, Stratford-upon-Avon, 1978*

London, 1978

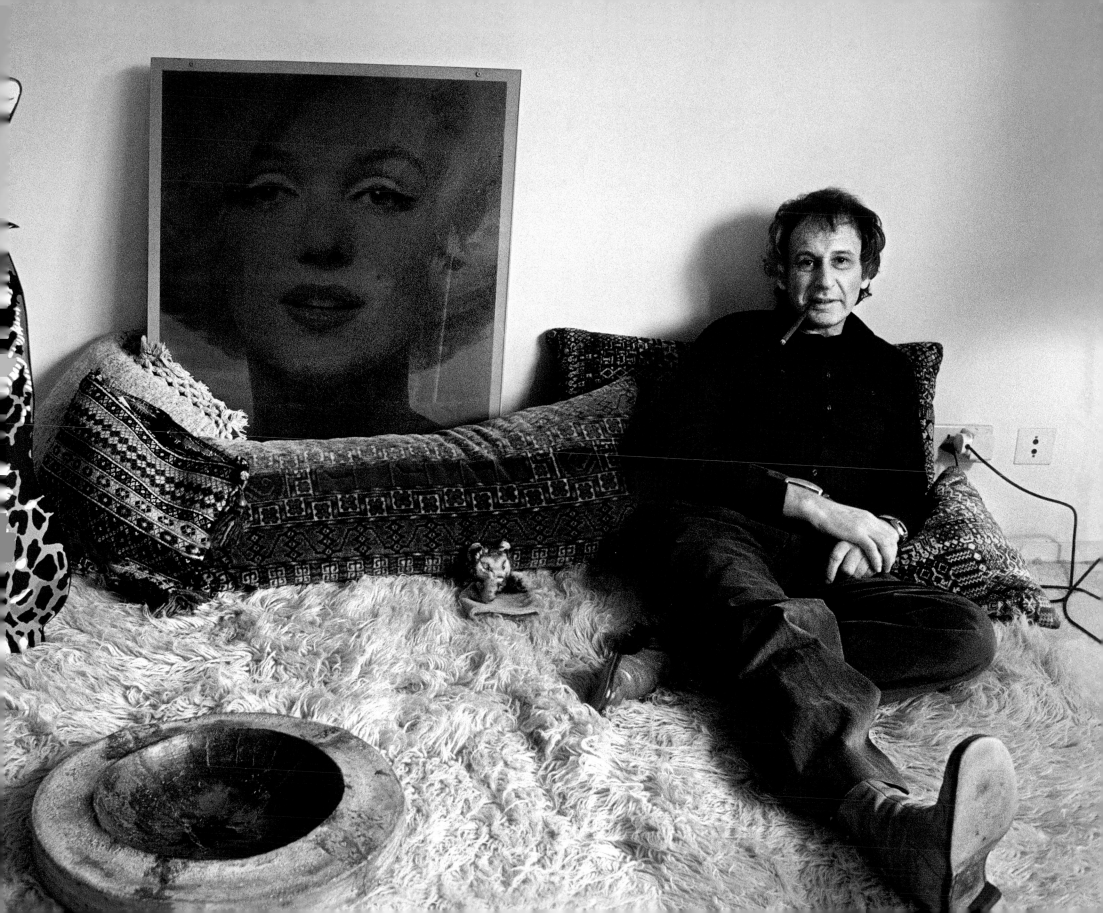

SARAH CALDWELL

THESE FINE PHOTOGRAPHS give a wonderful sense of the public Sarah Caldwell. Both the headshot of her strong and serious face next to music which was her life from the age of six when she won a violin contest, and the full-length seated picture of an outsized woman in a very feminine dress having fun in a theatrical pose. I see her humor and defiance, the defiance that led her to pick difficult and rarely performed modern operas staged in unconventional and brilliant ways. I see the intrepid, adventurous woman who fought outsized battles against huge odds, for money to create public understanding of more difficult dramatic music, for money to produce modern opera, for money to create a proper opera house, for music written by women and operas sung by women, for unfamiliar, difficult and glorious music. Boston never gave her a real opera house; no matter, in old movie theaters, playhouses, the cyclorama, an indoor skating rink, sitting in a canvas and wood director's chair, she conducted and directed performances I will never forget, of Prokofiev and Schoenberg and Verdi too. She fought for perfection. She had to control everything lest it not be perfect. She had to try every way in case a better one existed. I am reminded of her triumphs—described by a famous music critic as the single best thing happening in opera in America. *Time* magazine must have concurred as Caldwell's picture was on the cover.

In the end that strength and humor and courage and outsized talent were defeated by the lack of money to be had for her music; and her creation, the 31 year old Opera Company of Boston, collapsed under its debt.

For me, these two pictures evoke her story.

—*Zipporah Wiseman*

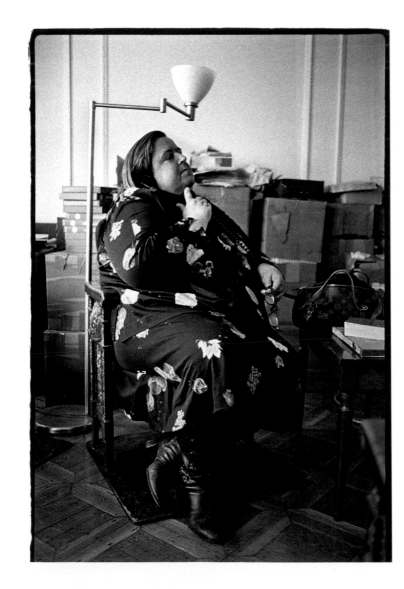

Opera Company of Boston, Boston, Massachusetts, 1975

34

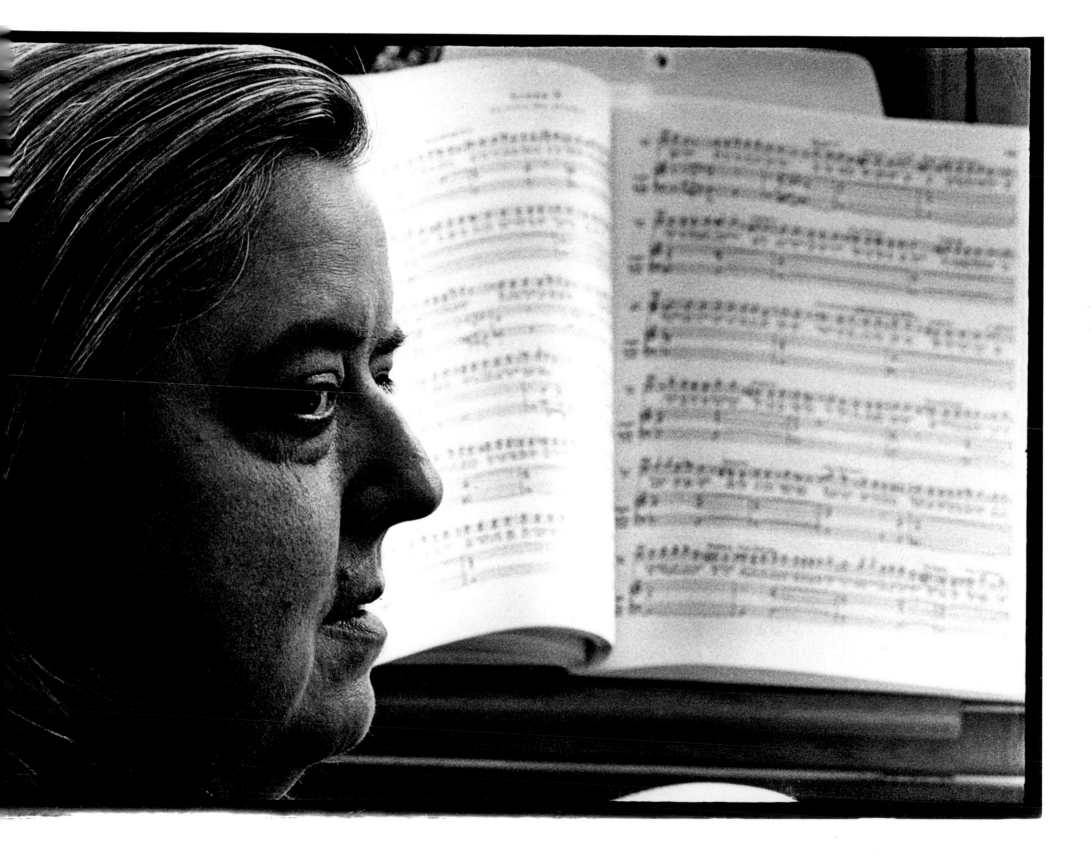

FREDERICK WISEMAN *and* ZIPPORAH WISEMAN

THE NIGHT THE FOUR OF US MET, the two couples became instant friends, Fred and Zipporah Wiseman, and my husband and I. We all had taken an instant dislike to a fellow guest at a dinner party, a pretentious and overbearing theater director who thought it necessary to let us all know that *Endgame* is a play by Samuel Beckett. Feeling a bond made us decide to get together the next night. My three children, all under five, were there and clearly they too liked our new friends.

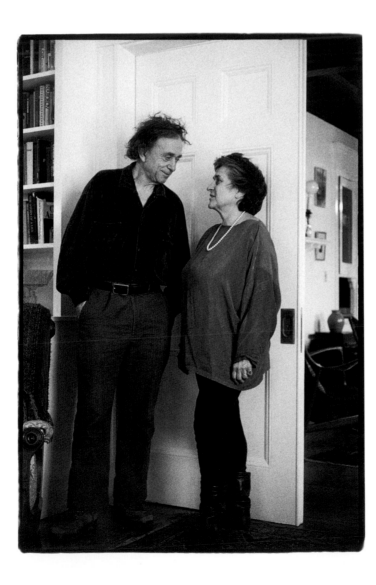

So a year later, in 1986, when moving from England to Boston, it was natural for us to seek their advice. From the outset it was understood that we probably couldn't afford a house in the neighborhood where they had been living for over twenty years. But Fred had some inside information: the house next door was going on the market in two days. He phoned us in England at 1 a.m. to let us know we might be able to buy it direct from the owner without going through a real estate agent. "Christopher, not Judith, should phone—he's an Anglophile". At 1:30 a.m. English time we called the owner; within minutes we had made a tentative deal. A few days later we bought the house sight-unseen and have been the Wisemans' neighbors ever since.

What's it like living a stone's throw from a documentary film-maker and a law professor? Bliss. So far as we know we've not been filmed, though Fred can see every move we make through the floor-to-ceiling windows, in our kitchen and living room. Zipporah often delights us by flashing their lights on and off to say hello. It's true that for the first few years, when we had no curtains, I'd phone next door and ask if they could pull down their blinds instead. Try to imagine Zipporah in our ten-foot-wide paddling pool with three children flapping about day after day when the weather is hot, or Fred ringing at 7:30 p.m., back from shooting a film out of town, and with Zipporah in Texas where she teaches, to say he can see that we are just starting dinner, "Mind if I bring my food over, I'll be there in a minute?" Or my cooking part of Thanksgiving dinner in the Wisemans' oven because we don't have enough room in ours. Then there's the occasional frantic phone call when Zipporah has locked herself out of the house. Long ago she planted a labeled key in our house knowing there'd be such moments.

—*Judith Aronson*

36

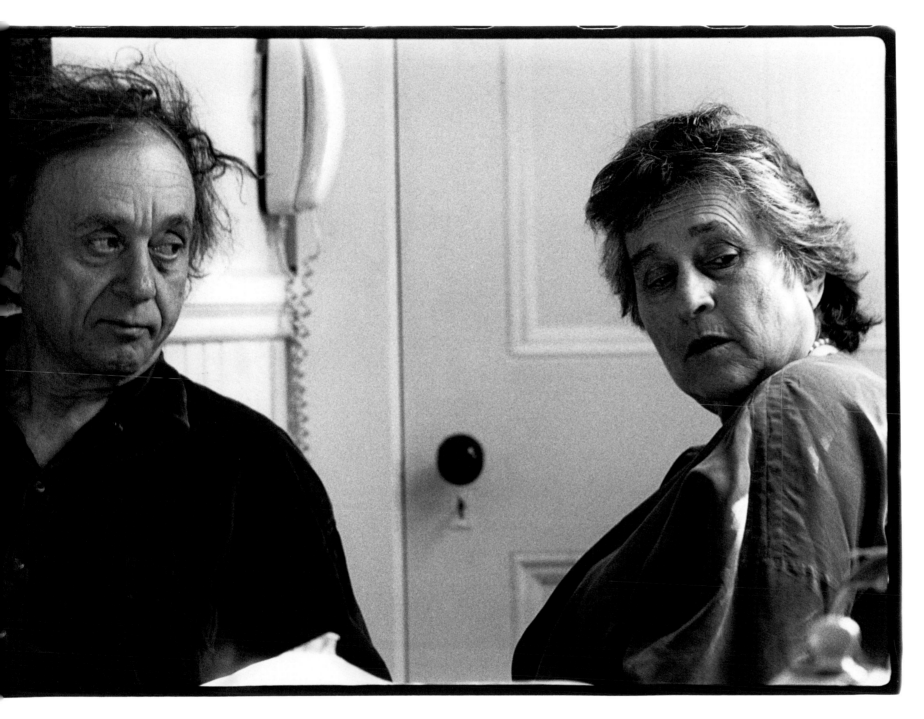

Cambridge, Massachusetts, 1994

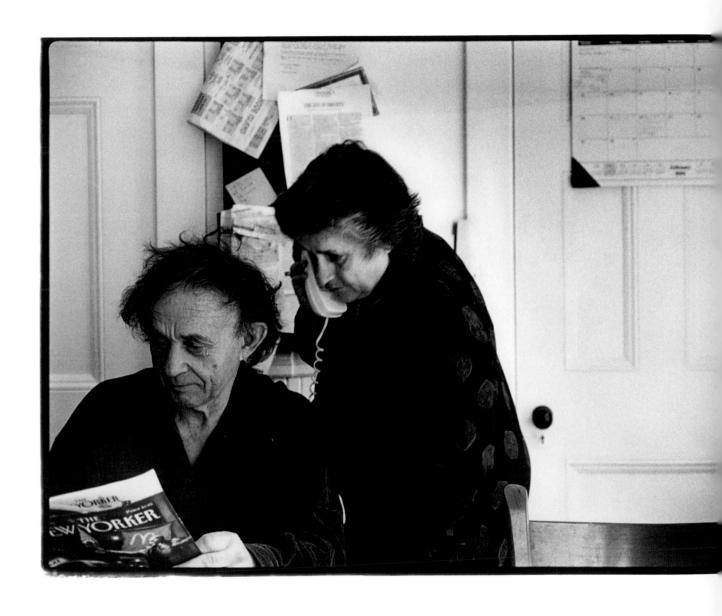

38

*Cambridge, Massachusetts,
1994*

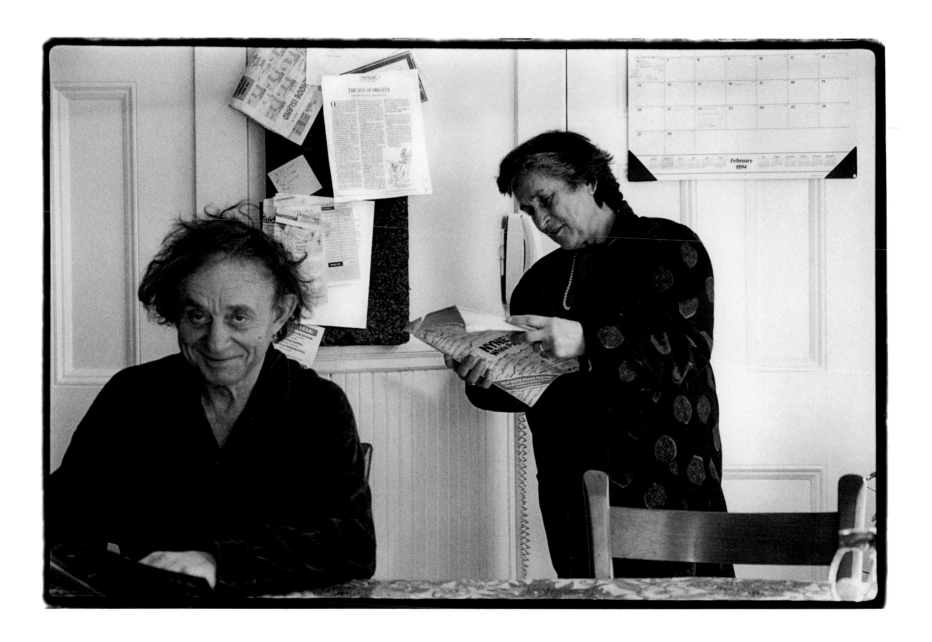

NORMAN MAILER *and* NORRIS CHURCH MAILER

THESE PICTURES BROUGHT BACK so clearly the deep winter nights of Provincetown, muffled sounds of cold waves serving as background music for an evening of warm light, decent food, and good, lively conversation. We were so happy to have Judith and Christopher come that night. Norman loved Christopher. He was an intellectual who appreciated Norman's ideas and tricky, magic verbiage in a way I no longer could, having heard it all many times before. We had a quiet life on the Cape, spending our days writing and reading. It suited us, as going to festive parties in New York had suited us twenty and thirty years ago. The highlight of our day was coming downstairs from our offices at six o'clock to sit in the bar, have a glass of wine and watch the sun set; and talk. After thirty-three years, amazingly, we still hadn't run out of things to say, but we were always happy to have new blood, like Christopher, Judith, and our friend Tom Piazza, a writer living in New Orleans, to liven things up.

As I look at these pictures, I see the gamut of Norman's expressions: expounding on whatever event that was in the air at the time and graciously listening (although he preferred talking!) to the opinions of others. He never lost his interest in politics, and was prescient in his opinions of events like the war in Iraq. He wrote a book about it called *Why Are We at War?* before it started, and everything he predicted has come to pass. He expounded on the fact that plastic is poison for decades, and now, finally, science is discovering that plastic, indeed, is poison.

Although the sport lost its luster for us after the great era of Mohammed Ali, Norman was still, at 84, an avid boxing fan, and he loved a football game on TV, although he would watch any sport. Like a young man, he was always discovering new things to research and try, the last passion being Texas Hold'em poker. The first thing he would do when he had a new interest would be to order a library of books on the subject, the second would be to try to get me and everyone else he knew interested as well. We usually were, drawn in by his enthusiasm.

And there in the photographs, unbeknownst to me at the time, are my reactions to him. In one, I'm intent on what he is saying, aghast at something outrageous he has just said in another, laughing at something funny in a third. In one photo my arms are crossed, as if I were protecting my heart against something. Perhaps it was the fear that it wouldn't be long before he left me. I treasure these fine photos, as memories of one of the last good dinners we had in Provincetown, although at the time we didn't know it. No one ever really does, do they?

—*Norris Church Mailer*

40

Provincetown, Massachusetts,
2007

WE'RE OPPOSITES IN MANY WAYS. There was one Jew, for example in the small [Arkansas] town she came from. But we are alike in many other ways. We were born within one minute of each other, 26 years apart. We have the same little bad habits. Neither of us can remember; we have to write things down. We have learned to live with one another. Norris has changed me enormously. I've felt a softening—her effect on me. One wants to be loved, after all, not for one's fame. One wants love one can live with, day to day. That is new in my life.

—*Norman Mailer*, 1983

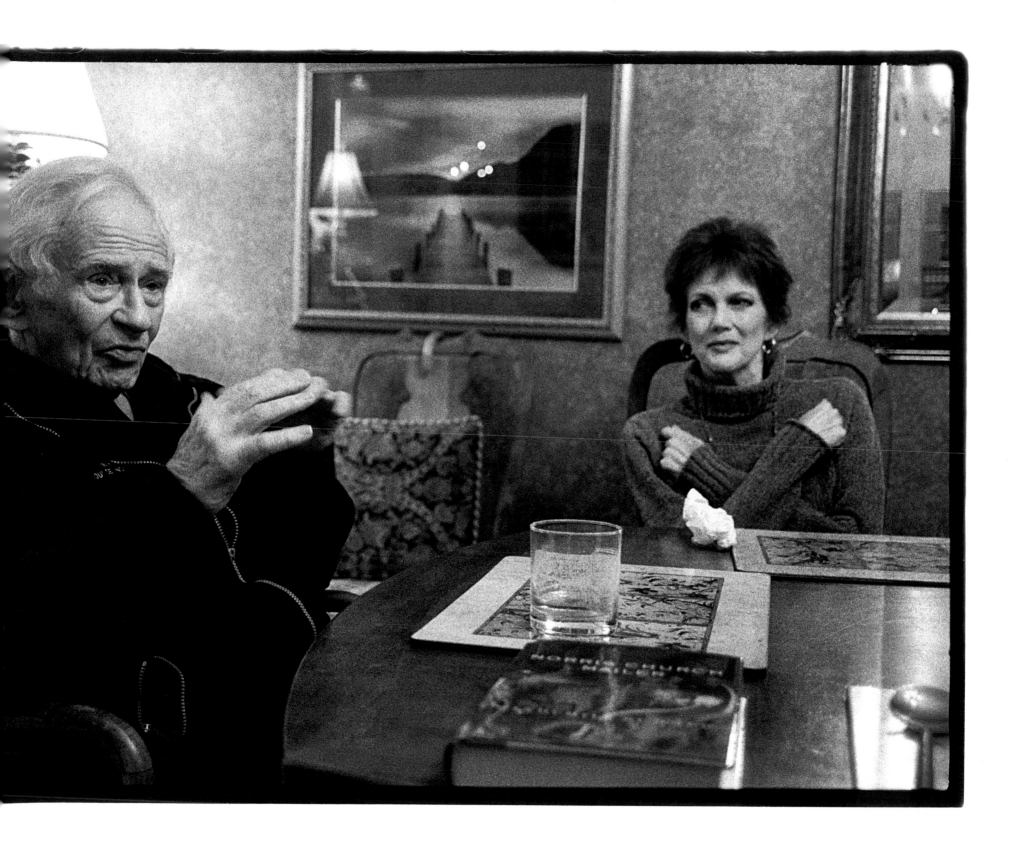

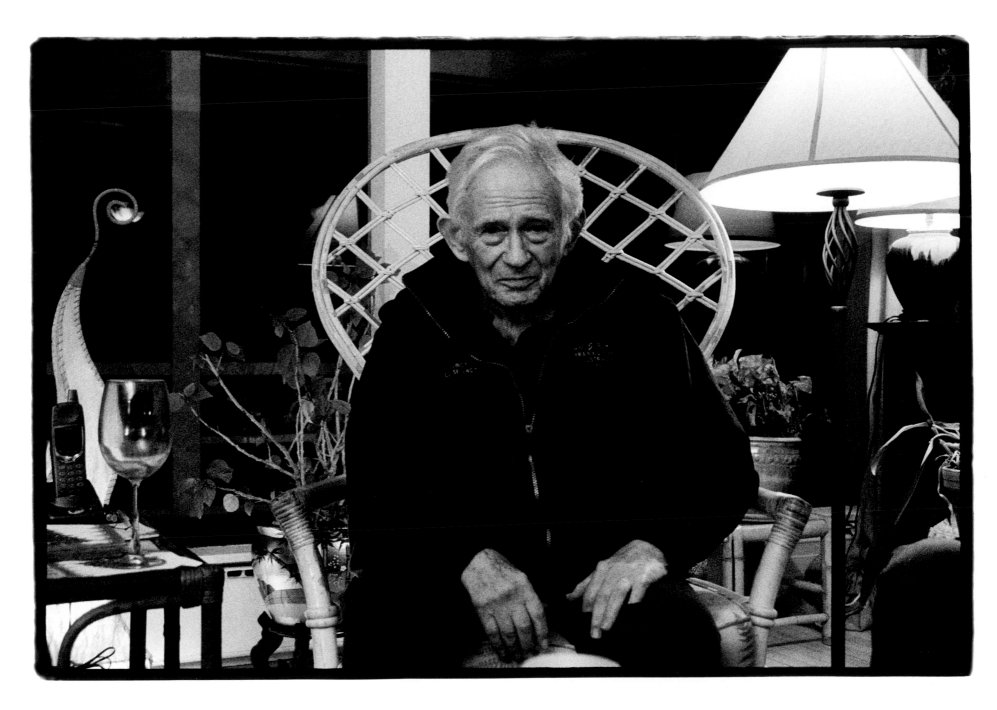

42

Provincetown, Massachusetts,
2007

WHEN I LOOK AT THE PHOTOGRAPH of Norman Mailer what do I see, a face that I recognize and know as Mailer because I have read many of his books, admire his writing, seen the book jacket and newspaper photographs and watched and heard him on radio and television. A great writer but also a celebrity. It is inevitable that I bring all that baggage to looking at and responding to his photograph. What would I see if I did not know all this. An old man sitting on a chair looking intently into the camera with sad, slightly baggy eyes, stumpy fingers and the outlines of his youthful handsome face visible behind the wear and tear of age (perhaps a bad and certainly only a partial description but there is no need for more since the photograph is here). Since I know who he is I interpret what I see through the filter of what I know which has nothing to do with the photograph except in so far as the photograph is the stimulus for the selective reverie I choose to have based on my experience as a reader. The photograph makes me think of scenes from

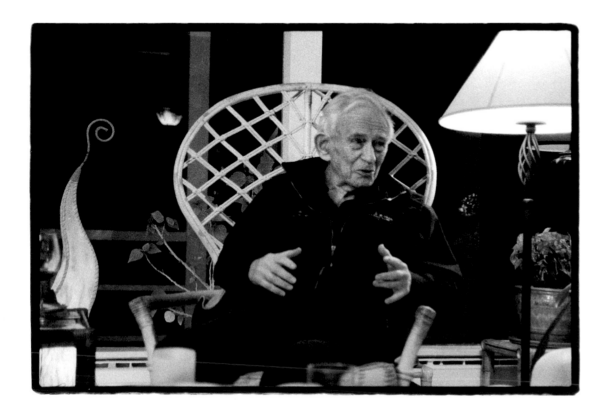

The Naked and the Dead and *The Executioner's Song* or the descriptions of Nixon at the Republican convention and Martin Luther King in Washington in 1968. I think of what those eyes saw, what his brain recorded and imagined, what his hands wrote as his whole body struggled with the sensations and emotions, associations and feelings of what he observed and felt and then registered on the typewriter or with a pen on paper, the tremor of seizing and recording his great treasure of experience and response and finding a form in which it could be transformed and live through his unique process of choosing the words to transmit his sensibility. These good photographs push me to try and think about Mailer and all that I have learned from and through him.

—*Frederick Wiseman*

43

AND YET, WHATEVER MAILER'S TRUANCY from the novel, or his self-mythologizing impulse, or the violence he does to our traditional moral values, perhaps it is none of these but only the paradoxical character of his talent that finally creates his present equivocal situation. Where a writer exists in this much contradiction, the realization of his possibilities is always chancier than it would be in a more unitary talent, and it would be hard to name a writer of our or any time whose work reveals a more abundant or urgent endowment which is yet so little consistent with itself—so much moral affirmation coupled with so much moral anarchism; so much innocence yet so much guile; so much defensive caution but such headlong recklessness; so much despair together with so imperious a demand for salvation; so strong a charismatic charge but also so much that offends or even repels; so much intellection but such a frequency of unsound thinking; such a grand and manly impulse to heroism but so inadequate a capacity for self-discipline; so much sensitiveness and so little sensibility; so much imagination and such insufficient art. Contradictions like these no doubt contribute to Mailer's appeal; but they also make for his limitations. And they describe a talent which necessarily lives on the sharp edge of uncertainty.

—*Diana Trilling*, 1965

44

Provincetown, Massachusetts,
2007

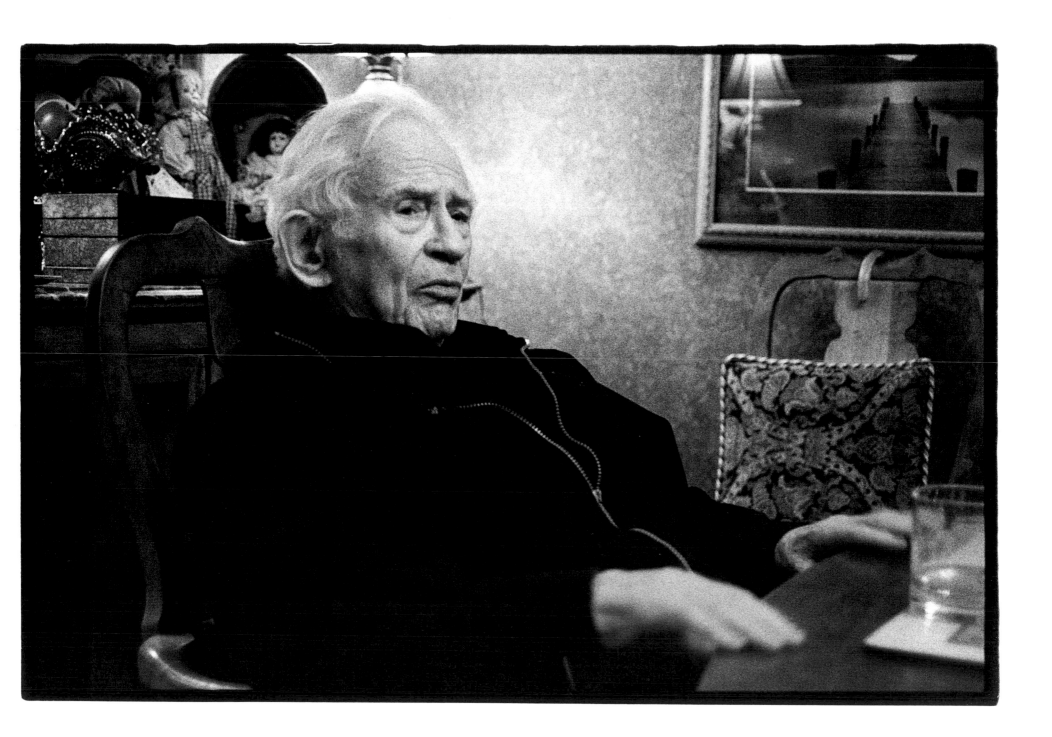

DIANA TRILLING

No, DIANA, THE PURPOSE OF A PHOTO isn't "to make one look beautiful". That is what you said you'd been hoping for, but it's hardly what makes most photographs worthy of attention. I may have disappointed you with this image but you do look fine—thoughtful, turned inward—the person I knew, if only for a brief time.

I remember the twinge I felt when you sensed I had offended Alice, my daughter, then only about four years old. I don't recall what I'd done, but you noticed that she was holding her own in the conversation and that I had dismissed her in some all-too-motherly way. I liked you for defending a young one and for noticing that she had something worthy to say.

Those writers to whom you gave your continuing support (always with wary reservations), such as Saul Bellow and, yes, Norman Mailer, had more in common with those with whom you disagreed, Robert Lowell for one, than you would altogether have wished. Like all of them, you spoke bravely. You were brave in the face of Lionel Trilling's death. Likewise in contemplating every day the comic memento mori that you had on the wall of your Manhattan apartment: the Saul Steinberg image of the respectable man who plods within parentheses that announce his date of birth at one end but are blank at the other: (1905–). In Steinberg's words, "He walks, followed by his birthday and facing his death day".

1905 happens to have been the year of your birth; 1996 the year of your death. The obituary of you by William Phillips in the *Partisan Review* managed with its final words to stumble into a great word for you, you who could make squeamish people squirm in combat: "We shall miss Diana's great candor, her insistence on the highest of standards, her loyalty to her family and friends, and her sincerity. But most of all, I miss our friendly squirmishes that ultimately cemented our friendship".

—*Judith Aronson*

46

Manhattan, New York,
1983

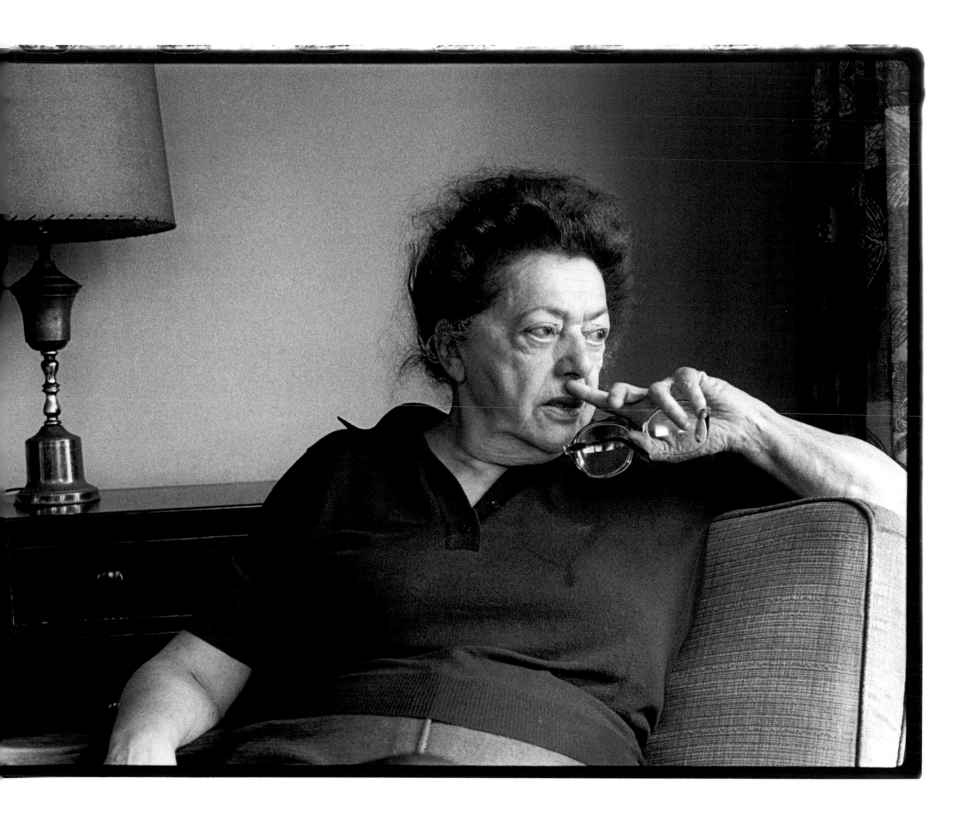

SALMAN RUSHDIE *and* ZAFIR RUSHDIE

THESE PHOTOGRAPHS were taken for the *London Review of Books* in 1981 not long before Salman Rushdie won the Booker Prize for *Midnight's Children*. They were commissioned to accompany "The Prophet's Hair", a story about "the famous holy hair of the Prophet Muhammad, whose theft from the shrine at Hazratbal the previous morning had created an unprecedented hue and cry in the valley". With the publication of *The Satanic Verses* seven years later, the hue and cry turned upon Rushdie himself, the fatwa was pronounced, and his life was threatened.

By a coincidence, the story has this intently evocative moment: "The youth left his father alone in the crowded solitude of his collections. Hashim was sitting erect in a hard chair, gazing intently at the beautiful phial". In one of these photographs of mine, the chair looks comfortable and so does Rushdie's son happily on his lap.

—*Judith Aronson*

IT IS HARD ENOUGH TO WRITE at one's best without bearing a hundred pounds on one's back each day, but such is your condition, and if I were a man who believed that prayer was productive of results, I might wish to send some sort of vigor and encouragement to you, for if you can transcend this situation, more difficult than any of us have known, if you can come up with a major piece of literary work, then you will rejuvenate all of us, and literature, to that degree, will flower.

So my best to you, old man, wherever you are ensconced, and may the muses embrace you.

Cheers,
Norman

—*Norman Mailer*, 1991

48

London, 1981

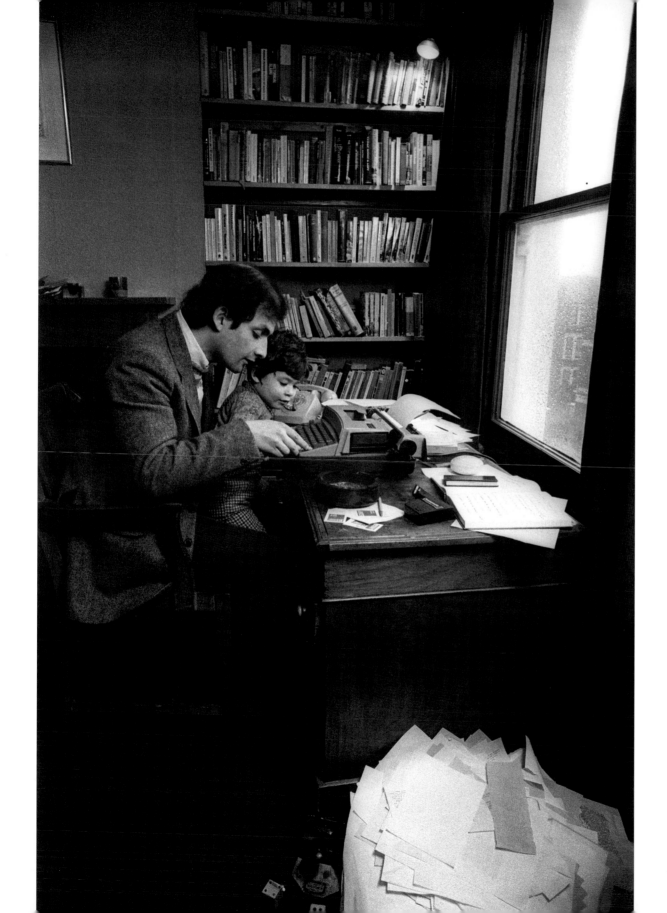

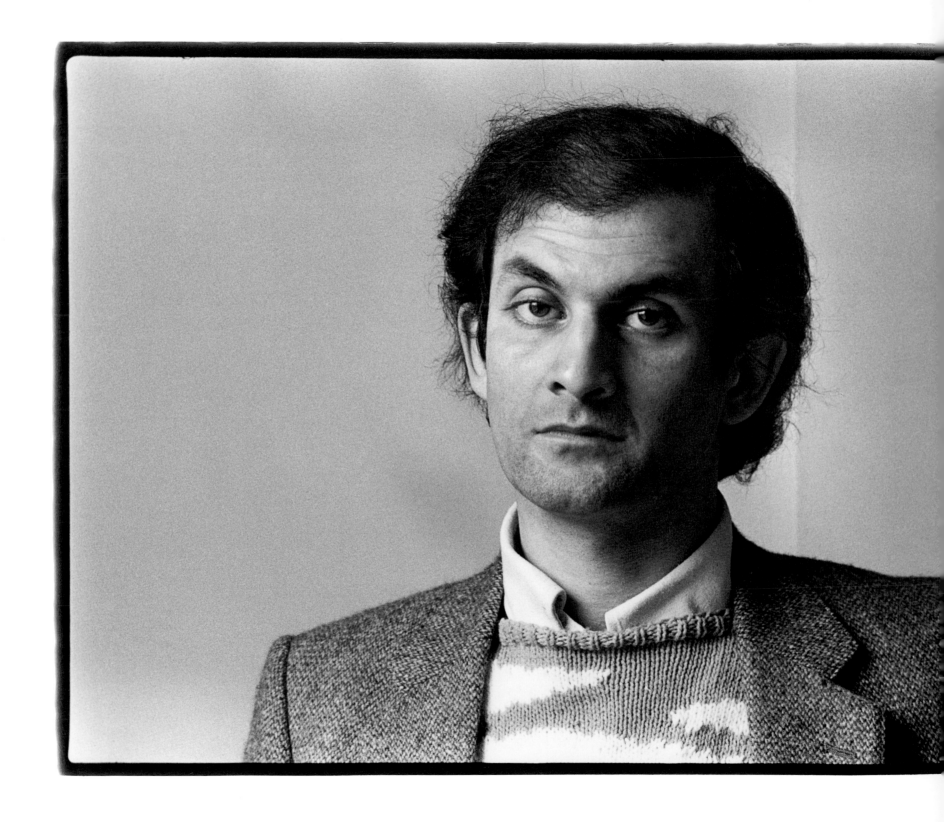

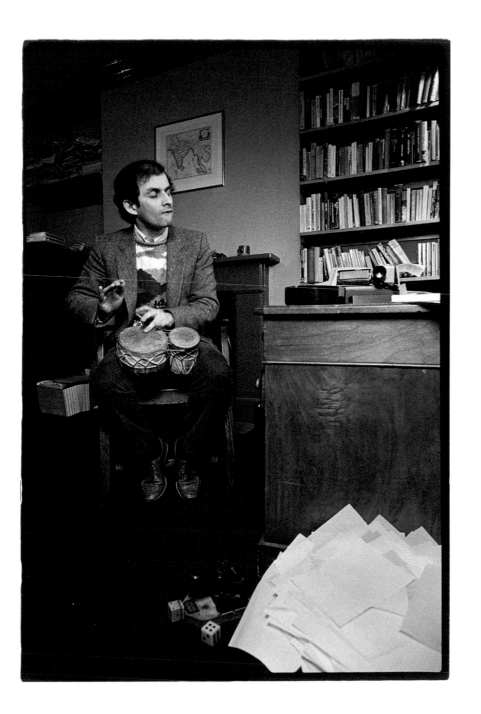

51

London, 1981

RALPH RICHARDSON

I CAME TO KNOW SIR RALPH RICHARDSON when I interviewed him on my talk show "Parkinson". As I wrote in *Parky:*

We went for lunch to Scott's Restaurant in Mount Street, Mayfair. (This was before its latest transformation, when it was the old established seafood restaurant lately moved from Piccadilly to Mayfair.) Sir Ralph turned up in mac, scarf, hat and umbrella in spite of the fact it was a pleasant day in early summer. He removed his hat but not his coat or scarf as we were shown to our seats. I had the impression he was auditioning the restaurant.

He called the manager over. "Terribly dark in here. Can't see the menu" he said. The manager immediately increased the wattage causing shuffling noises and no little complaint from shadowy booths where middle-aged men sat with much younger companions.

"Warm in here" said Sir Ralph. Instead of pointing out he was fully dressed for the arctic on what was a passable summer's day, the manager said he would turn the heating down.

Having now set the scene to his specifications, Sir Ralph removed his coat and scarf and got down to business. The menu arrived.

"Take that back" he said. "Don't need a menu in Scott's. I will have a grilled Dover sole and so will Mr Parkinson, boiled potatoes and a few green beans I fancy".

Then he turned to me and said: "Maybe you want chips? Never eat them myself but I will order them on your behalf". I hadn't said a word. I was still marvelling at this seemingly batty old man bossing the universe.

He ordered a very agreeable Montrachet and, when the food arrived, ate every chip he had ordered for me. Then he called the wine waiter over and had a scholarly discussion about the comparative merits of marc and grappa before ordering two large marcs.

He lived in a beautiful Nash terrace opposite Regent's Park, complete with lift. Upstairs in the kitchen, the wall was plastered with the lines of his latest play. This, he said, was one of his aids to learning his part. We finished a bottle of gin, whereupon he went to a lift with folding doors, put the gin bottle on the floor, shouted something down the shaft and dispatched the lift to the basement. Five minutes later the lift arrived back on the first floor containing a replacement bottle.

When I eventually and unsteadily departed his company and had time to consider the day, I realised that at no time had we discussed what he might talk about on the show, which had been the purpose of our meeting. What I also realised was that the lunch (and all that followed) had been designed by an impresario with the purpose of thwarting my ambition.

The entire performance, starting in the restaurant and concluding at his home, had been calculated to divert my attention from finding out anything about my guest other than he was a master of illusion.

After the interview at the BBC, and as he departed the Green Room, this remarkable man stopped at the door, turned and said, "Do you know what's wrong with a lot of actors today?"

We said we had no idea.

"They don't know how to die" he said. "If they are shot they die like this", and he lurched across the room before slithering in melodramatic fashion down the wall.

"In fact, they should die like this", he said, crumpling in concertina fashion until he lay on the floor looking like an empty suit.

He rose to his feet, doffed his trilby and wished us all a good night. When he left the room it was like a light going out.

—*Michael Parkinson*, 2008

52

Regent's Park, London,
1978

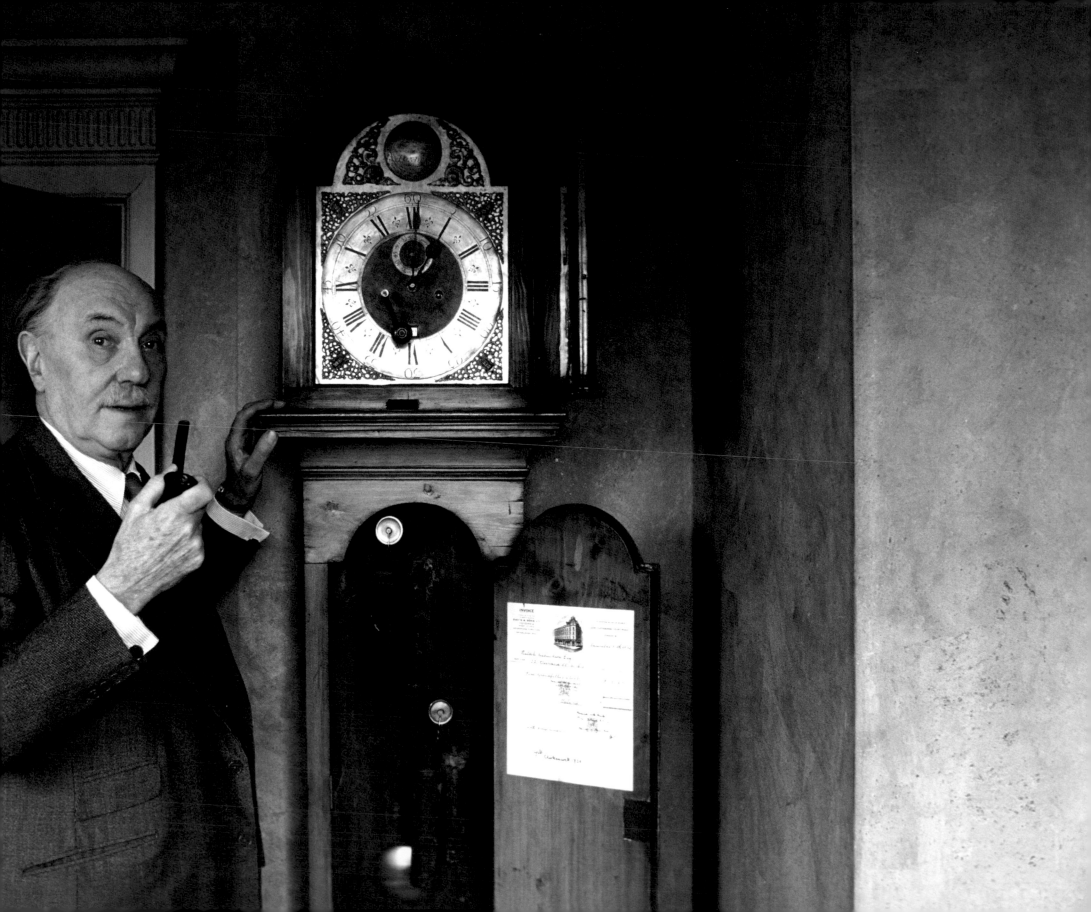

MICHAEL PARKINSON

A VERY GREEN PHOTOJOURNALIST I was when I showed up to capture on film the personality of "Parky", the television talk-show host, Michael Parkinson. It didn't exactly occur to me that he and I work similarly: try to put our subjects at ease and then prod them a little into displaying characteristic qualities that will intrigue outsiders—our viewers.

Others may have known then, but many more know now, that Sir Michael is a pro at this, having interviewed a thousand people over the years, including in the first series of eleven Orson Welles, John Lennon with Yoko Ono, Peter Ustinov, Spike Milligan, and Shirley MacLaine. When he invites more than one person on the show, usually from different backgrounds, they are linked by a common interest to form a double act. In the case of Fred Trueman, the cricketer, and Harold Pinter, the cricket lover, this was an obsession with the great game that used to be for Gentlemen and Players. This particular scene famously opened with Trueman greeting Pinter: "Now then Harold lad, what's tha' been up to?"

An answer from Pinter was to be in due course a succinct poem:

> I saw Len Hutton in his prime
>
> Another time
>
> another time

What fascinated me about Parkinson was that he's simply perfect at reversing the roles and becoming the interviewee. In the picture here he has just returned home from a game of cricket. My job was to illustrate his contribution to the *Telegraph* series "My Sunday". He greeted me at the door in his whites. I dutifully took photos and then asked, "How do you spend the rest of your Sundays?" Before long Parkinson was relaxing on the couch in his lounge wear, reading the newspaper and looking as natural as if I'd just sneaked around the corner. No prodding necessary. No self-consciousness apparent. No bravura. A natural. A gentleman and a player.

—*Judith Aronson*

54

Berkshire, England,
1978

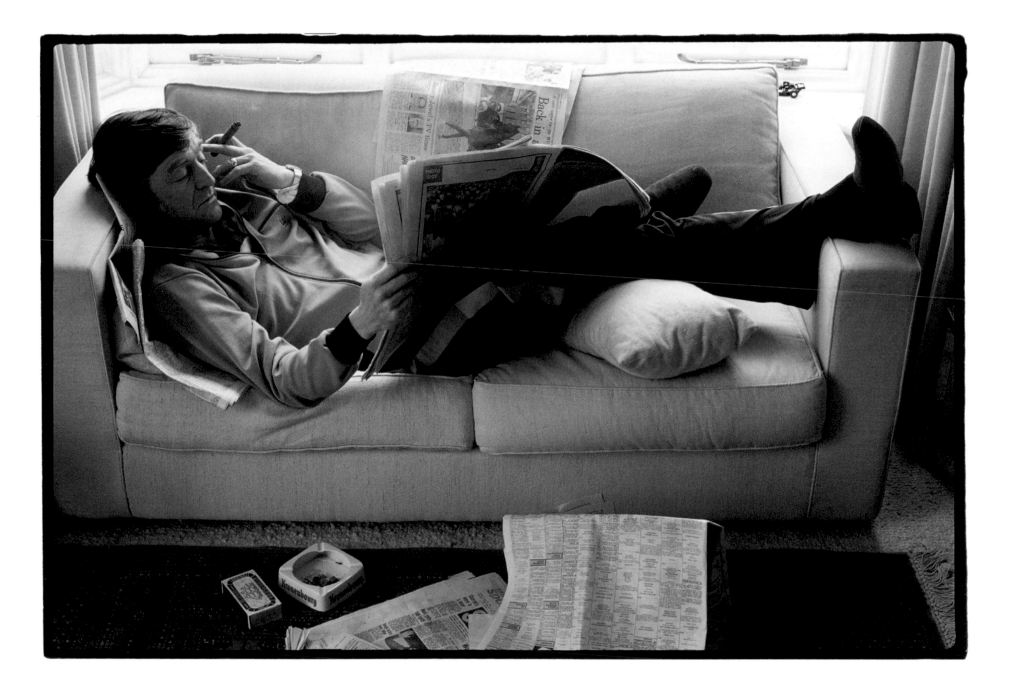

JOAN PLOWRIGHT

IN THE LATE FIFTIES I was one of several stage managers working for the English Stage Company at
the Royal Court Theatre in Chelsea. It was a terrific period at the Court. George Devine's playwrights
were causing a revolution in British theatre, and his actors would go on to be the senior players a
few years later at the National Theatre. One evening there was a public dress-rehearsal of Arnold
Wesker's latest play, starring Joan Plowright. The play ended with a long speech from Miss Plowright,
in which her character defiantly declares her freedom from her past and her determination to follow
her own star.

We the stage management, working on other plays in the repertoire, were allowed into
the theatre to watch this first public run-through. I remember nothing about the play except that
final speech. Miss Plowright gave it everything, and as it ended and the curtain fell, all of us stage
management jumped to our feet and applauded and cheered with wild spontaneous excitement. I
had a sense that we shouldn't be doing this; after all, we worked here—it was a bit like giving oneself
an ovation. But that did not stop us because she was so great.

I had another sense too: I felt, in however insignificant a way, that I was part of the revolution.
This—here and now—was part of the luck that had come my way.

—*Nicholas Garland*

With her children, Brighton Beach,
England, 1978

56

NICHOLAS GARLAND *and* ALEX GARLAND

OBVIOUSLY INTIMATE, the two people here are father and son. Like many parents and children, they chose different professions, but there are cross-currents. Nicholas, the father, an artist, printmaker, and longstanding political cartoonist for the *Daily Telegraph*, has also scored as a writer. *Not Many Dead*: *Journal of a Year in Fleet Street* marshalled his journal, recording the private discussions, the hirings, and firings, the outlandish gossip, the awful blunders and sometimes brilliant scoops of both the revitalized *Telegraph* and the embryonic *Independent*. The story led up to the launching of the *Independent* in 1986.

Alex Garland is the author of several bestsellers including *The Beach* that in the judgement of the *Washington Post* "combines an unlikely group of influences—*Heart of Darkness*, Vietnam war movies, *Lord of the Flies*, the Super Mario Brothers video games". Lately he has turned to film: as screenwriter and producer.

Son and father created *The Coma* (2004), an "ingenious *jeu d'esprit*, whose oddity and dark charm are enhanced by forty woodcuts by the author's father". The visual plays its part not only in the woodcuts, but in how the words imagine pictures: "It's possible that the nurse and the doctor were talking in a way that was careless or irresponsible, that they had forgotten the presence of the comatose in the way that people can forget the presence of cameras". There is a dark presence facing this reflection in words: a rectangle all but black. The next chapter opens: "I sank and I sank, and when I reopened my eyes, I was in total darkness". Facing this, a rectangle of total darkness. So 250 years after Laurence Sterne in *Tristram Shandy* mourned the death of Yorick, the famous black page lives again.

Here in Nick's home-studio we can imagine the conversation of these two men. We are not meant to know exactly what they are thinking. (Is Alex sitting or posing for me at the garden table?) But I happen to know that they think very well of one another. As well as of the cottage in a charming Gloucestershire village where thirty years ago, by coincidence, I photographed Nick's childhood friend Jonathan Miller and family one summer—a cottage that Nick has owned for all of Alex's life.

—*Judith Aronson*

North London, 1999

58

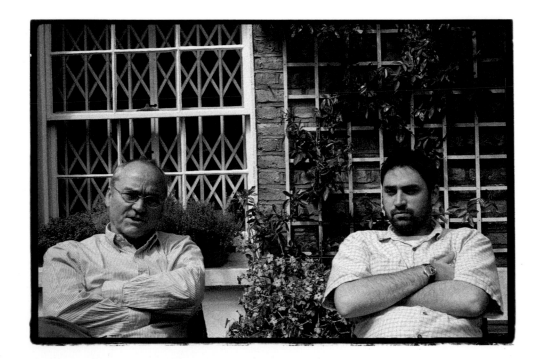

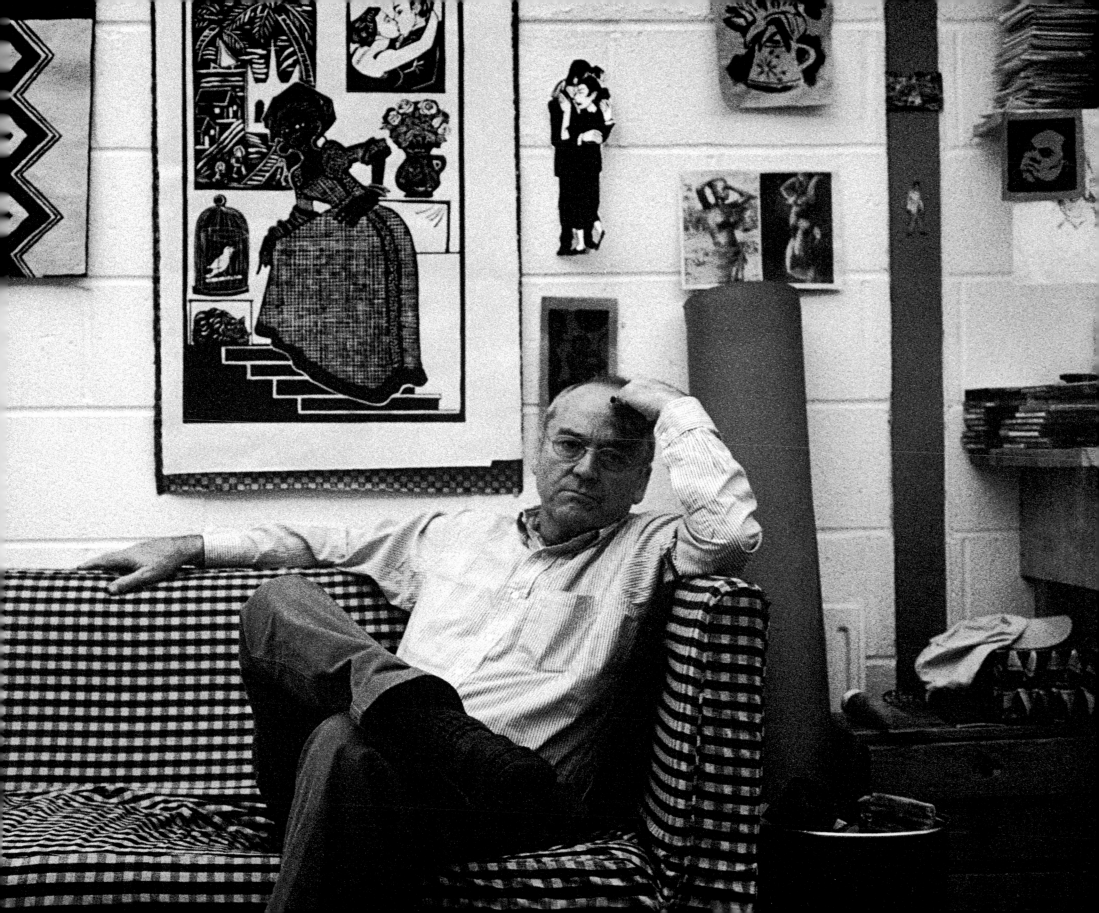

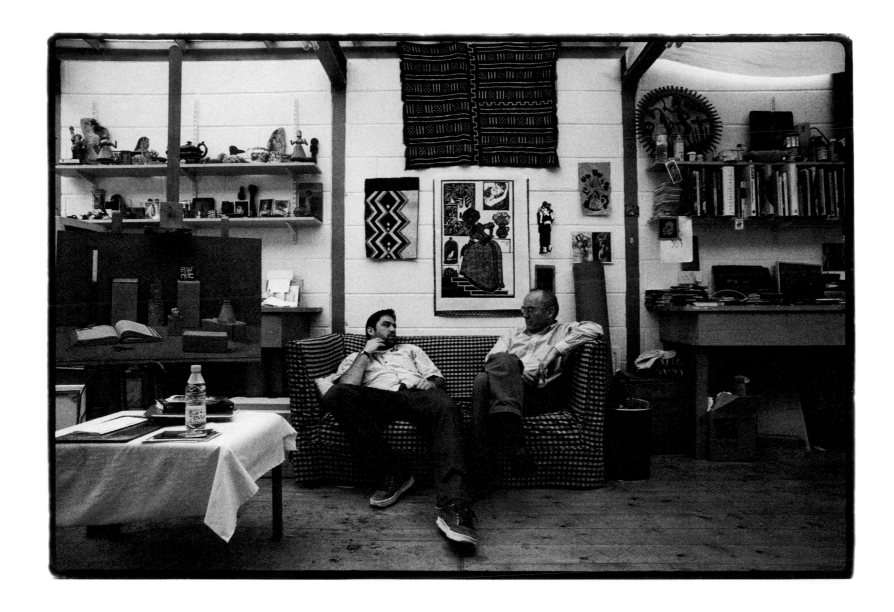

60

North London, 1999

61

HOWARD GOTLIEB

"HE CARES!", EXCLAIMED JOAN FONTAINE, whose photograph adorns his living room. "Family, friends, fans will slowly lose their memories of one's endeavors but Howard Gotlieb is determined that it was not in vain. As an archivist, Howard Gotlieb makes it seem worthwhile". There on the side-table is a photograph of the dashing young Gotlieb with Lilli Palmer. Bette Davis and Greer Garson are there in the room too, contributing to the spectacle that was Howard's life.

As the power behind Special Collections at Boston University, Howard had commissioned me to take portraits of his powerful betters: the Chairman of the Board of Trustees, the President, the Provost, the Dean. It wasn't long before I realized that the distinctive figure to catch was Howard himself, at home. I'd heard that his personal art rivaled that of the special collections. For him, there was no business like show business. His charm had courted generous benefactors. Not a rogue but roguish, Howard gave a happy morning as he positioned himself among his *objets d'art*. The Rembrandt, which he'd bought in a European street in the wake of the Second World War, is like Howard in not really being a snob, and doesn't mind being in the immediate vicinity of the air-conditioner.

—*Judith Aronson*

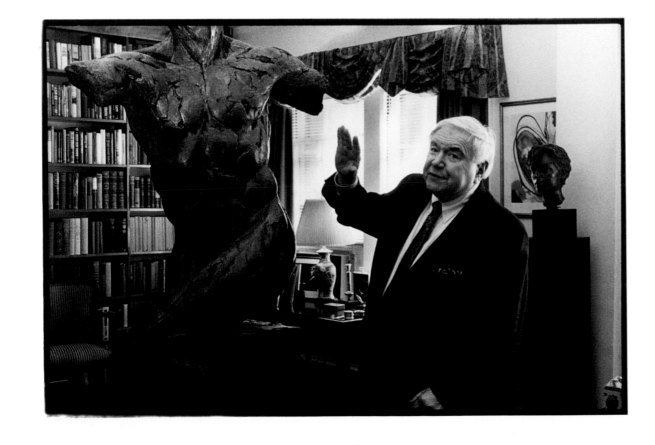

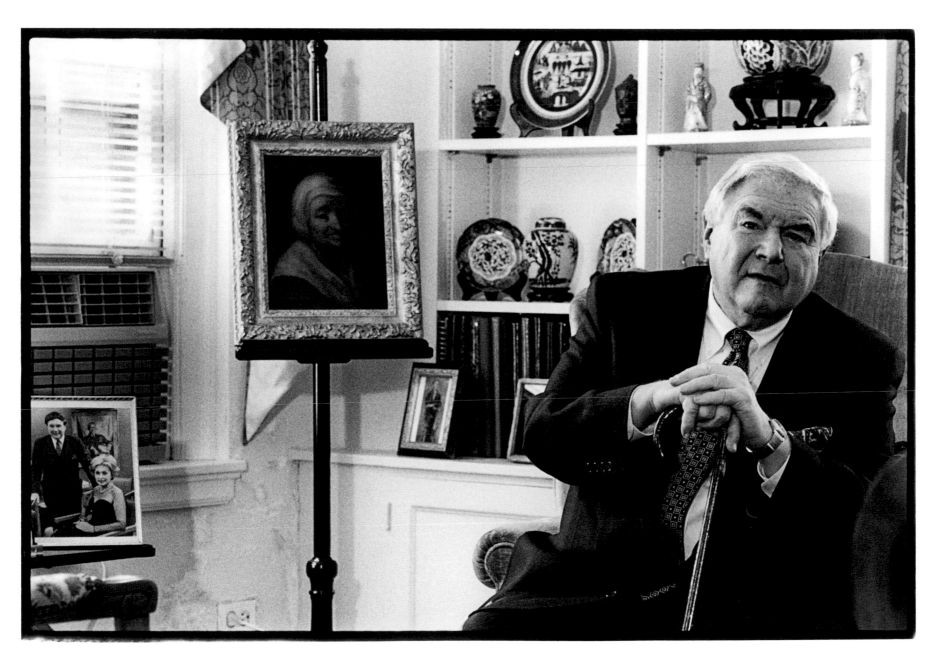

Boston, Massachusetts,
1999

CHARLES SAUMAREZ SMITH

THE YOUNG SAUMAREZ SMITH was just as he describes himself in the Foreword to this book. I hardly knew him when I was commissioned by the Master of Christ's College to take his photograph along with the other Fellows, but I could tell instantly that he was someone I'd like to know better. The middle-aged Saumarez Smith came to my attention 25 years later when I was meeting with the curator of photographs at the National Portrait Gallery, London, who asked if by chance I had a picture of the then director who was moving over to the National Gallery. They wanted a picture for the going-away party.

Of course I obliged, with the only photograph I had from 1979. This was all that was needed to renew our acquaintance. Some months later, after the party, Saumarez Smith emailed me from his BlackBerry while vacationing in Colorado, to say that he was delighted to see the photo again, asking if he might have a copy. Once more I obliged, not knowing that in a year or two I'd be asking him to write something for *Likenesses*.

The man today has been described by the *Evening Standard* (June 30, 2009) as "one of the more affable, even clubbable members of the London cultural commissariat".

Every communication I have had with him bears this out. My emails (only emails) are answered within a day, directly from wherever in the world he happens to be. When I asked if he would be willing to write an introduction or foreword for my book the answer was an immediate yes. When I brought three boxes of photos to the Royal Academy to assist him in this undertaking, I was invited to tea in his office, "which does nothing to dispel the myth of the institution's inherent cosiness. It's rather like a public school headmaster's study, with its large Victorian desk, stacks of books and sticky lack of air conditioning". One assumes that although he could change this if he wanted to, he likes everything just as it is. And when there was the usual editing to his piece to make it compatible with the book, the exchanges could not have been smoother.

But what above all makes me grateful to Saumarez Smith is his precise understanding of the character of my photographs. He articulated this in the first round. To reconstrue a Henry James phrase about a painting, I'd say Saumarez Smith has (for me) the "perfect prose of portraiture".

—*Judith Aronson*

Christ's College, Cambridge, England, 1979

64

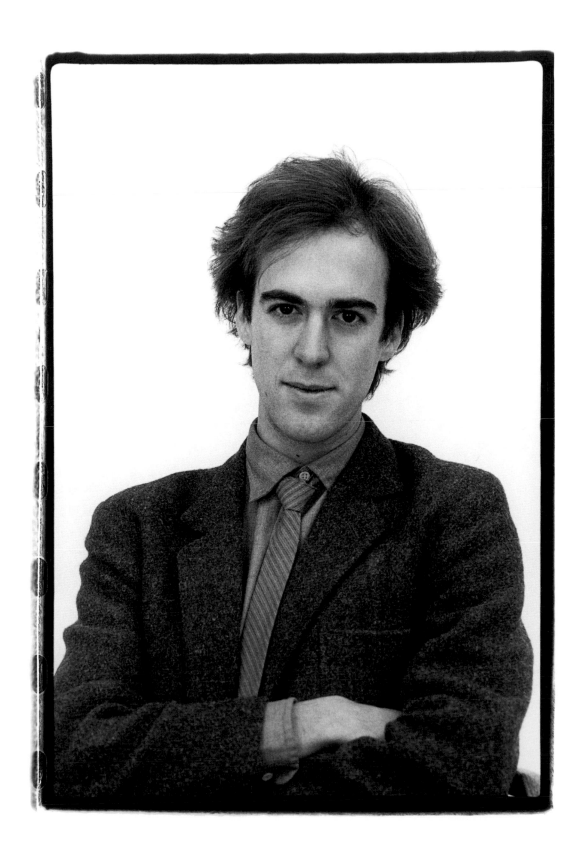

DAVID HICKS *and* PAMELA HICKS
EDWINA HICKS *and* ASHLEY HICKS

MY FATHER, INTERIOR DESIGNER DAVID HICKS, loved to look at 18th century "conversation piece" pictures by Zoffany or Arthur Devis, for the clues they gave to period decoration and lifestyle. Posed artificially, stiff and formal, families stare out at us from around a table, or against a fireplace, sometimes about to eat, or playing a card game together; sometimes just staring. Occasionally there is a conversation going on: a husband showing his wife plans of their new house, or reading to his family from some slim volume. Often children are playing with toys.

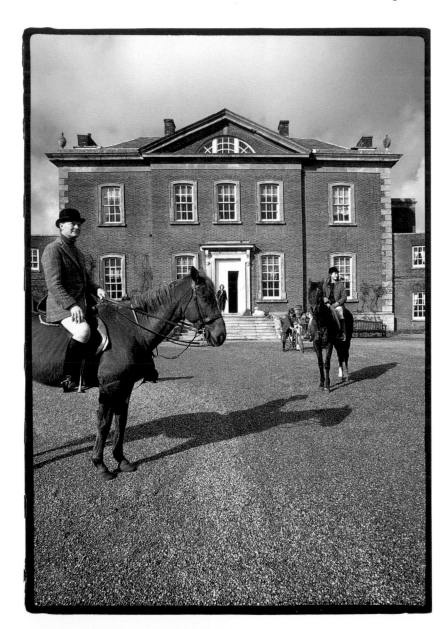

This picture is a conversation piece from 1977. My father is standing behind his elder daughter Edwina and myself, aged 16 and 15 respectively. We are pretending, following his instructions, to work on our scrapbooks. These were massive albums with pages of thick card, impossibly heavy and awkward to move about, specially made by a bookbinder with tooled leather spines, covered in David Hicks wallpaper. This was a regular feature of our lives, to lay these huge volumes out on the folding card-table in the Drawing Room and stick in photographs, souvenirs . . . and the occasional press-cutting telling of our father's growing fame.

The selection was made following his "advice"; the layout was made with the aid of his designer's eye. The glue—French "Scotch", dozens of tubes of which were bought every summer in France, all English glue being found unworthy—the glue, we were allowed to apply ourselves, although only under his keen supervision. We also wrote the concise captions ourselves, although he did dictate most of them. I clearly remember sensing the absurdity of this little performance, which seemed only too natural to my father, who had always been a performer (his mother, a keen amateur actress, had trained him well).

The setting was then one of the most photographed private rooms in the world. For 15 years it had featured over and over again in every decorating and fashion magazine. The house was then already for sale; a year later, the room would be dismantled, its contents auctioned off, and we would move to a much smaller house nearby. For now there was still the sublime chic of the room, with its "corn-coloured" linen stretched on the walls, its fine Rococo carved chimneypiece, its lovely Louis XVI furniture and stark modern paintings, its "tablescapes" (the word coined by my father in his seminal 1966 *David Hicks on Decoration*), collections of objects of one colour or material, arranged in sculptural groups on sidetables.

Just as those older conversation pieces tell us how families of the time lived, or how they wished the world to think they lived; so this picture shows David Hicks' vision of our life. In the perfect stage-set that he created, his children act out his little drama. Their "toys" are the books that immortalise their young lives, so heavy that they can barely lift them from their purpose-built, cobra-skin topped cabinets between the long windows onto the expanse of lawn.

—*Ashley Hicks*

Bedfordshire, England,
1978

67

RALPH STEADMAN *and* ANNA STEADMAN
HENRY STEADMAN *and* SADIE STEADMAN

"YE GODS, RALPH! A matted-haired geek with string-warts! They told me you were weird, but not that weird". Hunter S. Thompson sometime in the Seventies, not long before I was dispatched by the *Sunday Telegraph Magazine* to photograph Ralph Steadman at the home where he nursed his part of the newborn Gonzo journalism. Here is Steadman, a writer as well as an artist, describing the birth in his book *The Joke's Over*:

> It was a strange chemistry that brought it about and Hunter had thought the Kentucky Derby piece a "Goddamn failure" until it appeared in *Scanlan's* and a journalist friend from *The Boston Globe*, Bill Cardoso, wrote to him saying: "Hey, man! That Derby piece was crazy!! It was pure GONZO!" And that was the very first time that Hunter, or I, had ever heard the word "Gonzo".

Steadman sketched Thompson's idea for their new project that became *Fear and Loathing in Las Vegas*: "Record everything as it happened and then get it published exactly—facsimile—without editing. He wanted it to feel like his mind and his eyes were functioning simultaneously, like a Cartier-Bresson photograph—no cropping—the entire negative, without the usual futzing about in a darkroom later… . He welded into one the talents of a master journalist, the eye of an artist photographer and the 'heavy balls' of an actor".

When photographing I've often wondered whether writers see the connection that I see between our two pursuits. Obviously some do, but Thompson said that "photographers generally get in the way of stories. Steadman has a way of becoming part of the story. And I like to see things

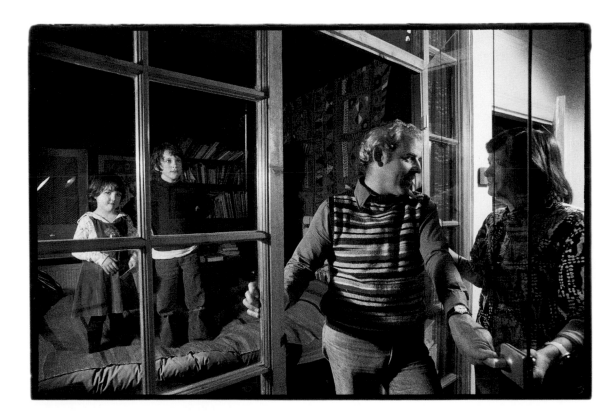

through his eyes. He gives me a perspective that I wouldn't normally have because he's shocked at things I tend to take for granted". Anyway Steadman was excited by the new approach, but nervous. " 'Send it over!' I said with false bravado. 'I'll see what I can do. Who is it for?' " Hunter's reply, "This music magazine, *Rolling Stone*. They've never heard of you but I assured them that no one else could do what I want".

In 1978 when I photographed Steadman, I too had never heard of him. The *Telegraph* liked it that way. Considering the wild, mischievous, and sometimes illegal schemes he perpetrated with Thompson and the resulting bizarre drawings, I'm tickled by my memories of the day I took his photograph. It was of a down-to-earth sweetheart, a cuddly family man. I followed him to the greenhouse where he performed one of his favorite pastimes, watering the plants, and then we went with his wife and children to the park to fly kites. He had an appealing innocence.

Steadman said that he felt like "Hunter's mynah bird back then. He tormented me as though I were in a cage. He was my hope and my misery. I wasn't sure what to expect at any moment. It was my innocence that saved me". As for Thompson, Steadman's "best

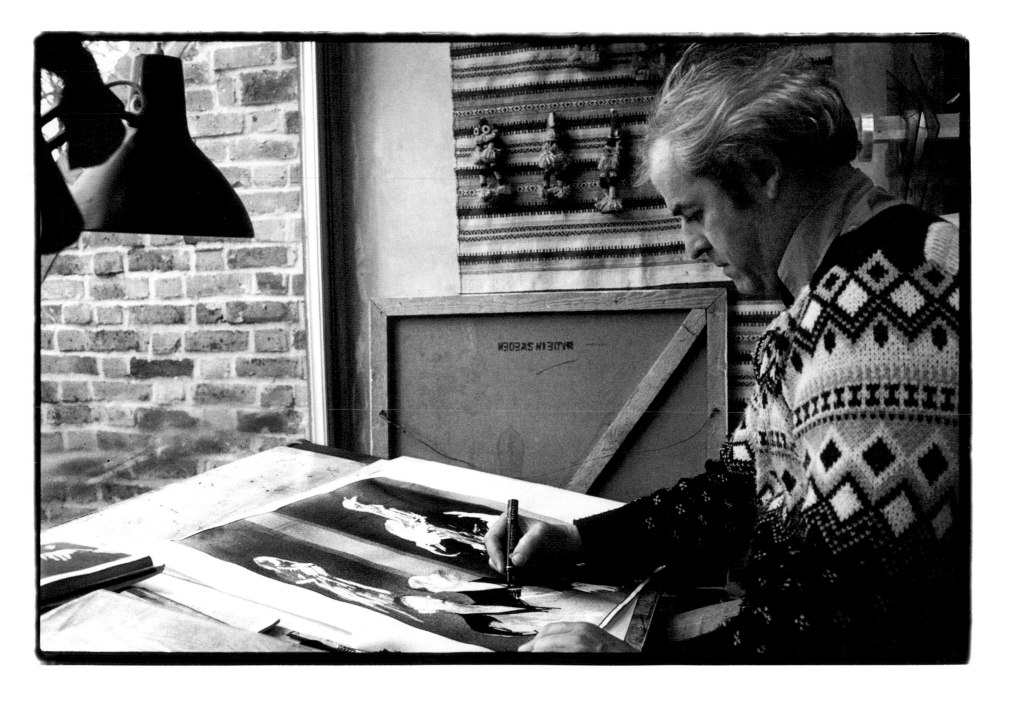

69

drawings come out of situations where he's been most anguished. So I deliberately put him into shocking situations when I work with him". In this spirit Thompson, in 1977, had Steadman make drawings of a contraption that would carry his "ashes into the firmament". A sort of spaceship and launcher. Together they went to a funeral parlor and arranged construction for the eventual day. The day after Hunter committed suicide in 2005, Steadman flew to Colorado from England to be there for the send-off.

—*Judith Aronson*

Fulham, London, 1978

MATTHEW CARTER *and* ARLENE CHUNG

MATTHEW CARTER HAS OFTEN BEEN CALLED the most widely read man in the world. He designs typefaces. So far 73 type families, which include 320 fonts. With typical fondness he has said "Designing type involves a billion possibilities. Once you make your first decision—serif or sans, say—half a billion decisions remain. And when you make your second—the thickness of each character, perhaps—a quarter billion remain, and so on. Old style or new, until finally you're down to ten thousand questions. Designers often get caught between two decisions, and those decisions occur somewhere just before you draw the first 'A.'" (As reported by David Berlow, a type designer of international repute himself and co-founder of Font Bureau, a digital shop with over 300 typefaces; from an article in the *New Yorker* by Alec Wilkinson, December 5, 2005.)

Carter has been no less decisive in designing a life in typography. He chose to forgo a university education at Oxford to study and practice the craft of type cutting at Holland's Enschedé en Zonen, and eventually settled in America. He distinctly remembers the headmaster of his boarding school calling him to task. "Carter, you'll never be a gentleman"—meaning a banker or a bishop or a general. His father was a touch harsh in saying that "The conversation at the dinner table might have been more interesting if Matthew had chosen another field"; but then Harry Carter was himself a distinguished historian of typography and may have thought that you could have too much of a type family.

Anyway, conversation could hardly be more interesting than Matthew Carter's. He is, too, a first-rate public speaker because he knows not only how to do it all but how to explain it all. Reserved though not too reserved (in stocking feet for my photographing him), he speaks directly to an audience in a way that is at once matter-of-fact and elegant. His Dwiggins Lecture in Boston, 2009 paid a generous tribute to a great type designer, Hermann Zapf at 90. It held my students spellbound, a tribute as much to Carter as to Zapf.

He has spoken of being "comfortable working with the tension that exists between the functional need for legibility and the aesthetic need to be slightly different". This is the age-old effort to reconcile form and function. He has the modesty of someone who is proud of his work, characterizing his enterprise with rueful humor: "There isn't much latitude in the manipulations a designer can perform on the individual letter. Only so much can be done to a "b" before it ceases to look like a "b". Its meaning is fixed and cannot change much. As with a piece of classical music, the score is written down—it's not tampered with—and yet each conductor interprets it differently. I'm what historians call a presentist. I know I can't look at the great French designer Garamond's work the way he did, in 1561".

He wisely chooses the letter *b* to illustrate his point and how it might lose its *b*-ness. If you teach typography as I do, you'd better not start at the beginning of the alphabet and speak of *a*-ness or dip into the middle and try *p*-ness.

—*Judith Aronson*

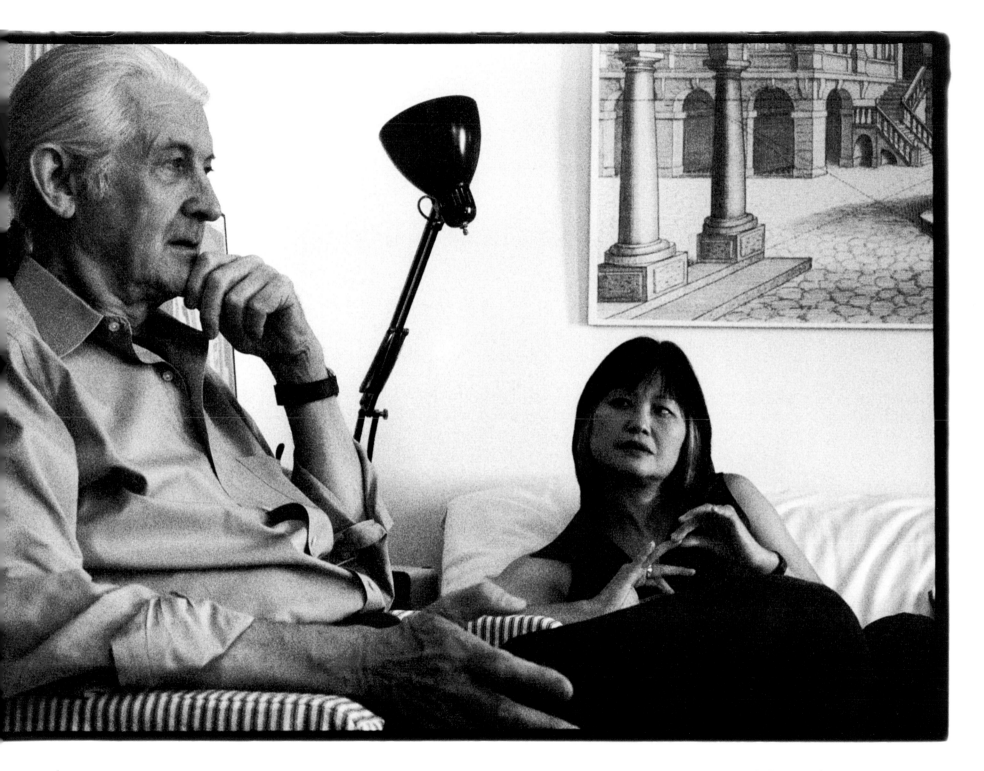

71

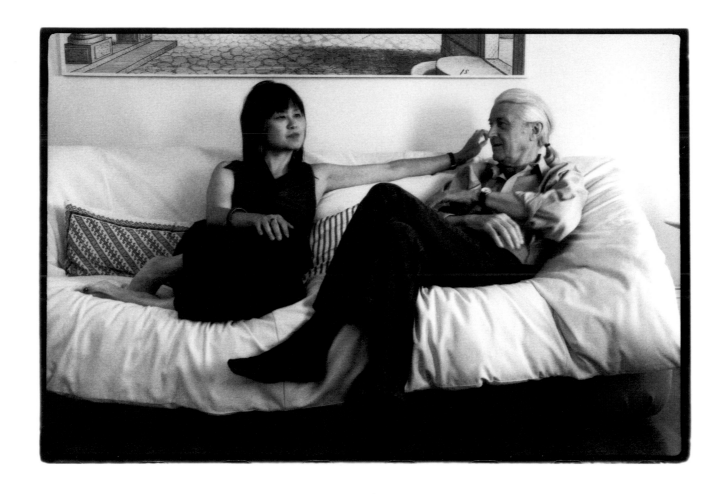

*Cambridge, Massachusetts,
2007*

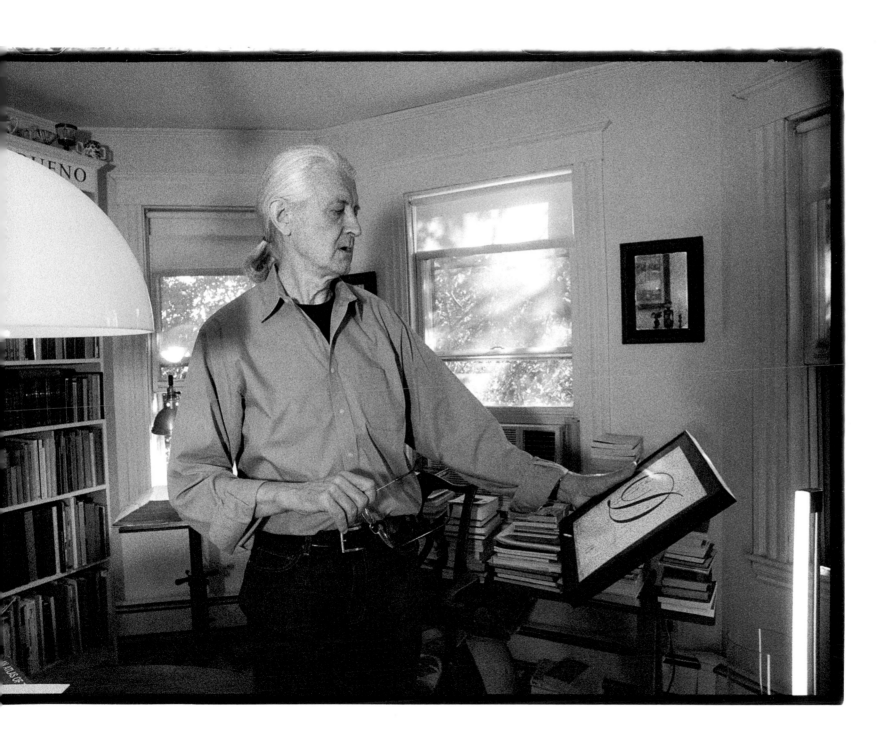

ANNE RIDLER *and* VIVIAN RIDLER

WHEN I WAS STARTING OUT as a designer and still living with my parents near Oxford (this must have been in 1958) I was commissioned by Vivian and Anne Ridler to do a piece of lettering, one of my first jobs. I knew Vivian because he was "Printer to the University", the centuries-old title given to the head of the University Press at Oxford, where my father worked. The lettering job was urgent and I was supposed to work on it full-time, but on a Saturday afternoon I played truant and went to a movie matinée. The cinema was the Scala (pronounced locally to rhyme with trailer), not far from the University Press in the part of Oxford called Jericho which at that time time had a rather louche reputation to the extent that undergraduates were not allowed to live there. The film was *The Crimson Pirate,* a splendidly swashbuck-ling adventure, a vehicle for Burt Lancaster's prowess as a circus acrobat. As I furtively took my seat in the Scala's auditorium I was greeted by name, turned around and saw Vivian and Anne sitting in the row behind me. I was astonished and embarrassed, caught shirking my job. I expected a reprimand for idleness but was congratulated instead on my taste in movies; they had seen it before and had come back to enjoy it again. I suppose as a callow 20-year-old I did not think that eminent printers and poets watched pirate movies on a Saturday afternoon, and certainly not at the Scala. So there were some lessons in life for me in that chance encounter—in kindness, generosity of spirit and enthusiasm for unexpected things—that I fondly remember, 50 years on.

—*Matthew Carter*

74

Oxford, England, 1994

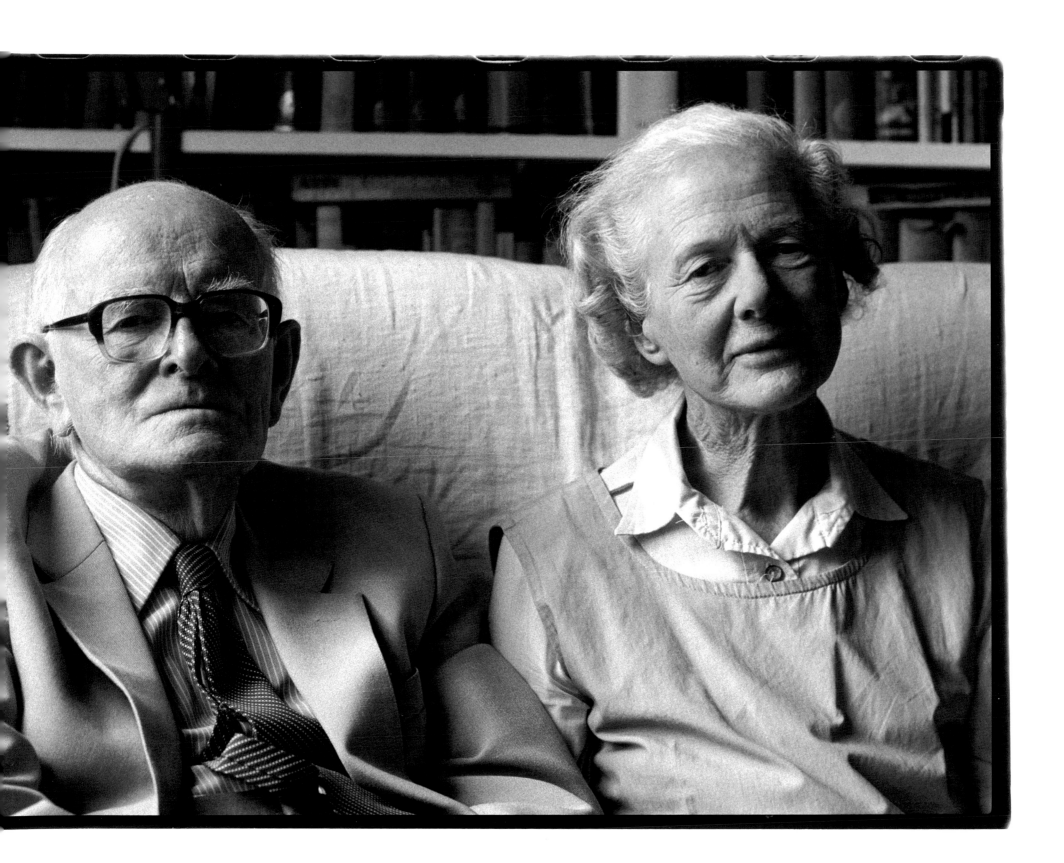

Oxford, England, 1994

ANNE RIDLER WAS A LOVELY and gracious being, in mind and spirit as well as in physical appearance; and a chaste and splendid poet, influenced by Eliot and Charles Williams (their theology as well as, or more than, their poetics) but in no way merely derivative from them.

In the late 1930s and early 1940s she had the opportunity to become a figure close to the heart of London literary politics. She was the niece of Sir Humphrey Milford, director of the (then) Oxford University Press at Amen House, London, where Charles Williams was on the editorial staff. As Anne Bradby she edited a volume of Shakespeare criticism for the "World's Classics" series of the OUP. George Barker and G.S. Fraser dedicated poems to her. My sense of events is that she finally rejected that possibility because she held to values which meant more to her than metropolitan literary triumph.

At one time she acted as Eliot's secretary and, almost certainly at his suggestion, edited the Faber anthology *The Little Book of Modern Verse* (Hopkins to Barker and Dylan Thomas), published in 1941. It was a book of and for the hour (Churchill's "their finest hour") as Humphrey Jennings's *Fires Were Started* was a film of and for the hour.

I heard her read to the Oxford University Poetry Society in the early 1950s. Our two meetings, one at a Lambeth Palace conference, the other in Cambridge, took place much later in the century. I wish now that we had met more often.

Her very happy marriage to Vivian Ridler (subsequently printer to the University of Oxford), and the pain of their wartime separation, were the impulse and setting for several of her finest poems. There is a major focus to her writing (I would here include her editorial essay on Charles Williams together with the poems) which instils new and vital cogency into the traditional Christian concept of the sacrament of marriage. For her, as for Williams, in Christian marriage sexuality is not "sublimated" or "transcended" but offered up, or transfigured, without the least diminution of erotic delight.

—*Geoffrey Hill*

My main holiday was planned as a trip to Italy with Jane Cowling, but first came my twenty-fifth birthday, 30 July, when after an ordinary office weekday I went down to Jane's room to consult her about something. David Bland appeared in the doorway with a friend whom he introduced as "Vivian Ridler from Oxford, where he works at the University Press". On this I remarked that Humphrey Milford, the London publisher, was my uncle. David's attractive-looking friend appeared to take this as a piece of name-dropping, for he said—as I thought rather dismissively—"O we're quite separate at Oxford". I was wrong about the tone, it seems, for Vivian says he decided then and there that I was the girl for him.

That was, I think, a Friday, and early the next week, as I was eating sandwiches in the Russell Square garden, to which we had the key, I opened the gate for David and the same friend, who was spending a few days' holiday with him. A day or two later, when I met David on the landing outside our room at lunch time, he said that he and Vivian wanted to look something up in the British Museum catalogue and would like my help. So we agreed to lunch together, and descended the stairs to the hall, where Vivian was leaning over Miss Swan's box as he talked to her. David muttered something to the effect that "She's coming out to lunch with us", and off we went to the Reading Room. We then went on to lunch at The Book, and that was that as far as I was concerned. But Vivian went back to Oxford and debated whether there would be any future in writing to me, or whether it would only lead to disappointment. Luckily he did write and propose a visit to a Prom at the Queen's Hall, to hear a Mozart Piano Concerto and the Jupiter Symphony. I was impressed by the handwriting on the envelope.

We met at the Hall, Vivian having caught the 5.15 from Oxford (docked of 15 minutes' pay for leaving early), and returned to 15 Taviton Street for something to eat before he left to get the last train from Paddington. I became aware as we were saying good-bye in the hall that he had very positively fallen in love; what struck me as delightful was that when I pointed out the mosaic paving and told him about Lewis Day his interest was vivid and not distracted by his feelings.

—*Anne Ridler*, 2004

Oxford, England, 1994

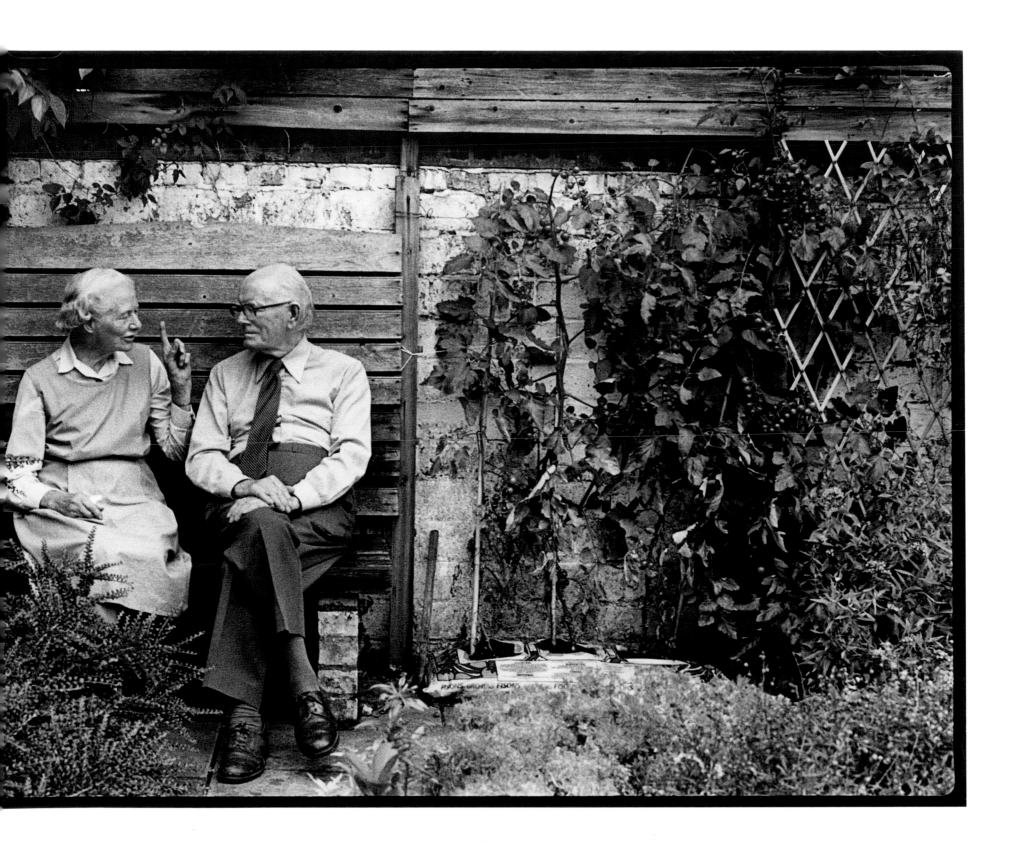

GEOFFREY HILL *and* ALICE GOODMAN

I FIRST MET GEOFFREY HILL in December 1980 at a party at Christ's College. We were both new in Cambridge that term; he'd come up—or down—from Leeds as a Lecturer in the Faculty of English and Fellow of Emmanuel College. I was an Affiliated Student at Girton. Geoffrey, as I met him and came to know him, was intensely serious. He wore black: a black fake-fur car coat from the early 1970s, lined in torn green paisley or a black trench coat with knotted belt; shiny black polyester flares, black shirts, sometimes with improvised cravats. "You're going out with a man who wears a *black shirt*?" my mother said, "Do you know what that means? Have you any idea who the blackshirts were?" I knew the meaning of Geoffrey's fuzzy pink socks: he was convinced that they were less likely to be lost in the College laundry. At the time this photograph was taken Geoffrey and I had been together for about two years (we married two years later). Geoffrey is self-consciously stylish in a Russian peasant shirt (black) and the famous socks. His hair has been made to stay in place across the top of his head. He knows all too well that he is under the eye of the photographer. I am looking at him too. Reading the photograph now, I try to make sense of our expressions. Am I curious? Adoring? Is Geoffrey trying not to laugh?

At the time this photograph was taken Geoffrey was bringing out the 1985 Penguin *Collected Poems* and I had just finished the first act of the libretto for *Nixon in China*, the typescript of which I'm holding in the photograph. Generally speaking, when Geoffrey has been writing, I haven't, and when I have, Geoffrey hasn't. It is as if we plug into the same electrical outlet. Look closely and you can see an overloaded adaptor plug underneath the table.

It is all allegorical; a comic allegory. Over the table you see an engraving of Chartres. You can't make out the detail, but there's a man who looks like Geoffrey walking down the street, leaning on a stick as Geoffrey does now. In the corner is a postcard of Nixon shaking hands with Elvis. On the wall hangs a black Stetson. I'm looking at Geoffrey. Geoffrey's looking at the cat. Monica, the cat, is looking at the camera. "Kind of like the Rublev Trinity", someone observed.

—*Alice Goodman*

80

Cambridge, England, 1984

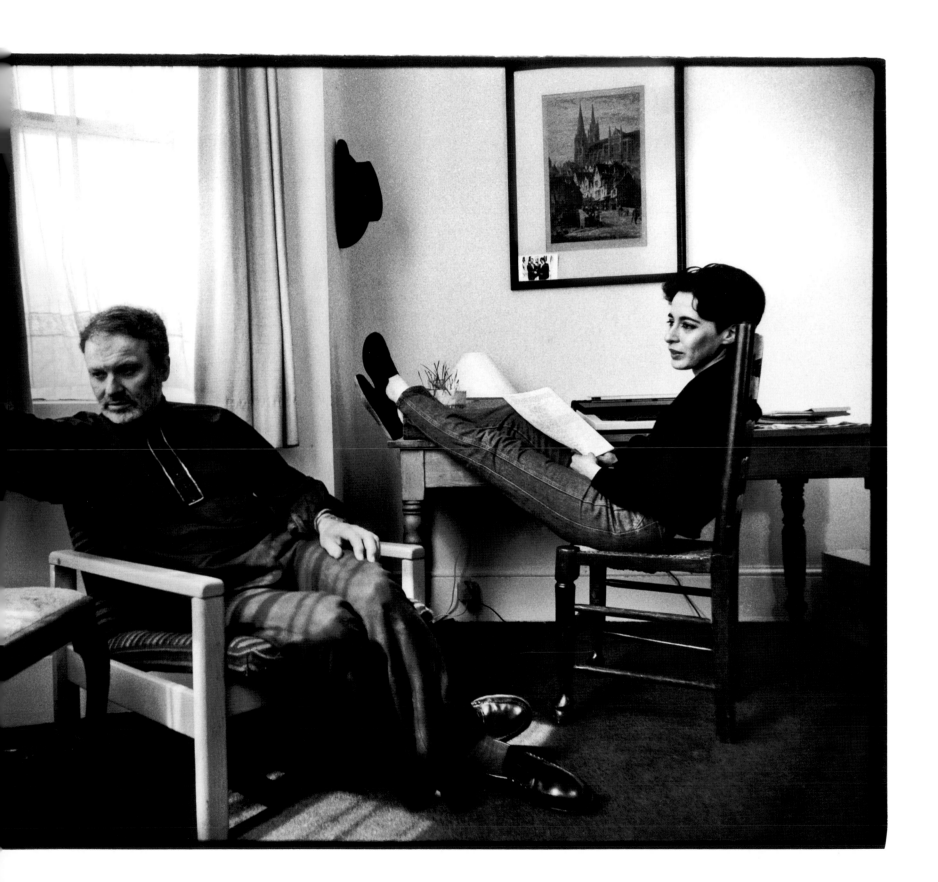

82

Emmanuel College, Cambridge,
England, 1984

"SHE HAS HELPED ME to see connections I might otherwise have missed". She, Alice Goodman. The speaker, Geoffrey Hill, who with characteristically firm self-respect says (in this *Paris Review* interview) *might otherwise*, not *would otherwise*. "Whenever Alice makes a technical comment I listen closely: ninety-nine percent of the time, she's right. I've changed a fair amount because she's said I should. She's also given me beautiful things, words, phrases. Her libretti for *Nixon in China* and *The Death of Klinghoffer* inspire me to emulation, *and* she taught me to read Frank O'Hara".

Alice can inspire in other ways as well; not only can she see connections, she can make them. She catches Geoffrey's attention and not only his, and she has the right to claim attention. The first time that she and I met was when she had recently moved to Cambridge, England from Cambridge, Massachusetts; she called out my husband's name inquiringly over the top of a clothes rack in Marks and Spencer. A mutual friend in America had suggested she look him up, and must have described him a bit. She may have guessed his identity by the three small children in tow. The children came to like her a lot, as much for the way in which she never talked down to them as for her cooking with them and her knitting handsome sweaters for them.

The poet-librettist has become an Anglican priest. The words that had been devoted to the art of opera are now turned to the Word. But she is happy still to catch in words the special quality of a person. For instance her husband, Geoffrey Hill.

—*Judith Aronson*

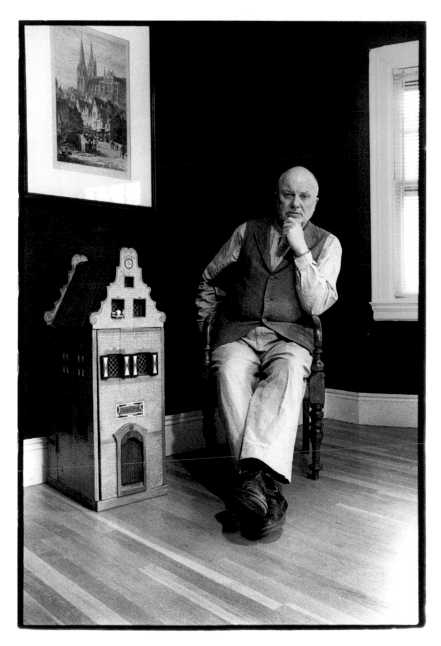

Brookline, Massachusetts, 1998

83

*Emmanuel College,
Cambridge, England, 1984*

CHARLES TOMLINSON, BRENDA TOMLINSON, JUSTINE TOMLINSON *and* JULIET TOMLINSON

"OH YES. THIS ISN'T JUST A COTTAGE, it's more than a cottage. This is the place!" He came to this reflection after insisting (in an interview with Julian Stannard in 2004) when discussing his early life, "We never really thought of Brook Cottage as just some remote English idyll. We just thought it was a live place to live. In a sense all these places—Italy, Mexico, America—are all of a piece for us. The centre of our existence was the muse and poetry".

A highlight of journeys back to England has always been seeing the Tomlinsons, neighbors and dear friends for over thirty years in Gloucestershire. Theirs is the remote life, one that seems especially so because their house sits at the lowest point in Ozleworth Bottom; not until the year 2000 was there a telephone. (The number is kept close to the chest.) There was the Victorian tradition of reading aloud en famille of an evening, often a Dickens novel. Tea at the Tomlinsons is served from a kitchen hardly changed from the time the cottage was built. It's especially fun, and not rare, when the family breaks from tradition: Charles pulling toffee, stuck between his teeth, into a stream of endless pleasure like a child with gum. Justine and Juliet, calming down our giggles with, "Dad, Dad, Dad, stop!" while Brenda smiles as a parent might, feeling pleased, but knowing she shouldn't. Charles, by sporting a native Mexican turquoise-and-silver ring, reminds us of their globe-trotting. His donning a Victorian mask reminded us that we were now in the 20th century. We feel anything but remote at Brook Cottage.

Octavio Paz explains that Tomlinson's work (both graphic and poetic) is "the product of many patient hours of concentrated passivity and of a moment of decision" (a flashback to Cartier-Bresson and The Decisive Moment?). "He can isolate the object, observe it, leap suddenly inside it and, before it dissolves, take the snapshot". This is not far from a live Tomlinson take. Here are the opening and the close of his "Snapshot":

> Your camera
> has caught it all, the lit
> angle where ceiling and wall
> create their corner, the flame
> In the grate
>
> * * *
>
> and yet
> you have set it down complete
> with the asymmetries
> of journal, cushion, cup,
> all we might then have missed
> In that gone moment when
> we were living it.
>
> —*Judith Aronson*

Ozleworth Bottom, Gloucestershire, 1985

Brenda Tomlinson, Juliet Tomlinson, Charles Tomlinson, Justine Tomlinson

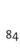

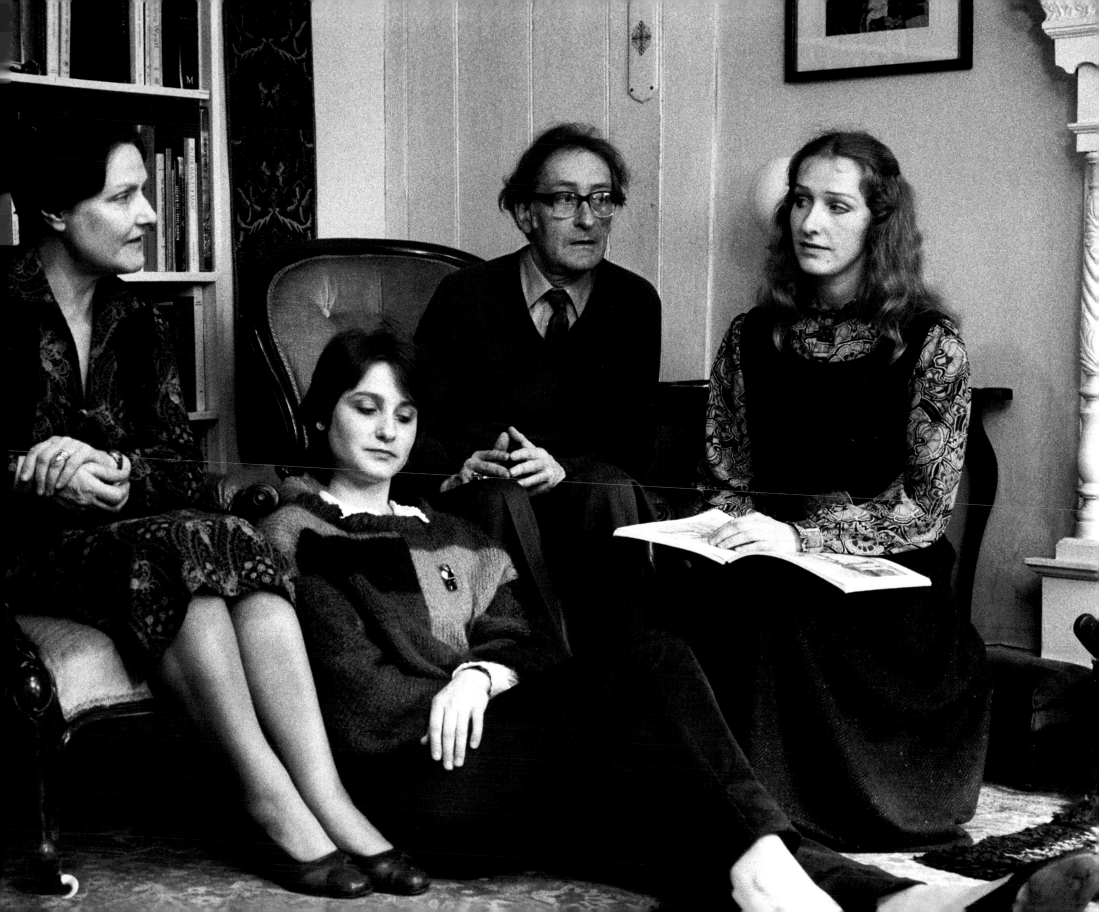

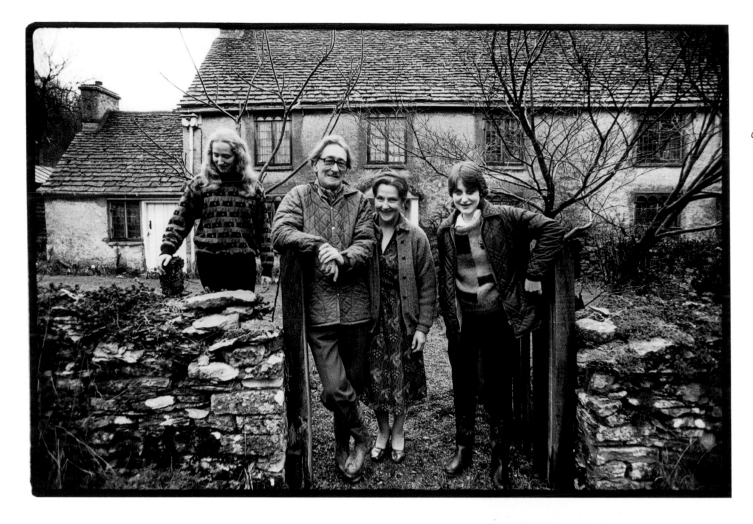

Ozleworth Bottom, Gloucestershire, 1985

With friends, Gloucestershire, 1985

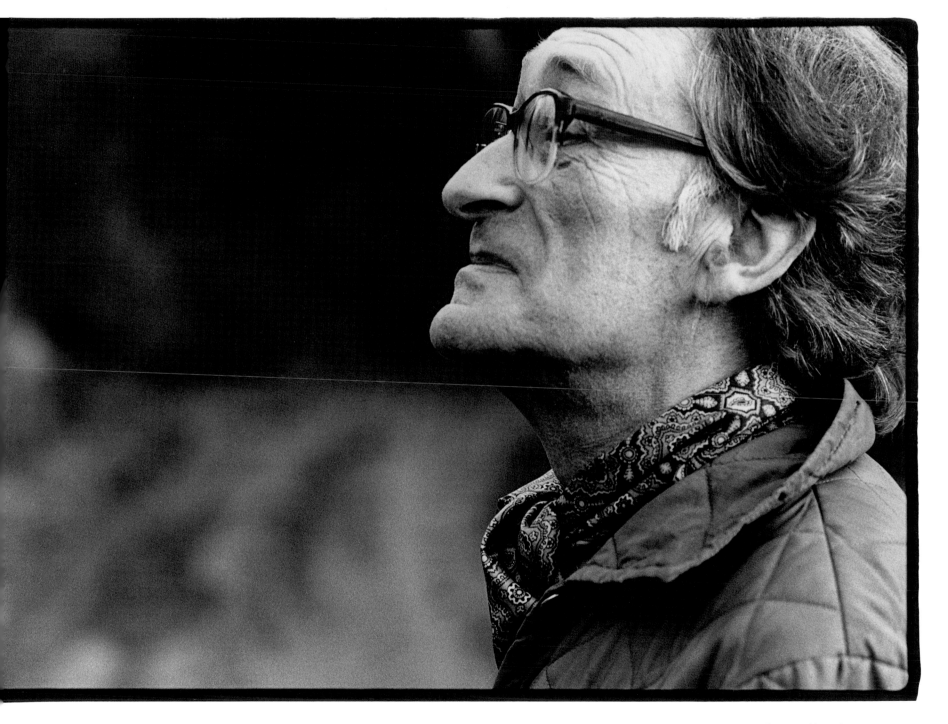

Gloucestershire, 1985

SAUL BELLOW *and* JANIS BELLOW

THAT LOOK ON SAUL'S FACE as he extends an arm to pet Moose lets you know a wicked zinger is on the way: "The handsomest Bellow", or "He looks like the maitre d' in a fancy joint". Blue-ringed brown eyes expand, and in context, in the moment, the ordinary becomes funny, eccentric, extraordinary.

With the harvest moon to blame for tonight's insomnia, I lie here, trying to remember how it was done. I'd gush, "Oh look at that little slip of a moon", and he'd toss back "Ah, yes, God's hangnail", or, Me: "Look at that beautiful moon over the water", Saul: "The night's vaccination mark", and, Me: "There's a full moon tonight", Saul: "Full of what?" The tempo lags when you lack the electric immediacy of provocation and reply.

I'm in an enviable position—luckier than most who find themselves inhabiting both sides of a bed. I can turn a switch (drown the moonlight) and read one of his books. Night tables piled high, garners rich with fully ripened grain. I reach for "Something to Remember Me By". An old man, Louis, narrates the story of a day long ago in dreary, somber Depression-era Chicago, a wintry day in which "there were no sights—more of the same and then more of the same". Odd that with this emphasis on how "there was little to see, almost nothing . . . " Louis's story should become an instruction manual about how to see, and for me, a reminder of how Saul saw. It's about his seeing. The capacity to translate nothing into something often rides on the dolphin back of Saul's comic genius. But sometimes a simple simile will do. When Louis tells us that in a Chicago back alley, "There would have been nothing to see . . . a yard, a wooden porch, a clothesline, wires, a back alley with ash heaps" we almost believe him. Then our young narrator (who has followed a woman into a strange apartment, and awaits her, naked on a grimy cot) transforms this bare sight: "What I saw of the outside were the utility wires hung between the poles like lines on music paper, only sagging, and the

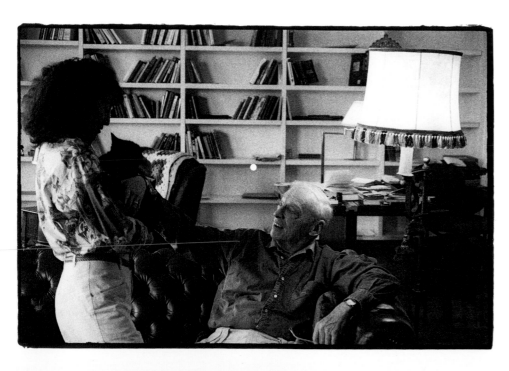

Boston, Massachusetts,
1994

glass insulators like clumps of notes". The moment's music ends here, because for all his erotic fever ("we had such major instruments to play") Louis never gets beyond a look at his love object. But "a look" misleads, because synesthete Louis has already feasted on his floozy—more fragrant than seen—"green banana", or the scent of the box of chocolates after the chocolates have been eaten—and more tasted than either viewed or sniffed—with her "salt, acid, dark, sweet odors".

We relax into the comedy, relish the simile's surprise, the synesthesia stretches us, and slowly we immerse ourselves in a seeing where there is nothing to be seen. Saul has just begun. When his Louis announces, "I saw and I saw and I saw", his awareness takes us beneath "apparent life" and into "real life", and "beneath each face", to see "the real face", until we have passed beyond the visible world, and into another. Though readers balk when a modern writer dips a toe in strange metaphysical waters, we're already in deep, and treading furiously. For Saul, the world itself prompts this vision. The challenge to capture the high specificity of the object with an infinite articulation of your own, is, in the Bellovian

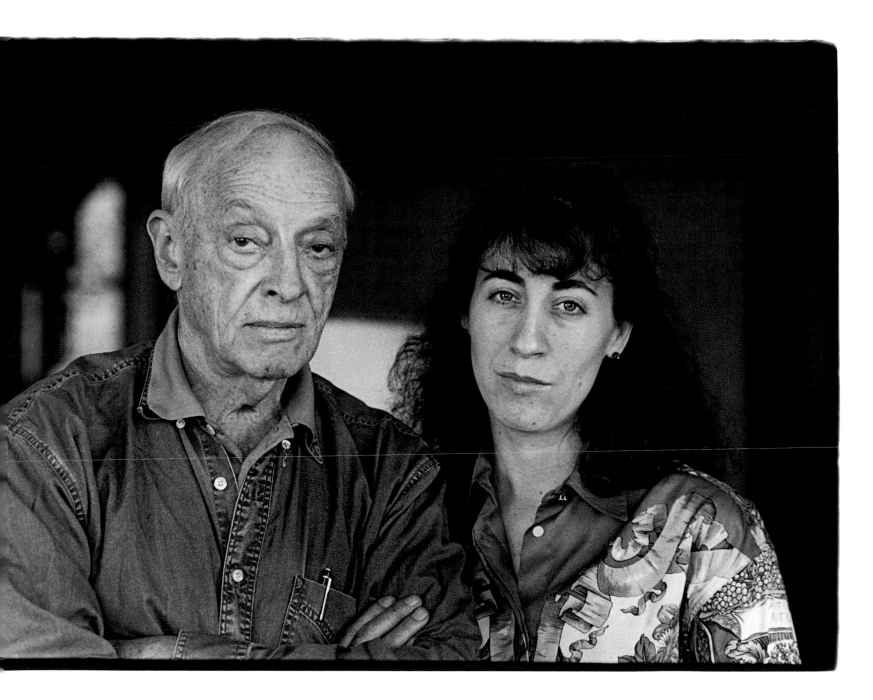

universe, "tacitly given by the phenomenon itself". The "exquisite notation" that Saul, like his Louis, found himself unable to resist, is a response to "an eccentric urge swelling toward me from the earth itself".

Lights out. When Saul was in the world I had access—borrowed access—to his metaphysics. Steeped as I was in his "singular sense of what it is to grasp specific instances", it never occurred to me that he might pack up his certainty about the world beyond, and the inevitability of reunion with those we love, and carry away these "strong impressions of eternity". In *Mr. Sammler's Planet,* "the living speed like birds over the surface of a water, and one will dive or plunge but not come up again and never be seen any more". When it was Saul's turn, he simply disappeared, taking with him what I knew of soaring.

—*Janis Bellow*

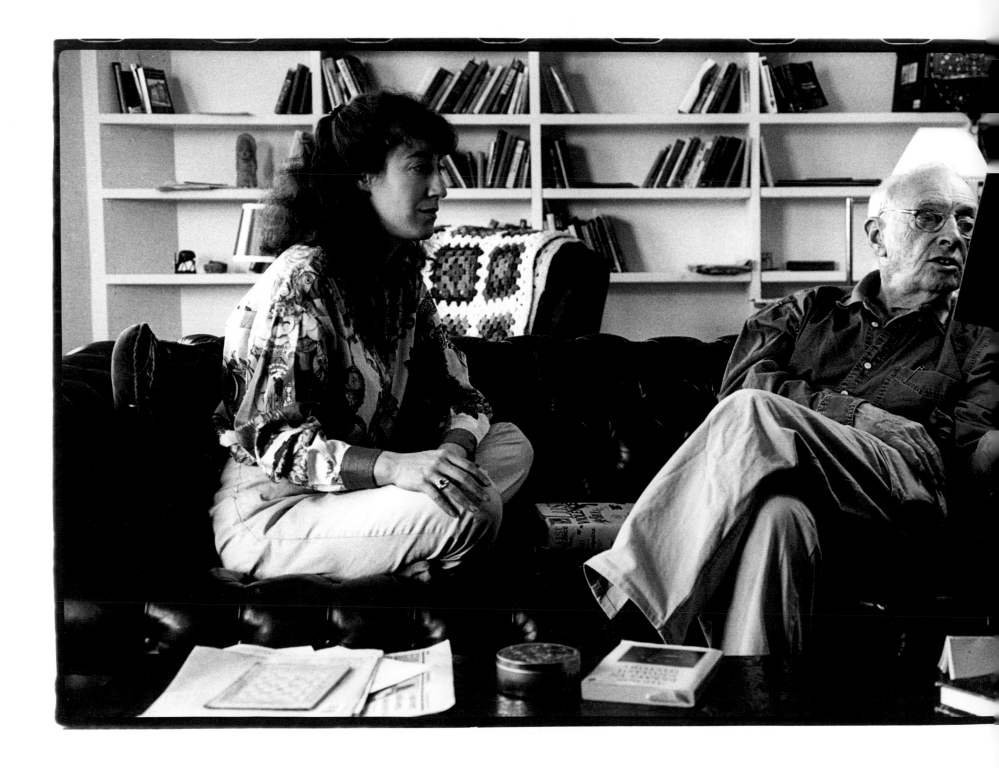

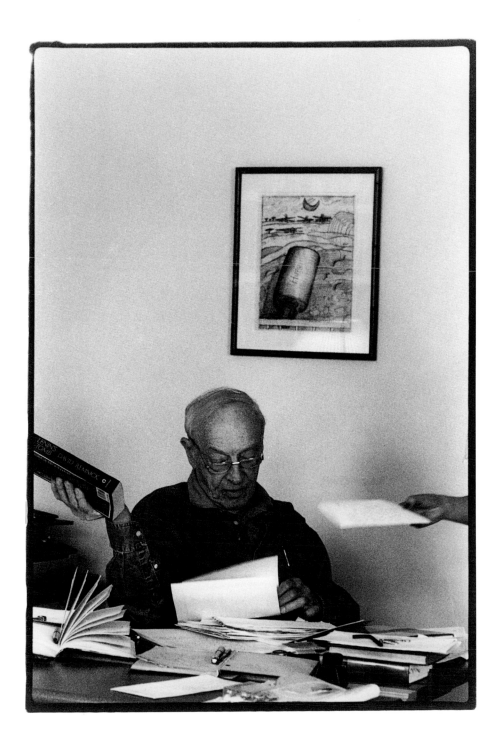

On *The Dean's December*

THIS REMAINS A PUGNACIOUS, feisty, quarrelsome, fierce book. It is a book to fight with, to be infuriated by, but it is also a book that will create in its readers the kind of passionate excitement and involvement that only real art can inspire. Like his dean, Bellow looks up to the stars with awe; but he knows the stars are not his job. His place, and his subject, is the earth.

—*Salman Rushdie*, 1982

Boston, Massachusetts,
1994

ROBERT PINSKY, ELLEN PINSKY *and* BIZ PINSKY

FOR QUITE A FEW YEARS BEFORE I met him, people kept telling me how much I resembled Robert Pinsky. And vice versa, people had been telling him. So it was with a certain amount of shared curiosity that, when Robert was up for a job at the writing program I direct, we agreed to get together at the old Howard Johnson's off Kenmore Square. Double takes? Well, look at Judith's photographs and judge for yourself. That's Robert, between his daughter Biz and his wife, Ellen. He looks a tad pained, not because of the proximity of his family but almost certainly because when the photo was taken he had been at the university long enough to adopt the expression I generally wear, most particularly— poor Judith!—when asked to smile. That's me to the left of my wife, Ilene.

Now go back to Robert. Really, the only difference I can see between us is that he has long sleeves and I have short, and that I have glasses and he does not. *Mon semblable! mon frère!* I think any fair-minded person must conclude that in this photo, as in life, he is a somewhat more Levantine version of his boss. It is this Middle-Eastern cast that causes him to be habitually stopped at airports. "But I am the Poet Laureate", he used to exclaim, which only got him whisked behind curtains and told to take off more than his shoes. Apparently Bialystok, land of my ancestors, got much less sun than the plains of Pinsk. What else do we see, aside from the blessing of our lovely wives? A certain wildness in the style of the coiffure, *n'est ce pas? Les nez*: suspiciously strong, suspiciously straight; I am not implying surgery so much as a distant admixture from either the Cossacks or Genghis Khan. Also strong, dark,

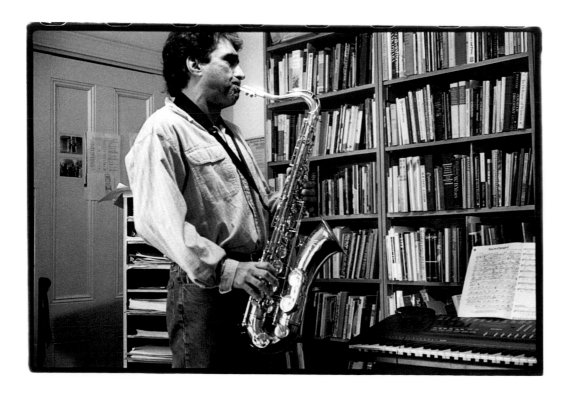

arched and bristling, *les sourcils*, yes, the eyebrows, which is what our students are confronted with at the first whiff of a sentimentality or a cliché. On the whole, I believe I am better dressed. Note, too, the different settings we have chosen for our portraits. Mine is before concrete, wood, brass, and—those hard steps—stone. The closed door behind says either Stay Out or Where the Hell is the Mailman or I have lost my key. The only link to Robert's setting is the vaguely floral motif on the left hand columns. Dingleberries? Perhaps. Or else a row of mating insects. Ah, but Robert poses before leaves, branches, trunks, with patches of sunlight breaking through—all befitting a poet insufficiently recognized for his sublimated yearning for the pastoral. Shirts and shirt buttons, pshaw! Thus, on either end of the Howard Johnson banquette, the mouse from the city warily eyes his country cousin—and, once again, vice versa. But let us not veer into the differences between us, like skills in poker or tennis (6-1, 6-1). Too much in common remains: the wide mouths, manly chins, the half-hidden ear, and the

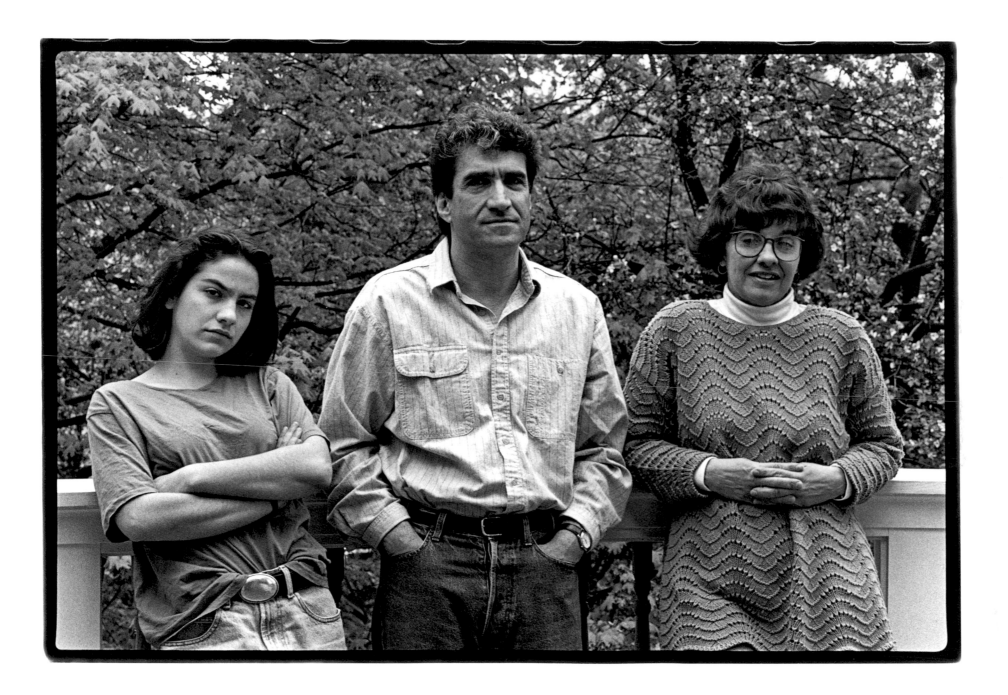

identical neck sizes of 15½. Any sensitive person could not help but respond to the deeply etched lines on each forehead and between nose and mouth with a sigh of compassion: What pain, what experience of life, what a lifetime of suffering here! I think I've gone on in this vein quite enough. What I haven't told you is how splendidly, after that initial meeting, we have hit it off, and, more important, how Robert year in and year out has brought as much to our program and his students there as he has to the world of American poetry, which in significant ways he has awakened and revived. He is the ideal colleague. The ideal teacher. The grandest of friends.

—*Leslie Epstein*

LESLIE EPSTEIN *and* ILENE EPSTEIN

"WORDS, LIKE NATURE, HALF REVEAL / AND HALF CONCEAL THE SOUL WITHIN" (Tennyson's *In Memoriam*, from the *Oxford Dictionary of Quotations*...). But then the same is true of photos, of faces, photos of faces. The novelist in Leslie Epstein often delights in looking very closely at faces. "At the register sits the Widow Stutchkoff-Pechler, no longer in black. Lipstick color: red, and red fingernail polish, with red rouge on the cheeks". "There are the waiters, Mosk, Margolies, Ellenbogen, gliding over the floor like skillful skaters on ice. Uptown Jews, with red, glowing faces, dip their egg bread in gravy and clasp in their fists their spoons" (*Goldkorn Tales*).

Most famously author of *King of the Jews*, he has said, "I'm not formally religious, but I have a sense of myself as a Jew, which comes out in all my writing". All, including even so affectionately light-hearted a reminiscence as his evocation here in this book, of the face—the nose—of his friend and colleague Robert Pinsky, compared with his own.

It pleased me that I was able to distract him from focusing too much on my camera. Helping me was the charming distractor, his wife Ilene, of whom Leslie has written with loving candor. An interviewer:

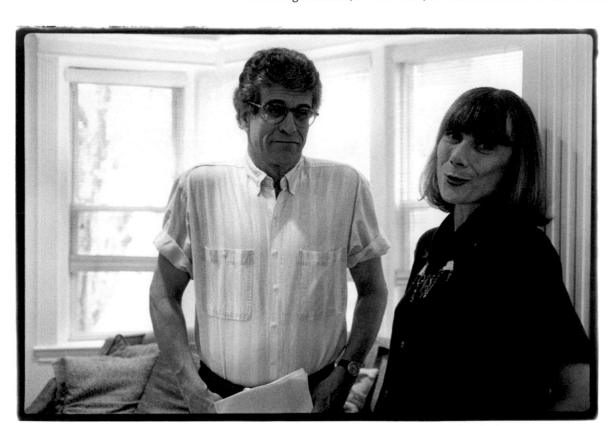

Brookline, Massachusetts, 1994

What was your philosophy in raising your children?

Leave it to the wife. [Laughs.] I think that unconsciously I married a woman who I knew would be the opposite of my mother. It's not a plan. You don't think it out, or any such thing. In retrospect, that was the case and so my children had a person of tremendous moral strength and completely selfless. Not having a selfish bone in her body was the example that our kids, I hope, picked up from their mother. They didn't pick it up from me.

What I picked up from him was that he is a King of Comedy.

—*Judith Aronson*

94

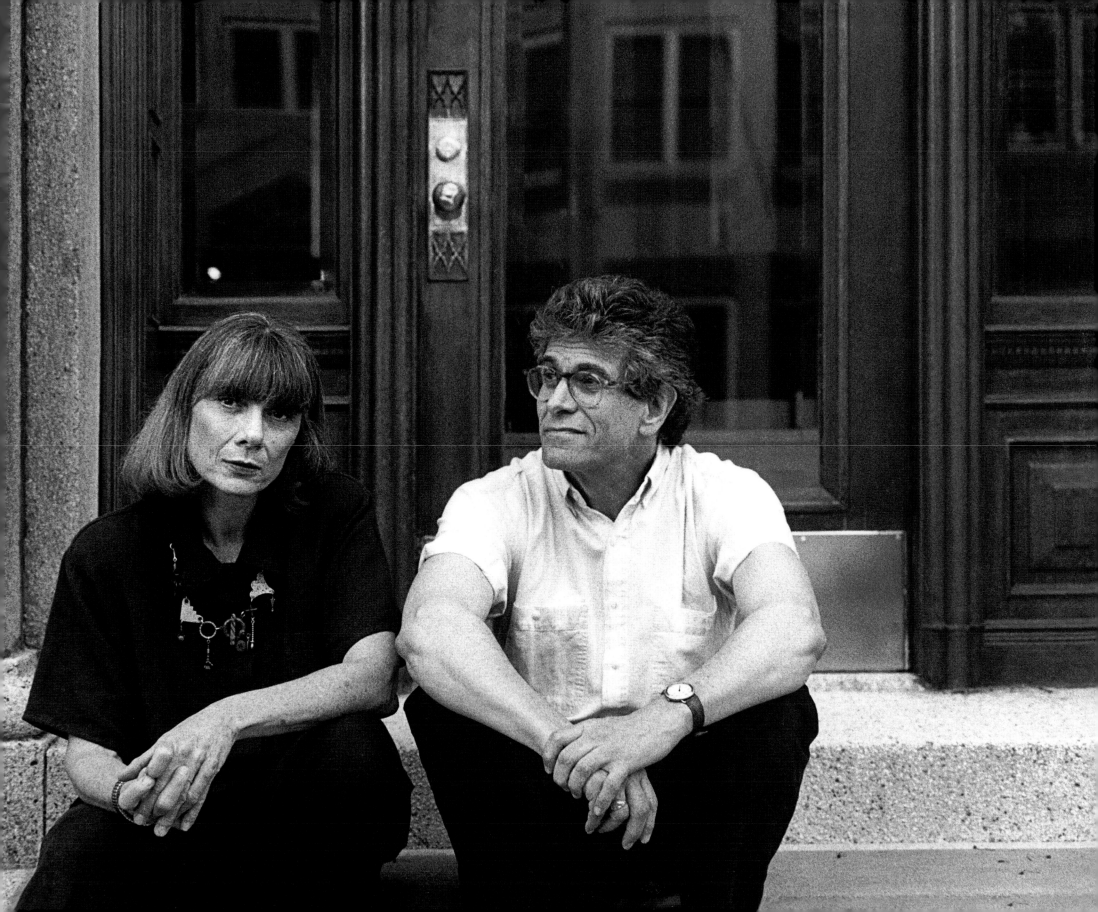

ROSANNA WARREN *and* ELEANOR CLARK
KATHERINE SCULLY *and* CHIARA SCULLY

SHE WAS DYING when Judith Aronson came to the Burrage House, in Boston, to take her picture. We didn't know she was dying, but you can see it in the photographs. Her eyes are half closed. She and I, mother and daughter, lean toward each other, but the space between us is already that gap between worlds you see in Hellenistic funeral steles, the charged air between the seated dead and the mourners who stand solemnly, sometimes holding a dove. She died two days later.

I didn't hold a dove, that day in the Burrage House where our mother lived in her last several years. My brother and I had struggled to find a place for her after our father's death. Like an obstreperous teenager in a boarding school, she'd been expelled from a genteel "old people's home" in Cambridge —"She's making the old ladies cry", the director told me severely. We had scrambled, trying to find "a residence" where a fierce, old, supremely intelligent, ornery

writer — a literary monstre sacré — legally blind, and suffering from emphysema and dementia, could live out her days in some kind of peace. It took many tries before we found the Burrage House, a late 19th century, pseudo-Gothic and Renaissance hodge-podge on Commonwealth Avenue. The interior was ornate, with high ceilings and elaborately carved mantelpieces. "Macka", as we called her, seemed to think she was Eleanor of Aquitaine in that décor.

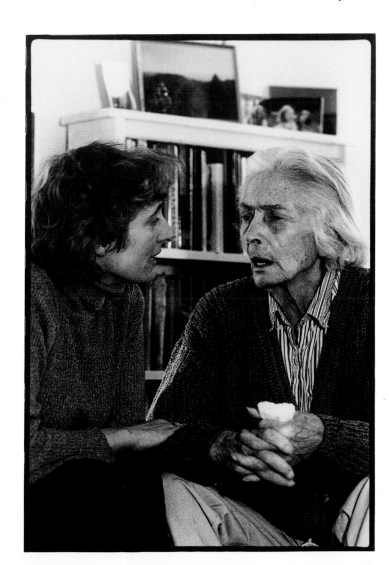

She was a magnificent bird of prey. Even though she endangered herself, we couldn't keep her locked up. Out she ventured each day, almost blind, making her way across several major streets to the Charles River, where she would walk along the Esplanade. How much she must have remembered on those walks. How much I remember, looking at these pictures. Her childhood in a failed chicken farm in a village in rural Connecticut. Her father had run away by the time she was four. She and her sister walked three miles each day to the one-room schoolhouse, and once, when a blizzard whirled in during the school day, they tried to walk the three miles back in the storm, aged six and seven, until they couldn't flounder any more in the drifts and dug a hollow in the snow to keep each other warm. Somehow—it seems miraculous—a farmer found them and brought them home in his horse-drawn sledge before they froze to death. I have always been haunted by that scene in the snow. When my grandmother, a hysteric from old, threadbare New England gentility, succumbed in her later years to solitude, sherry and morphine, I imagined her as lost in her own snowstorm of confusion.

Our mother, by contrast, pursued a life of honed lucidity. World after world took shape under her pen: Hadrian's Rome, Brittany, her childhood village, Trotsky's Mexico We had had our fights, inevitably. We loved each other ferociously. And if one of her greatest gifts to her children was her life—her uncompromising, passionate, artist's life—, another of her gifts was her death. My brother and I spent her last 36 hours at her side, holding her hands and caressing her brow in her room at the Burrage House, while outside, a blizzard blinded the city.

—Rosanna Warren

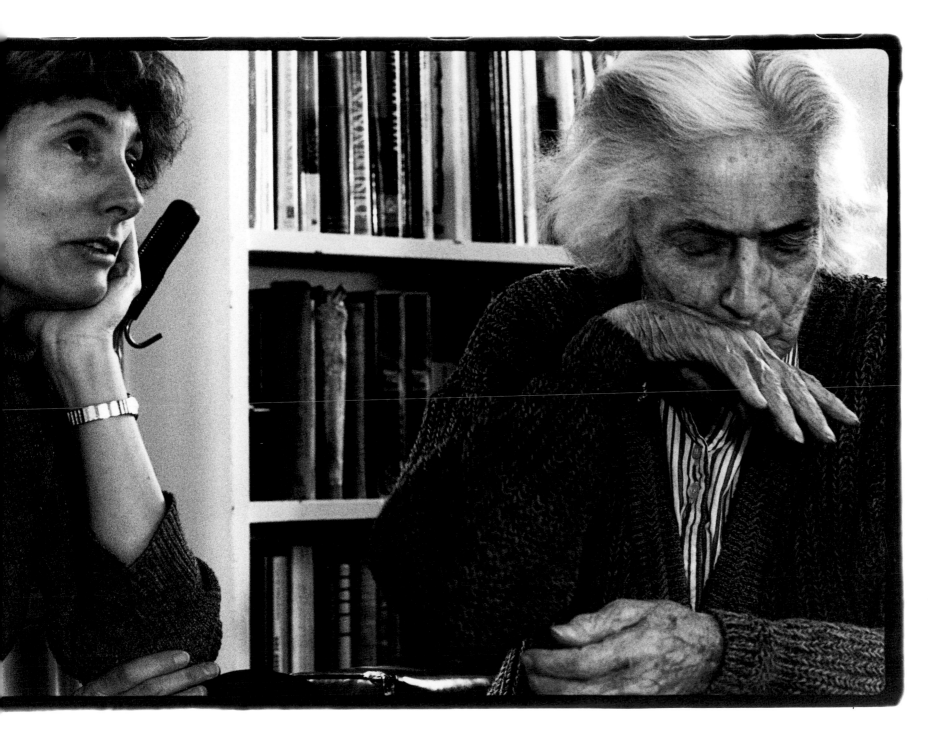

97

Boston, Massachusetts,
1994

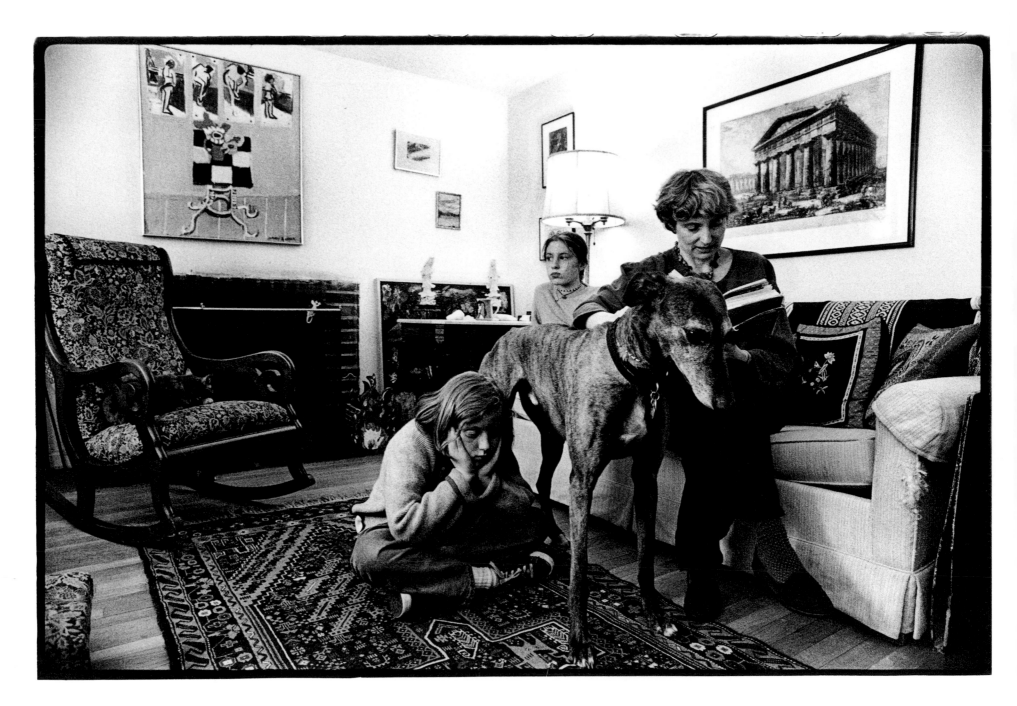

Needham, Massachusetts, 1996

THERE IS SOMETHING so right about these photographs catching Rosanna tenderly communicating with her mother, or tending to her children. I have only met Rosanna briefly a number of times, and always among a group of other writers and students at literary gatherings. Each time I have been struck with how kind and beautiful in spirit she is to people, how open and gentle. She is one of the living Graces of the US literary world. I have been communicating with her on and off over the last ten years and she has always been helpful and encouraging to me, even though she does not know me well. When we meet Rosanna,

> We are
> in reach: and palm
>
> to palm our life-
> lines trace, for a
> moment, a map.

These are the final lines of her poem "Umbilical" to her daughter Katherine as they reach for each other's hands. This sense of her spirit is translated in these photographs, the love for her children and her mother.

—*Greg Delanty*

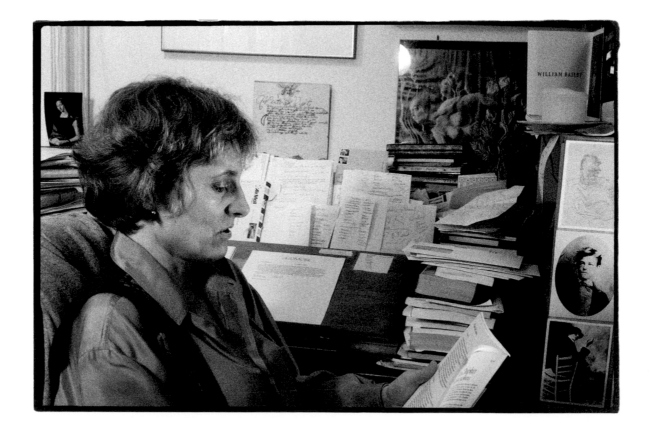

99

Roslindale, Massachusetts,
2003

CHIARA SCULLY WAS A BABBLING BABY of writers and poets. From the very beginnings, she would waddle around, haloed by her head of frizzy red curls, and already singing her own songs. I know about her Orphic beginnings, because I am her older sister, and I have been listening to her developing voice since her youngest gurgles and struggles to string words together. Her first spoken sentences, auspiciously lyrical, have become family lore. Mother, father, Chiara, and I were floating in a canoe, under the night sky, when two year old Chiara suddenly announced, "I am sitting in my mommy's lap and I fly up into the sky and I land on the moon and I fall to a star . . ." and she continued reciting an empyrean poem-narrative to her amazed parents. Until these tremendous first sentences, Chiara had barely spoken a word, causing our grandmother to fear she was backward.

Chiara has been using language with the same seeming innocence since her first full sentences in the floating canoe. Her poems charm their audiences, partly because they seem to flow perfectly and naturally from Chiara, who now, in her mid-twenties, is still as disarmingly cherubic and red-haloed as she is in this photo. This picture of effortless song, however, belies her rigorous and serious labor to study the rules of language and her exacting pains to improve her own poetic voice.

Perhaps she demands such strict study from herself because she understands the power of language to heal. At 17, Chiara was struck down by an illness that cloaked her in a terrifying, muted isolation for months. At times, during the worst parts of her illness, I had been afraid that I had lost my sister forever. Chiara slowly drew herself back into the world of the living, in part by turning to words. Through poems and memoir, she saved herself. Her tortured, wrenching recovery-in-words restored her to me, to all of us, as well.

—Katherine Scully

LOOKING AT THESE PHOTOGRAPHS of my older sister Katherine, taken years ago, I observe her with new distance and curiosity and see her more completely, rather than for the parts of her that stood out to me over periods of my life. What I see, in fact, is her instinct to approach the world with just such a critical eye.

In the photograph where she holds *The Joy of Cooking*, she stands in an isolated moment of thought. She engages only with the act of looking at the book in her hand. Yet the book itself is held oddly distant from her body. Her posture is stiff, her brow concentrated, while her free hand is curled in gentleness, as if she wants to touch her own face, but hesitates. She embodies the nature of her thought: a tender and suspended enclosure, an exacting examination, and a note of estrangement from both the object of her scrutiny and her own emotional response. In the picture, she encounters what she loves with sense, and keeps sensibility at bay.

I see these elements through all the photographs: her gesture and reason composed of straight lines, her resolute commitment, and the subtle self-protection embedded in both. I see a similar rigidity in the photographs of my grandmother, whom my sister deeply admired (though Eleanor's pose is more self-possessed, grander and more elegant).

—Chiara Scully

100

Needham, Massachusetts, 1996

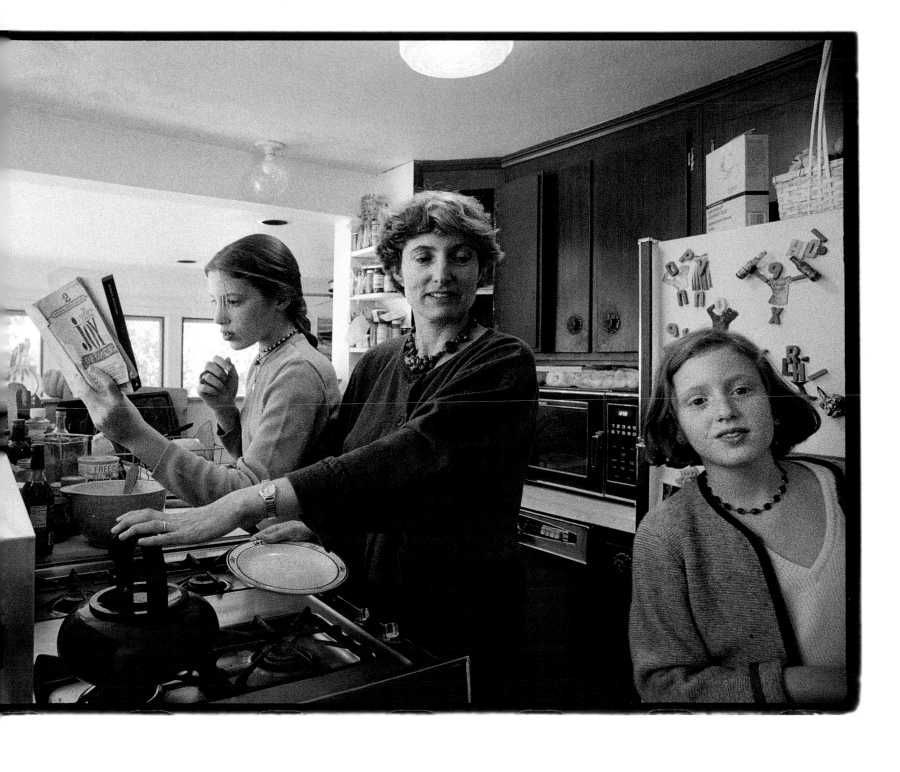

KEITH THOMAS *and* VALERIE THOMAS

SAYING THAT KEITH THOMAS'S LIFE'S WORK has been work wouldn't be altogether true, but he is after all the editor of the *Oxford Book of Work*, and it is astonishing how much work he has managed to get done. And has helped others to do. There are his major works of history: *Religion and the Decline of Magic*, *Man and the Natural World*, and in 2009, *The Ends of Life*. There is his public work, as President of the British Academy, as a Delegate of Oxford University Press, and as President of Corpus Christi College, Oxford.

Oxford colleges are very handsome places in which to live, especially—as the Oxford phrase puts it—for a Head of House. But a second home, a home from home, will help a man and his wife to stay sane. Keith and Valerie delight in the dear town of Ludlow, Shropshire, where their house straddles the entry-arch in the old town's fortification wall, a wall that is crowned and even carpeted with their tended garden. "And I come home to Ludlow", sang the poet A. E. Housman.

Back at Corpus, Keith ponders all those books, and does seem to be contemplating the clock for a moment. Not watching it, though. Not wishing work were over. If he isn't a workaholic (that recent disparaging term), it has to be because he is not addicted to work but enamored of it—and fulfilled by it. This is clear when he and his face smile, as well as when, in composure, they don't exactly. His face, like that of his wife Valerie, makes clear that he derives great happiness from the life that chose him. He is the last person to be told to get a life.

—*Judith Aronson with A. N. Other*

President's Lodge, Corpus Christi College, Oxford, 1993

102

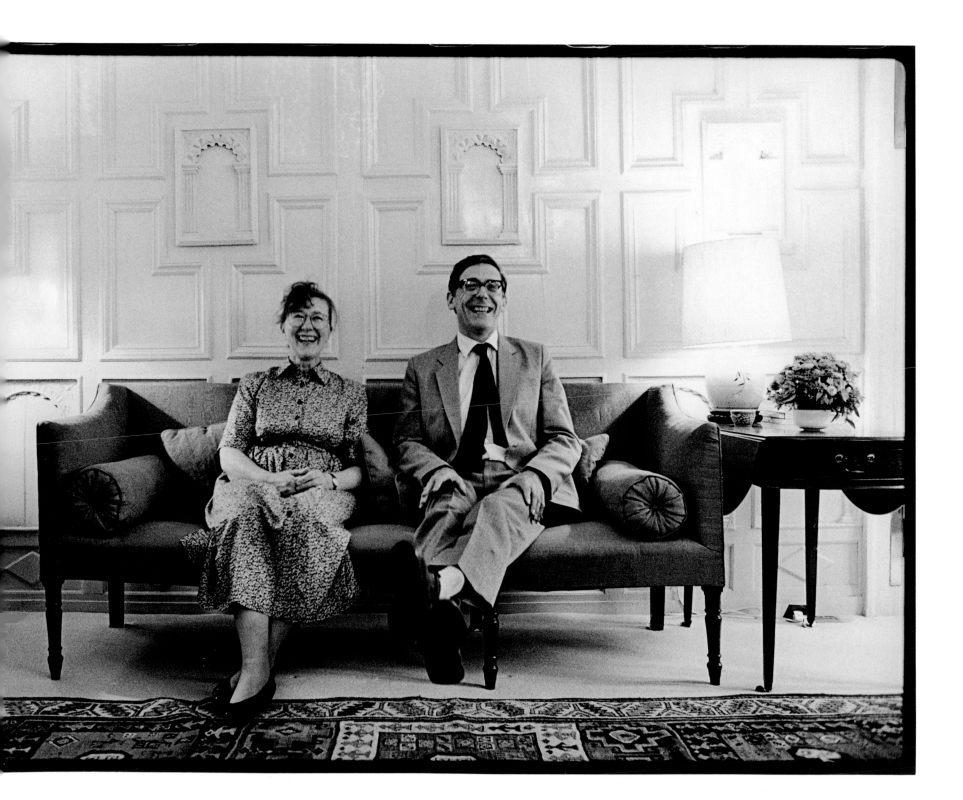

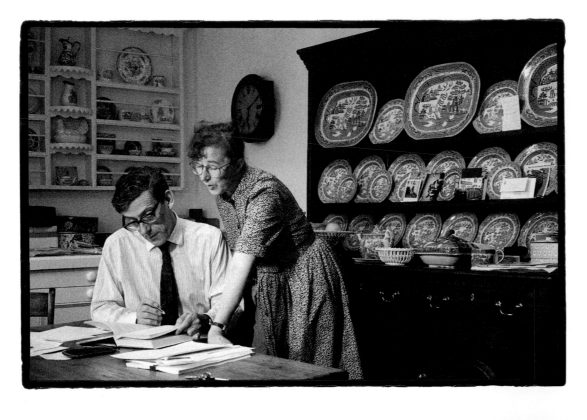

President's Lodge, Corpus Christi College,
Oxford, 1993

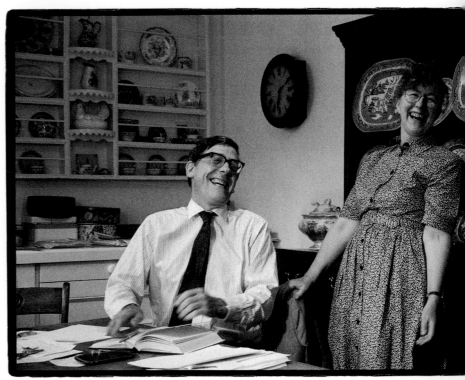

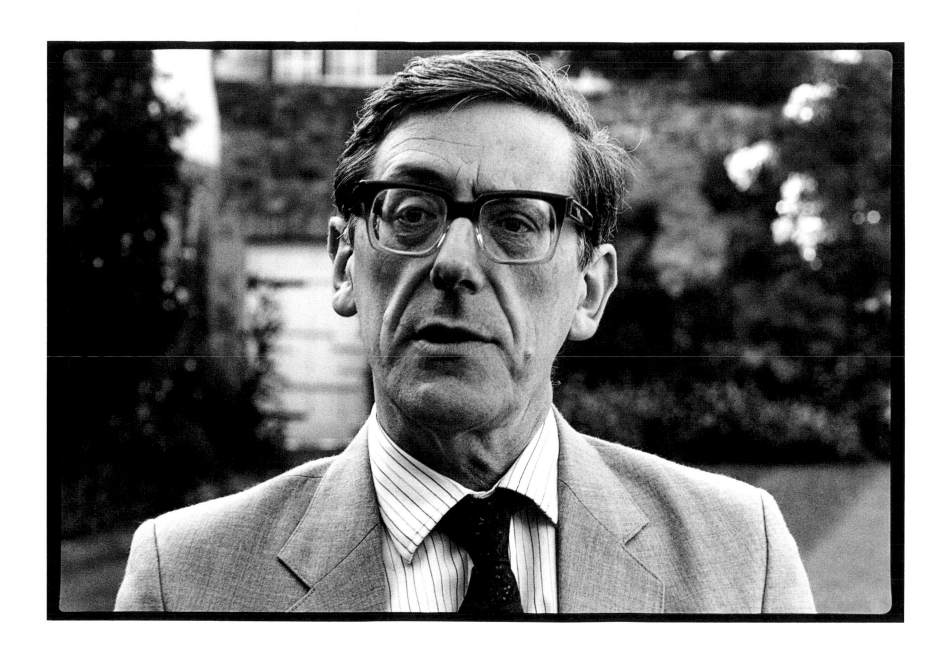

J.H. PLUMB

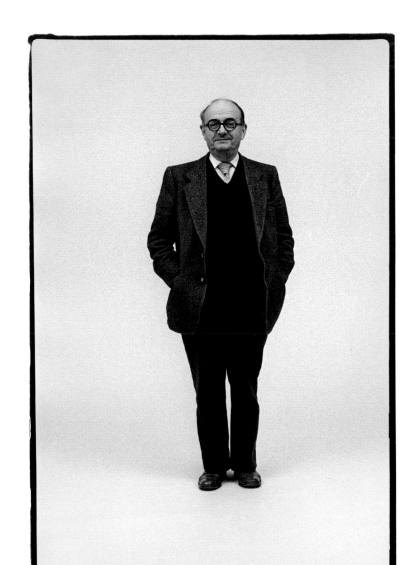

LAST SUNDAY, the select company of Gotham Knights lost one of its boldest and most Manhattan-besotted paladins: the historian Sir John Plumb died, at the age of ninety. The doormen at the Carlyle, where he rested his lance every spring and fall, called him Sir Plumb, but old friends like Pat Moynihan, Brooke Astor, and Brendan Gill called him Jack, as in Falstaff. Although Plumb was more taken with first-growth Bordeaux than with sack, he, too, was a virtuoso deflater of humbug, as well as a writer of pungent, often pyrotechnically dazzling prose. A lower-middle-class boy from Leicester, he had climbed up the academic hierarchy the hard way: rejected from Cambridge as a student, he was sent to languish in the limbo of the University College at Leicester, whose residents, in the early thirties, numbered just eighty students and faculty, "including", he used to say, "the hall porter who taught botany". After that bleak start, Plumb spent most of his life at Christ's College, Cambridge, where in the nineteen-sixties he taught novices like me, Roy Porter, and John Brewer to keep faith with the literary craft of narrative, to have the intellectual courage to tackle big subjects, and to see human history as an epic of social evolution.

Although he wore owlish eyeglasses, Jack Plumb, small, round, and feisty, was hardly your standard-issue cloistered, pipe-puffing don. He favored loudly striped shirts, soft-brimmed blue fedoras, fast cars, and big dark coats, in which he would stalk down Madison Avenue, make stage entrances at the Knickerbocker Club, or trot briskly through the Park. Ben Sonnenberg, the advertising and public-relations millionaire, threw open the doors of his Gramercy Park palazzo to Plumb, who revelled in the courtly glamour, especially since it had been earned by someone who came from nothing. Seated on the plumped-up brocade cushions, he held court there, summoning the "steward" for pots of tea served from Georgian silver.

Plumb divided humanity into those who raised the temperature of a room when they entered and those who lowered it, and he himself could be relied on for serious central heating. Half Edward Gibbon, half Max Bialystock, he was never happier than when he was ordering colossal ice-cream sundaes for my children at Rumpelmayer's, wolfing down shad roe at Gage & Tollner, or accompanying Brooke Astor to a Literary Lions evening at the public library. He brought a punchy ebullience to the historical journalism he practiced for *Horizon* and *The New York Review of Books*. For Plumb, history since Herodotus had been a public art, which somehow had become unnaturally imprisoned in the academy; unless it got out—at least for short breaks on parole—it would deserve to rot.

—*Simon Schama*, 2001

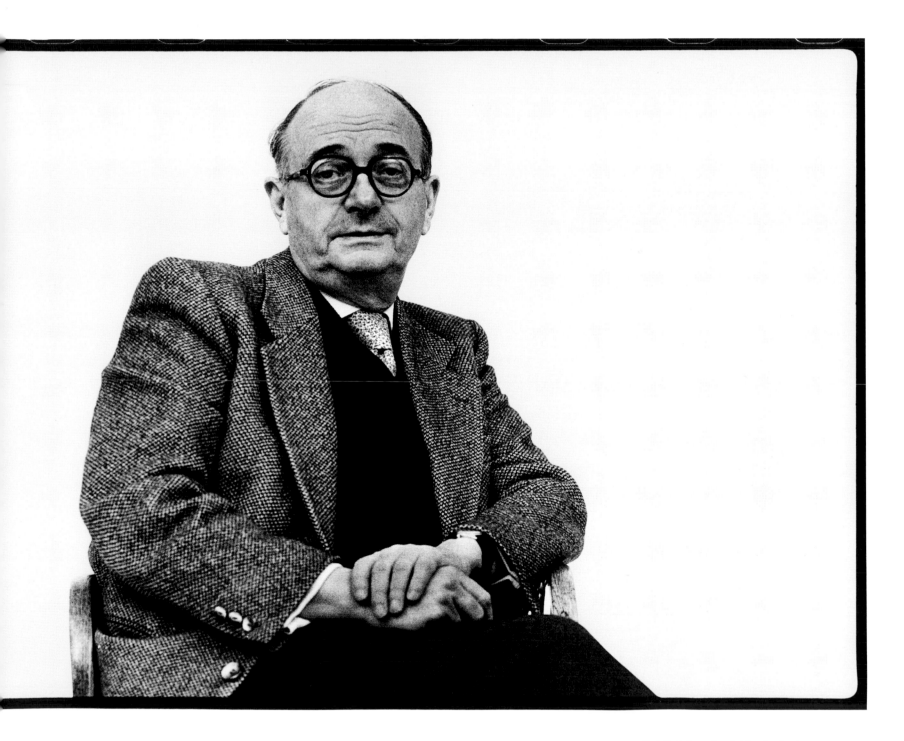

107

Christ's College, Cambridge, England,
1979

SIMON SCHAMA

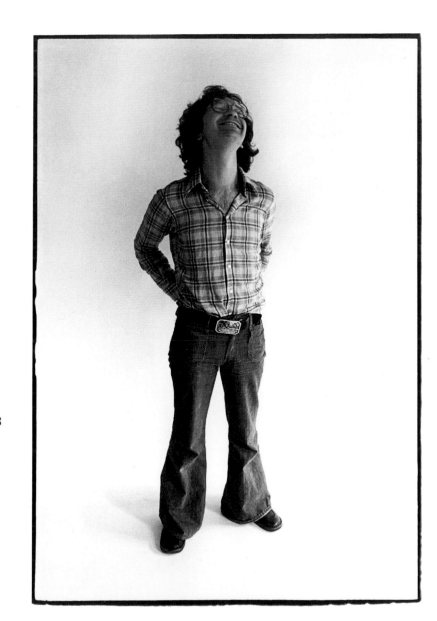

Simon schama is a dear old friend whom I met when he was in his twenties and we both lived in Cambridge, England. I asked him recently if he ever went back. Somewhat sheepishly he said, "I have this dream that every time I get near Cambridge the portcullis of Christ's College comes down on my head and that I have to sit the Tripos again in some subject I know nothing about like Sanskrit or biology". Why this dream? Is it that Jack Plumb, the Master of Christ's College, a most formidable figure who was Simon's mentor in history, lives on in his nightmares? Or is Simon's night-mind rebuking him for having left England for America, with his family, in the 1980s? Or that, though he knows scads and scads about many topics including his favorites (art and history), he fears someone might catch him out? Before I can get him to tell me what *he* thinks, he's onto another one of his stories, this one about his shoulder's being operated upon "by a youngster, and this with a regional anesthetic—out in the counties, you know. More than a local, but not quite a general anesthetic. Apparently I was singing Nirvana so I can't have been totally out there, but I'm all better now. The doctor said, 'As soon as you can make 20 Hitler salutes you are fine'. This didn't go down so well in conversation elsewhere".

On he goes delighting me with his banter and with all that he knows. He's that kind of Englishman whom you'd want at any party or just as well at an intimate gathering. He can turn any story into entertainment, but knows when to be serious too. No wonder the BBC regularly plucks him away from New York for many a blockbuster series, with best-selling books that accompany them: *A History of Britain* "ate my life for four years", but far from bowing to his exhaustion he signed on for further deals for page and screen. All this he's managed while teaching away at Columbia University.

Like all stars, he's sometimes over-extended and he'd be the first or the second to admit it. But he's open, affectionate, and (a TV personality) most personable, and he is a great company.

—*Judith Aronson*

Cambridge, England, 1976

108

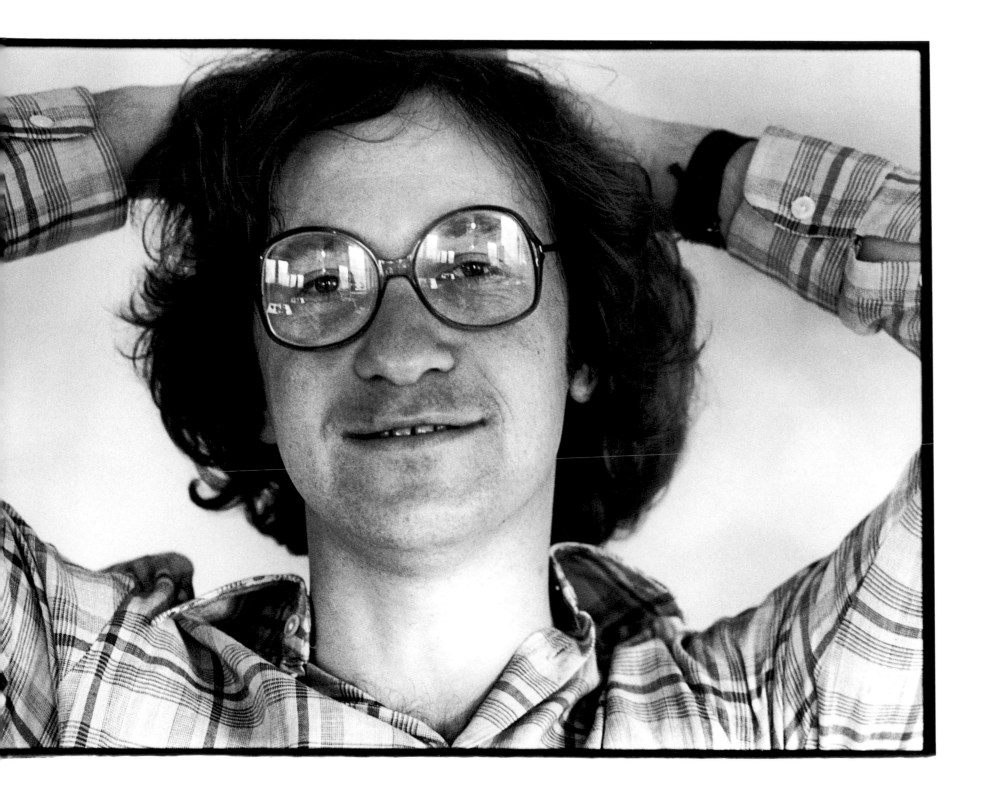

DEREK WALCOTT *and* SIGRID NAMA

ONE OF THE SADDEST THINGS I ever saw was an elephant padding along a tree-fringed shore near the tourist resort of Anse Chastenet on St. Lucia. A millionaire's amusement, the slave tusker was held on a long chain between two of those twisted trees, and swung his trunk lamentably in rhythm with his ancient bulky tread, domed pate straight ahead, too grandly tragic to bother with our self-indulgent, useless, boat-bound sympathy. I thought of Derek, whom I had read in thunderstruck pleasure, but not yet met, not, I hasten to say, as the alter ego of the shackled jumbo but as the only writer I could think of who could trumpet the animal's rage and while he was at it, help me murder the millionaire. Walcott is himself a beast on an ocean shore but as you'll notice from these pictures of himself and Sigrid, of a distinctly leonine cast.

When we did finally meet up, in Boston in the mid-80s, that citadel of wintry distinction seemed to me the last place he would want to be. I took Derek to be of the Craft, the historian's that is, and the right kind, the unsentimental bard; who had taken the savagery of time's doings right into his bones. Herodotus and Walcott would have got along and for all I know they already have. Derek grew up Methodist but was gleefully corrupted by the savour of an island patois-sung Catholicism that never lost its pagan animation. His churchbells are the "moaning conch" sounded through the giant ferns and over the baby volcano with its gaseous burps and leaks. For Walcott, classical disciplinarian of metre though he is, there with Homer, Virgil, and Dante, history is a purposeful dishevelment, a wild throw in the air, landing bleached on the beach, salt-filmed, rinsed by the hard island rain that hammers through his lines.

He seems much given to the mirror, but always with aan unsparing self-regard at the "knotted white hair"; the cordage of veins; life's merciless mottling. But he must like these images Judith has caught; for they set him where he needs to be, in the hot island light; beside Sigrid. And from the expansive, deadset strength he squares before the lens, it's an easy thing to infer the landscape beyond the frame: the twisted sea-almond trees, the "crusty grouper, onyx-eyed . . . weighted by its jewels like a bald queen" swimming off shore beneath the "uncontaminated cobalt"; peeling pirogues on the sand.

Walcott is the most painterly poet and a poetic painter and his peregrinations are made with chums who include Tiepolo, Pissarro, Claude and Turner, his image of that last painter's "drizzling twilights" better than anything Ruskin contrived. You can travel with him into chilblained London; the Greenwich Village stoop where he was once beaten by punks and concluded that while that might have been an episode of American youth, "if love's that tough I don't want it"; to limestoned Mantua or the banks of the Ganges.

But the Prodigal returns, always to the island and its "uncouth features"; the "onions, jackfish, bread, red snapper"; to the "wires of rain" and twine-twists of "casual"roads; to Castries whose acrid burnings he holds in his lungs; to the place where at fourteen "I drowned in labouring breakers of bright cloud" and was possessed by an infallible sense of what he had to do. Lucky us.

—*Simon Schama*

110

St. Lucia, West Indies,
1994

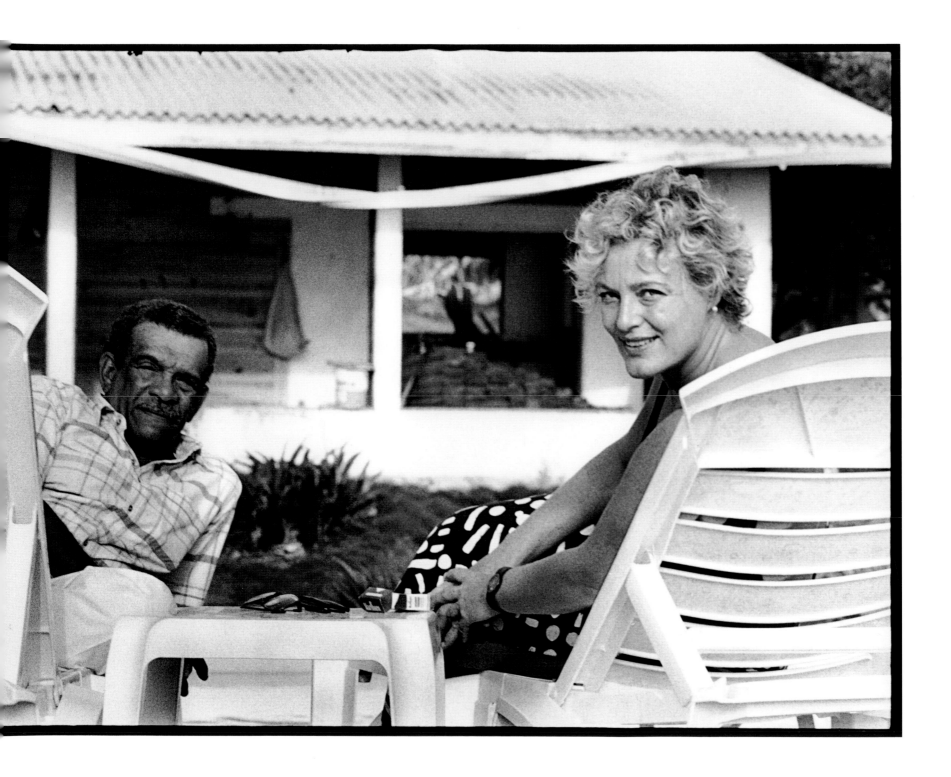

For those awakening to the nightmare of history, revenge—Walcott had conceded—can be a kind of vision, yet he himself is not vengeful. Nor is he simply a patient singer of the tears of things. His intelligence is fierce but it is literary. He assumes that art is a power and to be visited by it is to be endangered, but he also knows that works of art endanger nobody else, that they are benign. From the beginning he has never simplified or sold short. Africa and England are in him. The humanist voices of his education and the voices from his home ground keep insisting on their full claims, pulling him in two different directions. He always had the capacity to write with the elegance of a Larkin and make himself a ventriloquist's doll to the English tradition which he inherited, though that of course would have been an attenuation of his gifts, for he also has the capacity to write with the murky voluptuousness of a Neruda and make himself a romantic tongue, indigenous and awash in the prophetic. He did neither, but made a theme of the choice and the impossibility of choosing. And now he has embodied the theme in the person of Shabine, the poor mulatto sailor of the Flight, a kind of democratic West Indian Ulysses, his mind full of wind and poetry and women. Indeed when Walcott lets the sea-breeze freshen in his imagination, the result is a poetry as spacious and heart-lifting as the sea-weather at the opening of Joyce's *Ulysses*, a poetry that comes from no easy evocation of mood but from stored sensations of the actual:

> In idle August, while the sea soft,
> and leaves of brown islands stick to the rim
> of this Caribbean, I blow out the light
> by the dreamless face of Maria Concepcion
> to ship as a seaman on the schooner *Flight*.
> Out in the yard turning gray in the dawn,
> I stood like a stone and nothing else move
> but the cold sea rippling like galvanize
> and the nail holes of stars in the sky roof,
> till a wind start to interfere with the trees.

It is a sign of Walcott's mastery that his fidelity to West Indian speech now leads him not away from but right into the genius of English.

—*Seamus Heaney*, 1988

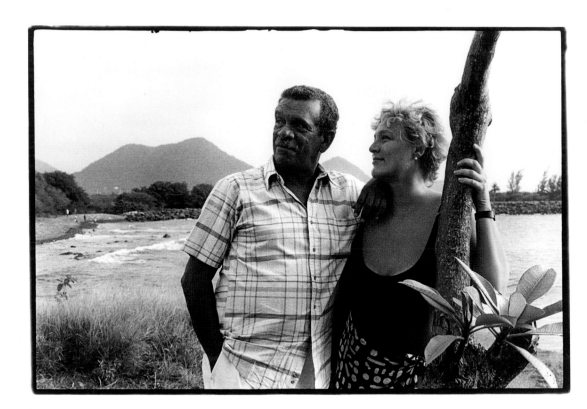

St. Lucia, West Indies,
1994

SEAMUS HEANEY *and* MARIE HEANEY

THERE WAS A REVIEW by A. Alvarez of Seamus's book, a very upsetting review—to put it mildly—in which he was describing Heaney as a sort of blue-eyed boy. English literature always has a sort of blue-eyed boy. I got very angry over the review and sent Seamus a note via my editor with a little obscenity in it. Just for some encouragement. Later, in New York, we had a drink at someone's house. From then on, the friendship has developed. I see him a lot when he is in Boston at Harvard. I just feel very lucky to have friends like Joseph [Brodsky] and Seamus. The three of us are outside of the American experience. Seamus is Irish, Joseph is Russian, I'm West Indian. We don't get embroiled in the controversies about who's a soft poet, who's a hard poet, who's a free verse poet, who's not a poet, and all of that. It's good to be on the rim of that quarreling. We're on the perimeter of the American literary scene. We can float out here happily not really committed to any kind of particular school or body of enthusiasm or criticism.

—Derek Walcott, 1985

MARIE HEANEY LIFTS THE HEART. I have been fortunate enough to have often been in the Heaney household. One feels at home talking to Marie as she cultivates her plants with such certainty, fixing supports for her flowers so they can grow and blossom. She has the strength and humility to allow you to be yourself, to blossom into your best self; to laugh, gossip, curse, give out about the poetry world, be concerned about friends, chat about her two sons and her daughter, to have a laugh. She is naturally modest of talking about her own work: her work in publishing, her fine writing in *Over Nine Waves: A Book of Irish Legends*. She is also a marvelous cook and if you're lucky in the midst of lively table-talk, she might sing. She can also be very witty and that is caught in these photographs. The playfulness between her and Seamus is evident.

Both Marie and Seamus make everyone feel special. I have often realized this when I hear other people talking about a night spent in the Heaney household, how they felt at home. When I am in the Heaneys' company I could stay there forever. All this, of course, will embarrass her, but to finish and to quote a poem "The Clothes Shrine" of Seamus:

> As if St Brigid once more
> Had rigged up a ray of sun
> Like the one she'd strung on air
> To dry her own cloak on . . .

Marie is the light beam where we hang our heavy wet coats and are "made light of".

—Greg Delanty

114

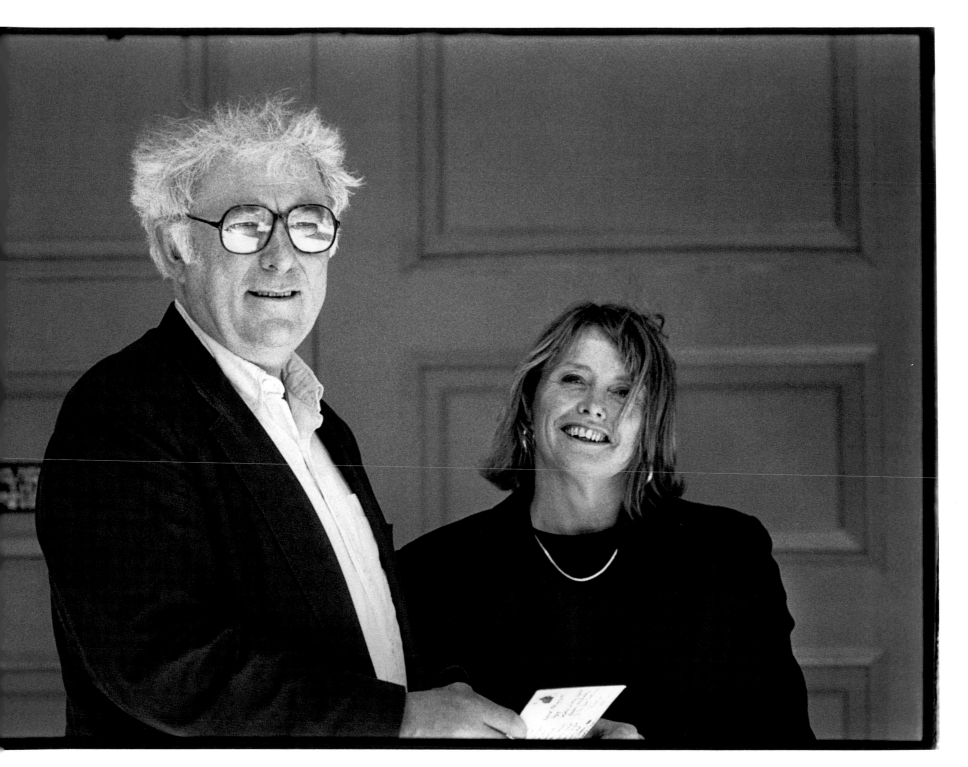

115

Harvard University,
Cambridge, Massachusetts, 1994

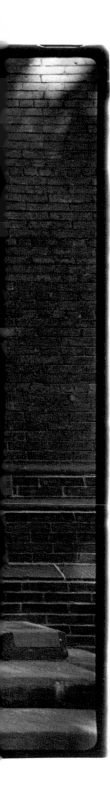

GREG DELANTY

BURLINGTON, VERMONT. THE EARLY 1990S. Late winter afternoon, a few hours before I am due to give a poetry reading in St Michael's College. I have come up from Harvard and my host is taking me for a walk along the shore of deep-frozen Lake Burlington, where the skaters swerve and skim "in games confederate', as Wordsworth once put it, "along the polished ice". But where Wordsworth's skaters "hissed" along, these ones produced a deeper sound, a sort of steady chthonic murmur, as if the "url" in Burlington were being "rolled round in earth's diurnal course". So we stopped and stood for a good long while, just listening, facing the old ice-music, and I knew even then that the moment would turn into one of those oddly abiding "spots of time".

My host was friend and fellow poet Greg Delanty, native of Cork city and graduate of its university, poet-in-exile, poet-in-residence, erstwhile Olympic swimmer and lifeguard, passionate anti-war and anti-nuclear activist, lover of "a bit of a laugh"—not necessarily the Yeatsian "randy laughter", although he is often to the fore among porter drinkers, his accent unmistakable in the throng, the most unadulterated Cork accent you'll hear west of the Atlantic.

This gutsy, gleeful, gossipy Greg Delanty is the friend I meet every time he comes back to Ireland, the one whose demotic idiom can never prevent high seriousness breaking in or out, the one who reminds you by his utter dedication to the art and his forthright, even furious enthusiasms and dismissals that a poetic vocation is being pursued in earnest. And this is also recognizably gregarious Gregory of Corkus, author of a merry work in progress, a pseudo-Greek Anthology, a cod literary game refracting strong convictions, among other things a coded "who's who and what's what in the poetry biz".

But for all the good company we've enjoyed at pub counter and kitchen table, for all the bonding and banter, the poet in him and the one in me were closest when we stood recollected in tranquility that afternoon in wintertime Vermont.

"Rum do, this art", the painter Turner is supposed to have said once. Ditto this poetry.

—*Seamus Heaney*

118

Cambridge, Massachusetts, 2007

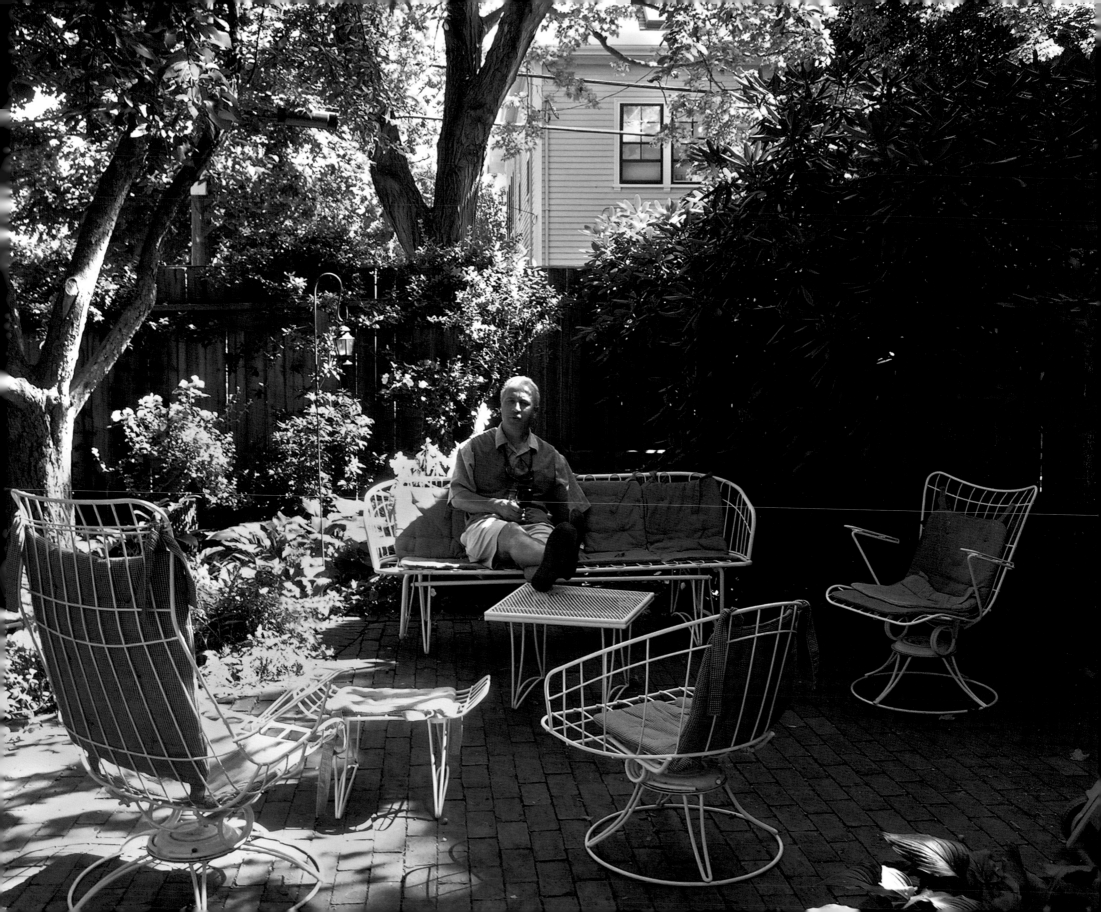

120

Cambridge, Massachusetts,
1994

Cambridge, Massachusetts,
2007

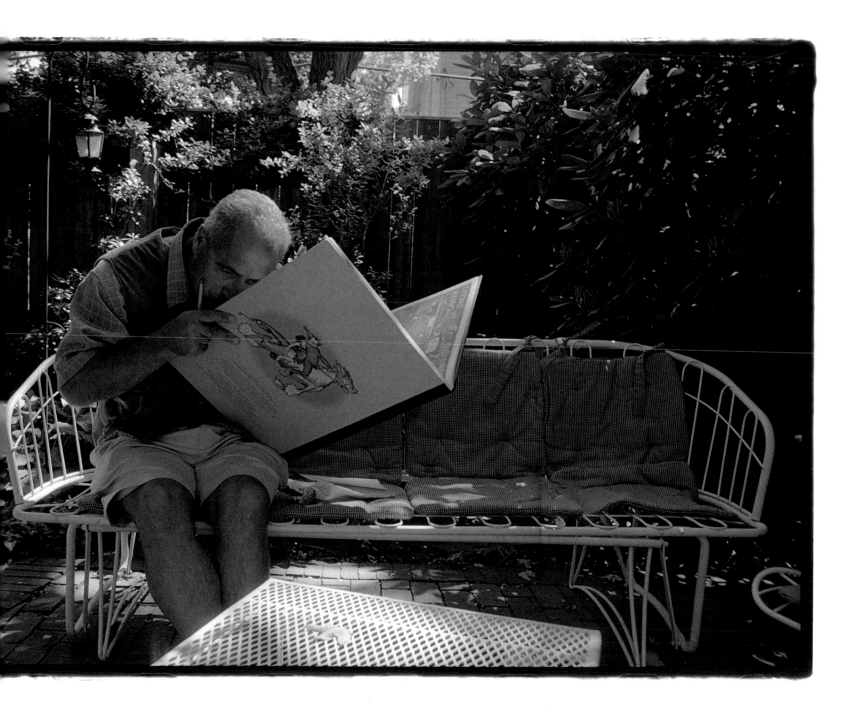

KEITH SIMPSON

I WILL NEVER FORGET THE FIRST QUESTION Keith Simpson asked on the day that I photographed him for a *Sunday Telegraph Magazine* cover story. Would I be interested in accompanying him to an autopsy? Of course I shouldn't have been surprised since he was the Home Office forensic pathologist. But taken off guard, I deferred by referring the question to the *Telegraph* editor. He confirmed that this would be an excellent idea as long as the photographs were not too gory and there was room at the top for the name of the magazine. Keith Simpson's importance was such that when we approached the mortuary, he pressed a button in his car, and garage-like doors opened. We were immediately in the frigid room with the dead body. I took a deep breath and began photographing, not intimidated by the smell or scene, so engrossing was the situation. (When asked if I'd like to go to his next autopsy, of the musician Keith Moon, I declined.) The picture I took was of a young woman recently killed in an auto accident. From the angle within the picture, one saw only her naked feet with a manila identification tag, as well as the surgical instruments. Two policemen were also in the photo. It seemed just what the paper wanted. Unusually, a photo editor phoned me that very evening to say that the images were perfect. Not a single photo from the autopsy was used in the end. The managing editor turned those photos down, saying they weren't the thing for the Sunday breakfast table. But a number of pictures were used, including, on the cover, one of Simpson holding the evidence from a famous murder that he had solved many years after it occurred.

—*Judith Aronson*

122

*King's College Hospital,
London, 1978*

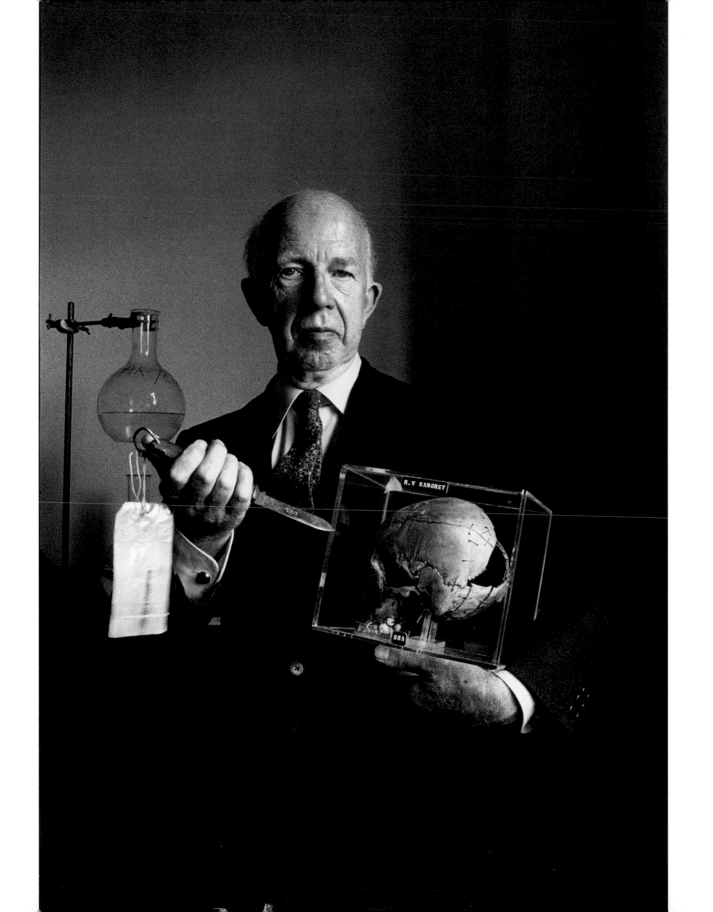

124

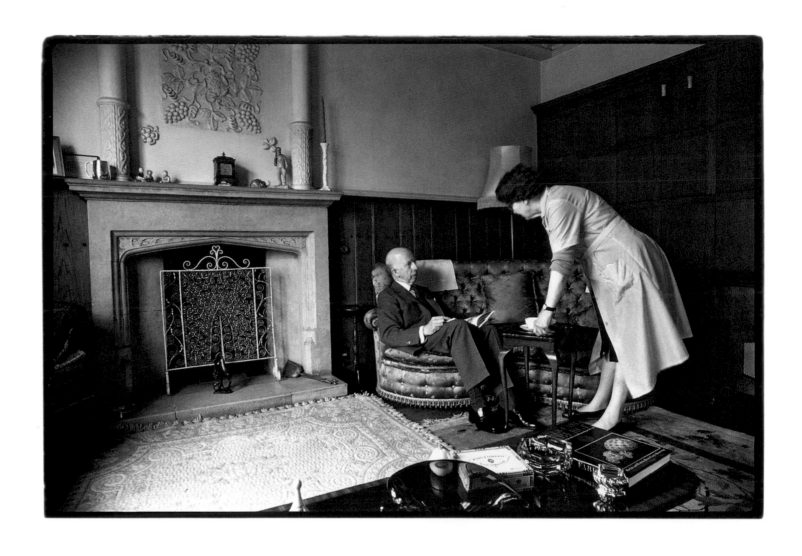

London, 1978

*With granddaughter, Bedfordshire,
England, 1978*

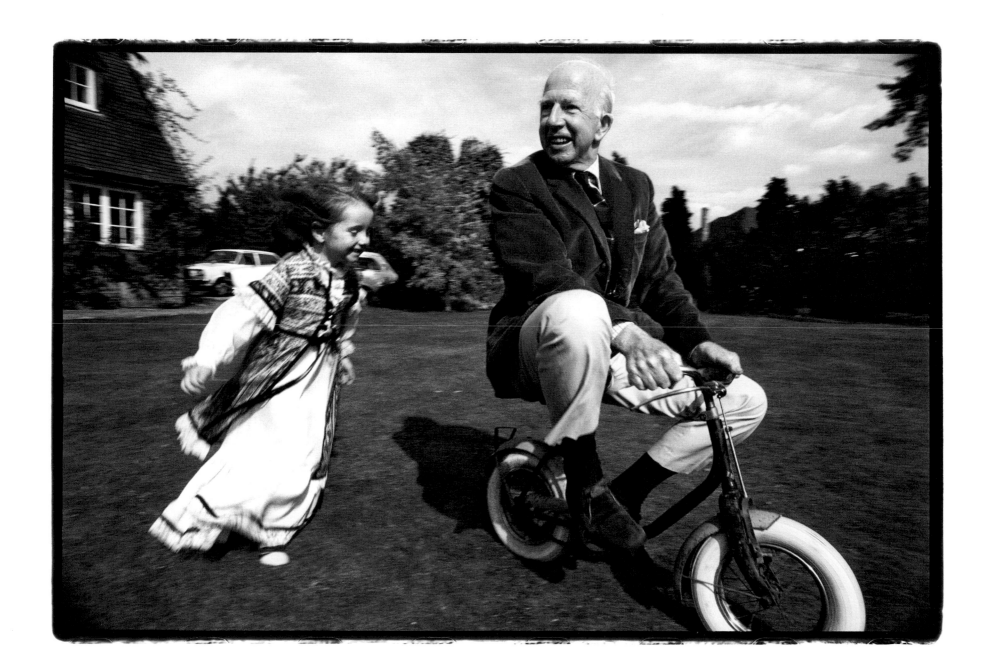

ACKNOWLEDGEMENTS

Most contributions are original to *Likenesses*.

Previously published contributions are dated by year: letters with the date when written (Robert Lowell on William Empson and on Jonathan Miller, I. A. Richards on William Empson and on Robert Lowell); poems, articles, memoirs, and interviews have the year of publication.

William Empson

On I. A. Richards, from *Argufying: Essays on Literature and Culture*. Reproduced with permission of Curtis Brown Group Ltd, London on behalf of the Estate of William Empson. Copyright © the Estate of William Empson 1987.

Seamus Heaney

On Derek Walcott, from *The Government of the Tongue*, Faber & Faber, 1989, and Farrar, Straus and Giroux, 1990.

From "The Clothes Shrine", *Electric Light*, Faber & Faber, 2001, and Farrar, Straus and Giroux, 2001.

Geoffrey Hill

On Robert Lowell. Thanks to Geoffrey Hill and to Clutag Press for permission to quote from the pamphlet version of *A Treatise of Civil Power*, 2005.

Robert Lowell

On William Empson and on Jonathan Miller, from *The Letters of Robert Lowell*, edited by Saskia Hamilton, Faber & Faber, 2005, and Farrar, Straus and Giroux, 2005.

On William Empson, from *Words in Air: The Complete Correspondence between Elizabeth Bishop and Robert Lowell*, edited by Thomas Travisano with Saskia Hamilton, Farrar, Straus and Giroux, 2008.

"I. A. Richards. *Goodbye Earth*" from *History*, Faber & Faber, 1972, and Farrar, Straus and Giroux, 1973.

Norman Mailer

Thanks to the Mailer Estate for permission to quote from Rick Soll, "Norman Mailer: A Man, An Artist, A Cultural Phenomenon" in the *Chicago Sun-Times*, August 7, 1983.

William Miller and Jonathan Miller

> Thanks to William Miller and Jonathan Miller for permission to quote an exchange between them from the *Sunday Times*, July 9, 2006.

Michael Parkinson

> On Ralph Richardson, condensed from *Parky—My Autobiography*, Hodder & Stoughton, 2008.

Harold Pinter

> "Poem" from *Various Voices*, copyright © 1998 by Harold Pinter. Used by permission of Grove/Atlantic, Inc., 1998, and Faber & Faber, 1999.

I. A. Richards

> On William Empson and on Robert Lowell, in *Selected Letters of I.A. Richard*s, Oxford University Press, 1990.

Anne Ridler

> Thanks to the Ridler family for permission to quote from *Memoirs* by Anne Ridler, The Perpetua Press, 2004.

Salman Rushdie

> From the 1982 review of Saul Bellow, *The Dean's December*, in *Imaginary Homelands*, 1991.

Simon Schama

> *A New York Knight* by Simon Schama, originally published in *The New Yorker*. November 5, 2001. Copyright © 2001 Condé Nast Publications. All rights reserved. Reprinted by permission.

Ralph Steadman

> From *THE JOKE'S OVER | Bruised Memories: Gonzo, Hunter Thompson and Me*. Copyright © Ralph Steadman 2006, reprinted by permission of Houghton Mifflin Harcourt Publishing Company. William Heinemann, 2006, reprinted by permission of the Random House Group .

Robert Stephens

> From *A Profile of Jonathan Miller* by Michael Romain, Cambridge University Press, 1992.

> From *Knight Errant: Memoirs of a Vagabond Actor* by Robert Stephens and Michael Coveney (permission, A P Watt), Hodder & Stoughton, 1995.

Charles Tomlinson

> On Robert Lowell, from *American Essays*, Carcanet Press, 2001.

> "Snapshot" and "Against Portraits" from *New Collected Poems*, Carcanet Press, 2009.

Diana Trilling

> On Norman Mailer, from "The Moral Radicalism of Norman Mailer" in *Claremont Essays*, Secker and Warburg, 1965.

Derek Walcott

> Thanks to Derek Walcott for permission to quote from his interview with Edward Hirsch, 1985, on Robert Lowell and on Seamus Heaney, in *Conversations with Derek Walcott*, edited by William Baer, University Press of Mississippi, 1996.

> From "The Schooner 'Flight'", in *Collected Poems, 1948–1984*, Faber & Faber, 1990, and Farrar, Straus and Giroux, 1986.

Rosanna Warren

> From "Umbilical", in *Stained Glass*, W. W. Norton & Co., 1993.

127

IDENTIFICATIONS

Cambridge Cemetery, Cambridge, Massachusetts, 1974

HENRY JAMES, O.M.

NOVELIST · CITIZEN
OF TWO COUNTRIES
INTERPRETER OF HIS
GENERATION ON BOTH
SIDES OF THE SEA

NEW YORK APRIL 15 1843
LONDON, FEBRUARY 28 1916

H JAMĖS LOT
←

THOMAS WENTWORTH
HIGGINSON

Design by Judith Aronson

Typefaces: The Sans by Lucas deGroot; Penumbra by Lance Hidy

Pre-press and production consultant: Scott-Martin Kosofsky,
The Philidor Company, Lexington, Massachusetts

Printed in duotone on 157 gsm GoldEast matte
by Everbest Printing, China

The author gratefully acknowledges an award for *Likenesses* from the
Simmons College President's Fund for Faculty Excellence, 2008